Profusely Illustrated

Edward Sorel

Profusely Illustrated

Alfred A. Knopf New York 2021

THIS IS A BORZOI BOOK
PUBLISHED BY ALFRED A. KNOPF

www.aaknopf.com

Knopf, Borzoi Books, and the colophon
are registered trademarks of Penguin Random House LLC.

Library of Congress Cataloging-in-Publication Data
Names: Sorel, Edward, 1929– author.
Title: Profusely illustrated : a memoir / Edward Sorel.
Description: New York : Alfred A. Knopf, 2021. | "This is a Borzoi book."—Colophon.
Identifiers: LCCN 2021010240 (print) | LCCN 2021010241 (ebook) |
ISBN 9780525521068 (hardcover) | ISBN 9780525521075 (ebook)
Subjects: LCSH: Sorel, Edward, 1929– | Cartoonists—United States—Biography.
Classification: LCC NC1429.S568 A2 2021 (print) | LCC NC1429.S568 (ebook)
| DDC 741.5/6973—dc23
LC record available at https://lccn.loc.gov/2021010240
LC ebook record available at https://lccn.loc.gov/2021010241

Jacket design and illustration by Edward Sorel

Manufactured in Germany

First Edition

In memory of Nancy, who gave me the happiest years of my life

Fortune brings in some boats that are not steered.

—WILLIAM SHAKESPEARE, *Cymbeline*

Contents

Author's Note

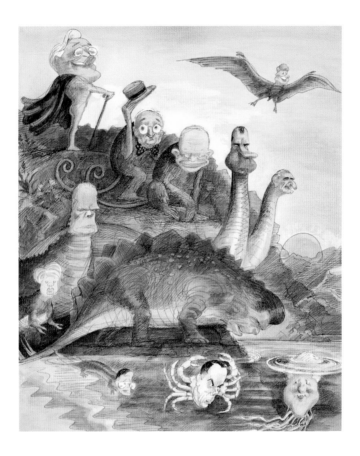

This book serves two purposes. One of them is shamelessly self-serving: to save a few of my drawings from the oblivion that awaits most protest art and almost all magazine illustrations. The second is to offer an explanation for how the United States ended up with a racist thug in the White House. My belief is that it was made possible by the criminal acts committed by the twelve presidents who preceded Trump. To buttress my argument, I will digress from my narrative now and then to describe their crimes. These exposés will be brief, so don't start skimming every time the book goes political. It will only hurt for a few minutes.

—E.S.

Profusely Illustrated

1

Portrait of the Old Lefty as a Young Lefty

I had the good luck to have a warm, upbeat, beautiful mother who told me, when I was twelve, that I really looked better in eyeglasses, and that I was really very bright, though my teachers thought otherwise. She gave me unconditional love, and as a result I went to her with all my worries and insecurities, even when I was already a man. Here's an example. I was twenty-three, and had finally succeeded in getting a girl into bed for the first time—bear in mind that this was the 1950s, not the '60s—but I had failed in that crucial rite of passage. I was distraught. I told Mom, and after giving it a moment's thought, she said:

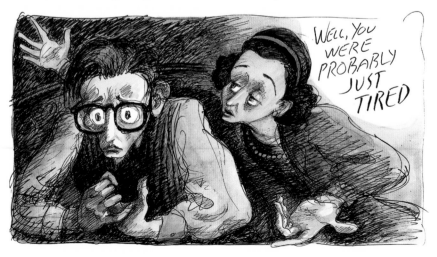

I knew from seeing those Andy Hardy movies that the proper person a son should go to when such a calamity happens was his father. But my father was no Judge Hardy, and we didn't live in a spacious Victorian house on a tree-lined street in a town called Carvel, somewhere in the Midwest. We lived in a fifth-floor walk-up in the Bronx, and there wasn't a room suitable for a "man-to-man talk." Furthermore, my father, Morris Schwartz, was not a justice of the court. He was a door-to-door salesman, and far from being wise and benevolent, he was stupid, insensitive, grouchy, mean-spirited, fault-finding, and a racist. Let me also add that he made slurping sounds when he ate soup and always had cigarette ashes on his jacket.

People meeting my parents for the first time surely asked themselves, "Why do you suppose she married him?" I wondered the same thing. Why did tall, beautiful, Rebecca Kleinberg marry short, jug-eared Morris Schwartz? (If you're confused because my father's surname is different from mine, I legally changed it to Sorel the moment—the second—I got a steady job.) Whatever reason Mom had for marrying him, I wished he would just somehow disappear. I clearly remember when I was eight or nine, being with him on a nearly empty subway platform, and thinking that, if only that one woman wasn't standing there, I could push him in front of the oncoming train, and no one would see me doing it. Of course, when I grew older, I realized how wrong that would have been. *The motorman would have seen me.*

Clearly, I was going to be stuck with him until I could find work and move out. Yet I couldn't stop myself from asking Yetta, the youngest of Mom's four sisters, "Why did Mom marry him?" She was as flummoxed as everyone else. Even Aunt Jeanette, the college graduate in the family, who always had a Freudian explanation for everything, couldn't come up with a reason. She assured me that Papa and Mama Kleinberg had begged Rebecca not to marry him. And Mom wasn't pregnant. I was born two years after they married in 1927.

Of course, I couldn't flat out ask my mother, "Why the hell did you marry him?" But when I was in my teens I thought I might

get a clue to the answer by asking Mom how she and Morris met. Here, pretty much, is what she told me.

"I was sixteen when I heard about a job in a ladies hat factory on Houston Street. This was a few months after Mama and my sisters and I arrived in America from Romania in 1923. Papa was already here. He had come earlier and sent for us as soon as he had saved enough money to bring us over. Papa had rented a walk-up apartment for us just above the Third Avenue El in the Bronx. It was nowhere near Houston Street, so I asked Papa for carfare. He told me I was too young to work, but I insisted that I wanted to work, and so he gave me three nickels. Two were for the subway that would take me to the factory and home, and one was for lunch.

"I still hadn't learned about the ins and outs of the subway, and I got so lost that I had to use my second nickel to get the right train to Houston Street. I made it there and told the man who did the hiring that I had come for a job. When he heard my English, he began speaking to me in Yiddish. He asked if I wanted to work by hand or by machine. I knew that machine operators made more than trimmers, so I said, 'Machine,' and he brought me over to this long table with dozens of sewing machines, all operated by men. Women didn't want to work on machines, so the men weren't friendly at first, but by lunchtime I was making straw hats almost as fast as they did. When the bell rang for lunch, the men left, but I had to save my last nickel to get home. While I sat at my sewing machine, one of the hat blockers came over and asked why I wasn't going out. When I explained, he said he'd lend me the money for lunch and take me to the Automat. And that blocker, Eddie, was your father."

Mom may have suspected that my question about how they met was really "Why did you marry him?" After telling me about the borrowed nickel, she added that Morris had come to America five years before she had, and so in those early days of their "keeping company" he spoke English better than she did. Was she saying that she mistook him for being educated? I said nothing. Then she murmured, "He told me he would kill himself if I didn't marry him."

What?!! She married him out of pity? Why couldn't she give me an explanation that made sense? I could imagine a few. Who wouldn't want to leave a bedroom that you had to share with your four sisters? But Yetta had told me that Rebecca had other suitors, and one was rich. Why didn't she marry him? Was Mom afraid that a rich man would force her into a life of subservience to a husband, like the Jewish women in her shtetl in Romania? Was marrying a crazy man who threatened suicide preferable to a rich man who would tell her what to do?

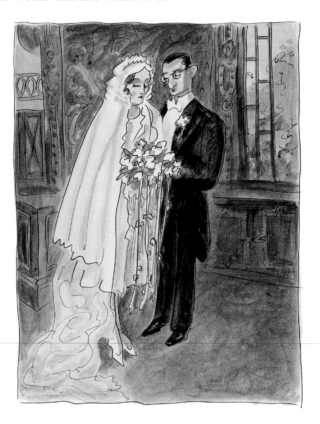

Above is a reasonable facsimile of my parents' wedding picture. I know it looks as though Morris is levitating ten inches above the ground. That's because in order to appear taller, he stood on a small platform, which was later retouched out.

My mother was twenty when that picture was taken. Morris was thirty, but by then he was no longer a blocker of hats. He had bought a car and become a door-to-door salesman of dry goods in

suburban Long Island, long before shopping centers dotted that landscape. Many of my father's lantzmen from Poland became rich peddling goods on the installment plan. My father did not. When the stock market crashed a few months after I was born, going door-to-door became a hard sell. Mom was forced to end her years as a stay-at-home housewife and return to the hat factory. She once told me that she was the only woman in the United Hatters, Cap, and Millinery Workers union who was a machine operator. I know that's not as much of an honor as being the first woman admitted to the New York Bar, but Mom took pride in it.

What to do with me while Mom was at work was solved when she rented rooms in the same building where her parents lived. My grandmother Pauline (Perel, in Yiddish) Kleinberg would take care of me. Her husband, Hyman Kleinberg, had a tailor shop in the East Bronx. He always seemed happy to see me when he got home. I loved both of them. Grandma made certain that, if there were any egg yolks in the chickens she bought on Fridays, I got them in my soup. In those days, chickens weren't packaged as they are now, featherless and with their innards removed. Grandma had to hold the chicken over the gas range to remove the feathers, and when she cut the hen open she sometimes found a whole egg or a few yolks. Later when I started going to school, it was Grandma who saw to it that I looked neat and had a handkerchief for my perpetually runny nose. Of course, I loved being with Mom at night too, except that that's when *he* was around, and when he was around there were always arguments, and in our tiny apartment there was no place to hide.

One afternoon when I was eight, sitting at one of those chair-and-desk combos that were bolted onto the floors at all public schools, I suddenly felt odd. I didn't know what I was feeling, but I raised my hand, told the teacher I didn't feel well, and asked if I could go home. I was told I would just have to sit there until the class was over. I managed to do that, but when the bell finally rang and I stood up to leave, I wasn't sure I'd be able to make it the four blocks home. Fortunately, it wasn't winter, and the walk was

downhill, but as soon as Grandma opened the door I collapsed on the floor.

I don't remember much after that, but I know that Dr. Minkin came over that evening. In 1936 doctors made house calls (it was two dollars for office visits, three for house calls), and that night he didn't have to climb five flights. I was in my grandparents' apartment, which happened to be on the ground floor. I'm told I had a very high temperature and was having trouble breathing. The doctor wanted to call an ambulance and get me to a hospital, where I could get oxygen, but Mom wouldn't allow it. If I needed oxygen she would rent an oxygen tent, even though she was warned that it would be very expensive. The reason for Mom's refusal to allow me to go to a hospital stemmed from her experiences in a Viennese facility for displaced persons during World War I.

When war broke out in 1914, the town of Dornavátra, where my grandparents lived, was part of the Austro-Hungarian Empire, and my grandfather Hyman Kleinberg was drafted into the imperial army. The town at that time was right on the border with neutral Romania, which would soon be joining the Allies—France, England, and Russia. When that happened, there would be skirmishes along that border and air battles above the Kleinberg home. During one of these, my grandmother watched in horror as machine-gun fire from one of those dogfights came close to killing her daughter Yetta.

Deciding then and there to flee, Frau Kleinberg bought a horse and wagon, took bags of sugar that she could use for barter, and started off for Vienna with her five daughters, the eldest of whom, twelve years old, was my mother. They made it to Vienna, and were placed in a fortress-like building with thousands of other refugees. They were now essentially prisoners. When Grandma began losing her hair she recognized her symptoms as diphtheria. There was an infirmary, but Grandma had heard from others that those admitted to the hospital never returned. When inspectors made their daily rounds, she hid all signs of her illness.

Grandpa, meanwhile, had been wounded at the front. Now on furlough, and learning from letters that his wife was in Vienna,

he searched all the refugee centers until he found her. She was weak, but had managed to avoid being carried off to the hospital. Grandpa bribed a guard to allow him to take his wife "out for a walk," and since she was leaving her five daughters behind, the guard was certain she'd return. Hyman—Chaim, in Yiddish—got Perel to a doctor, and days later he returned to rescue his children. In the interim, Rebecca cared for her younger sisters, constantly reassuring them that of course Papa and Mama were going to come back.

That experience was the reason Mom didn't let me go to the hospital. She never spoke about how deeply she had gone into debt to pay for the oxygen tent and the private nurse that I eventually needed, or whom she had borrowed the money from. When I no longer needed oxygen, I was carried up to my parents' apartment. A cute teenager named May—she was "colored," a term that was politically correct in 1936—was hired to stay with me. I was still bedridden, but could sit up and draw pictures on the white cardboard placed in the shirts from the Chinese laundry. While so engaged I listened to soap operas on the radio. I remember drawing a Dick Tracy comic strip, but with my own story.

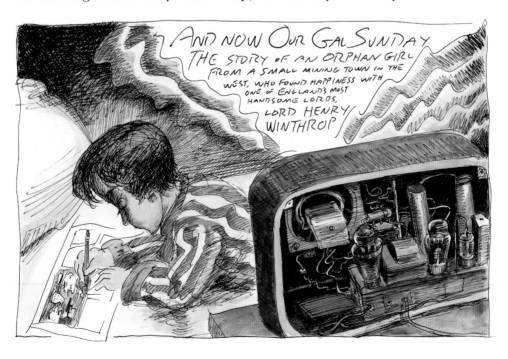

One Sunday, after many months in bed—remember, no peni-
cillin—my mother said that it was such a beautiful day, we should
go outside. I was bedridden for such a long time that my legs atro-
phied, and walking downstairs, even while holding on to the banis-
ter with one hand and my mother's hand with the other, was very
difficult. "But Mom," I said, when we were halfway down, "if it's
this hard going down, how am I going to get up?" "Don't worry,"
she assured me, "now that you've had practice going down, going
up will be easy." I didn't believe her, but when I did go up those
five flights—very slowly—it really did seem easier.

I worried about being left back in third grade, since I had been
sick for most of it, but Mom went to see the principal and got me
promoted along with my old classmates. There was an art period
in fourth grade, and now the action drawings that I had begun
doing while I was recuperating were admired by both classmates
and the teacher. A boy named Ernest, who had been considered
the best artist in the class the last term, was furious to see that I
was now the one considered an artistic wonder by our classmates.
For me, who was always the last chosen in gym class for the base-
ball games, being thought of as the best at anything was something
new. When Mom went to P.S. 90's parent/teacher night, she was
told by my teacher that I had unusual talent.

Unusual Talent!!! For the mother of a child who had never dis-
tinguished himself scholastically, talent at drawing was a straw to
grasp at. Mom enrolled me in a Saturday art class at Pratt Insti-
tute, in Brooklyn. The subways were safe then, and there was
nothing unusual about a nine-year-old traveling for over an hour
from the Bronx to Brooklyn by himself. A year later, Mom read
about another Saturday art class for children, and this one was
absolutely free. She enrolled me. The class took place at the Little
Red School House in Greenwich Village. Mom traveled down there
with me for my first session.

The room where we would do our painting was huge, and had
a skylight. Thirty or more sturdy easels were placed around the
room. Mom walked me over to the teacher and introduced me to
him. He was very tall, at least six foot four, thin, and even with

eyeglasses, very handsome. His name was Augustus Peck, and he had a warm, welcoming voice. I, along with all the other students, was given a wooden box with a handle, which I opened to discover a complete set of oil paints, brushes, turpentine, and an enamel palette. It was mine to keep so I could paint at home, and it cost absolutely nothing. The lady bountiful who had supplied these precious gifts to us was Gertrude Vanderbilt Whitney. The Whitney Museum on Eighth Street, which I passed each Saturday on my way to the Little Red, *was her museum!*

Some of the other students in the class were older than I was, and some made better pictures than I did. What was interesting was how different the subject matter was for each student. Some painted flowers, some painted portraits of their parents, and some painted the buildings in their neighborhood. I painted people doing things. I noticed that Mr. Peck spent more time with me than he did with some of the others.

The best way to get to the subway from the Little Red School House was to walk up Eighth Street, where the Whitney Museum of American Art was located then. The museum was, by today's standards, small, but it was large enough to house several paintings by John Sloan, William Glackens, Reginald Marsh, Maurice Prendergast, George Bellows, Edward Hopper, and many other contemporary artists in their permanent collection. My favorites were Sloan and Hopper. I wanted to paint like them when I grew up. But who would teach me? Not Mr. Peck. He was content to just have me "express myself."

Years later, when the Internet made it possible, I went to Google Images and looked up my beloved art teacher from the Little Red. I saw that he was in no position to teach me what I wanted to learn. The work of his that I found went from one 1930s style of drawing to another. None of the pictures showed any sort of individuality or skill at drawing the human figure, and none of them told a story. In fact, I would never find a teacher who could teach me to paint like John Sloan, and perhaps I'm lucky that I didn't. By the end of the 1930s, abstractionists like Stuart Davis were in, and the artists of the so-called Ashcan School were out. John

Sloan spent his last years attempting an utterly new style so that he could once again be regarded as an innovator. It didn't work.

Before we leave the Depression, let me share two memories. One is in my grandparents' apartment, but not the small one that held my oxygen tent. This was a larger apartment they could no longer afford. On this particular day, the rooms were empty. Everything had already been moved except the upright piano in the living room. Don't ask me how a tailor in the Bronx could afford a piano, but now he didn't have the money to transport it, and in any case there would no longer be space for it in the smaller apartment they were moving to. Aunt Sally and her husband, Moe, both unemployed, were still going to be living with my grandparents. When Moe told them that he could sell the harp buried in the piano as scrap metal for *fifteen dollars,* they gave him permission to break into it. How could they refuse? Sally and Moe were penniless.

I was about six or seven, and I remember a big, brawny friend of Moe's showing up with a sledgehammer to help him with the demolition. When the first thunderous blow was struck, Grandma covered her ears and ran out of the room in anguish. This was, after all, the piano that Nettie and Yetta had played Mozart and Beethoven on. But both of those daughters were married now and had their own apartments. I continued to watch in awe as Moe and his friend smashed the piano to pieces, finally pulling the harp out of its mooring. They smiled triumphantly. But Grandma was devastated.

The other memory is listening to a series of men singing in the backyard of our five-story building. Some of these men accompanied themselves with a guitar, others with a mandolin or an accordion. Most sang currently popular songs, but since we were in a Jewish neighborhood a few sang songs in Yiddish. These "performers" only appeared in warm weather, when the windows were wide open, and they usually had a companion who scurried to pick up the coins tossed to them. Grandma always gave me two pennies, wrapped in a small torn-off piece of newspaper, to throw down to them.

This form of panhandling with music must have been going on in every city in the country during the Depression, because in 1936 Columbia Pictures produced a movie called *Pennies from Heaven* in which Bing Crosby supported himself in just such a manner.

And speaking of Bing Crosby, I suddenly realize that I haven't told you anything about my other "family," the one made up of the Hollywood actors I saw every Saturday morning at my neighborhood movie house. It was the supporting actors of the 1930s—Donald Meek, Leonid Kinsky, Zasu Pitts, Edna May Oliver, Franklin Pangborn, Mischa Auer, and dozens of others—that I felt especially close to, because they appeared on the screen so often. I became so addicted to the movies that even as a boy I began reading movie reviews in the newspaper, the way other boys read the baseball batting averages of their favorite players. In those days newspaper reviews included a box that listed every single character in the film, and the name of the actor who performed the role. I studied those listings avidly so that I'd know the name of every actor when I went to see the movie. Those black-and-white movies, with their reassuring happy endings, were bright spots in a Depression that seemed as though it would last forever.

Although no one can offer an exact date for when the Depression ended, I'll tell you when I knew it was over. It happened in the summer of 1939, when I was ten. I had shown up at our movie theater on Saturday morning with exactly ten cents, and was told that the price had gone up to eleven cents. Not having even an extra penny, I ran the four blocks to my empty apartment (my parents sometimes had to work on Saturdays), and I took an empty milk bottle back to the grocery store and redeemed it for three cents. Weeks later a Hershey bar went from five to seven cents. The Depression was over.

As I mentioned, Jeanette was the only aunt to graduate from college. Like many at the time, she had concluded that capitalism was incapable of providing jobs, and she joined the Communist Party. As a communist, Jeanette felt compelled, when there was a band playing at one of her sisters' weddings, to use her long scarf

to do a solo dance in the manner of Isadora Duncan—another fervent supporter of the communist regime in Russia. Jeanette fancied herself as the only unconventional member of the Kleinberg family, but when Sally, her younger sister, was about to get married, Jeanette eloped with Harry Katz so she wouldn't be regarded as an old maid.

Harry was also a communist. Aunt Yetta was not a Party member, but her husband was, and she echoed all of his beliefs. I remember walking down a street with her when we passed a newsstand that displayed a close-up photo of a smiling Joseph Stalin on the front page of the *Daily News*. "All you have to do," Yetta told me, pointing to it, "is just look at his eyes to see that he's a good man."

Although Aunt Nettie was not a member of the Communist Party, she felt so guilty about having married a man who made fifty dollars a week during the depths of the Depression that she gave money to all of Jeanette's Commie causes. And when Harry lost his job because of his union activities, it was Nettie who funneled money to them. I mention all this to show why, by the time I was eight, I was already a lefty, collecting silver foil from empty cigarette packages and then rolling it into balls that could be made into bullets for the Loyalists in Spain fighting Franco.

In fifth grade, my political awareness inspired me to lead an insurrection. It happened at P.S. 90, when a young magician came to perform for our class. He wasn't dressed in a tuxedo or a cape, but he did have a top hat, and after some tricks with cards he began pulling things out of the hat. One item was an enormous square banner with a gigantic red dot in the center. I perceived this to be the flag of Japan, whose brutal soldiers had invaded China in 1937. I had seen newsreels of the devastation caused by the bombing of civilians, so when I saw that red dot on a white banner I couldn't stop myself from booing. There was a moment of awful silence, when everyone in the class stared at me, but I kept booing. Then suddenly, some other classmates saw the banner as the Japanese flag and joined me in booing. I guess their parents were lefties also. The poor fellow, in a panic, tried to explain that

a white flag with a red dot meant only that it was safe to ice-skate, but it took him a few minutes to regain his audience and his composure.

My part of the Bronx was like a shtetl, where all boys began Hebrew school two years before they turned thirteen and had their bar mitzvah. On the following page is an illustrated account of how I was able to (miraculously) prepare myself for my bar mitzvah in just two short weeks.

In 1943, my mother, convinced that the Depression was over and that Hitler would lose the war, allowed herself to become pregnant and gave birth to her second son. He was named Norman. Mom seemed delighted to have another child, even though she would be forced to return to work in just a few months. My father, who never seemed to derive joy from anything, was as uninterested in his second son as he was in his first. Some months after Norman was born, my mother went back to the factory and an elderly spinster, Mrs. Jacoby, was hired as caregiver for Norman, until he was old enough for Grandma to care for him. My father was now back in a millinery factory working as a blocker because to be a door-to-door salesman in Long Island you needed a car, and gas was now rationed.

By my reckoning, I must have been in my second or third year at the High School of Music and Art when Norman was born. Many who applied for that famed New York public school were turned down, so getting accepted seemed to certify that I had talent. But nothing I was taught at M&A helped me improve my drawing skills. The watercolor teacher insisted we use a fat brush to get bold, abstract effects, and the woman who taught sculpture disdained anything figurative or naturalistic. Only the totally abstract would be accepted. I did what I was told to do, then went home to our empty apartment and used tiny watercolor brushes to paint detailed pictures of street scenes with people actually doing things. I loved painting what I saw, not shapes and lines. Happily, the class in etching and lithography allowed me to draw subject matter that interested me. A lithograph I made of some run-down old houses won an award from the annual *Scholastic* magazine

My Fabulous (1942) Bar Mitzvah by Edward Sorel

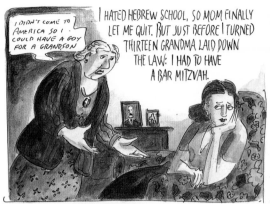

I HATED HEBREW SCHOOL, SO MOM FINALLY LET ME QUIT. BUT JUST BEFORE I TURNED THIRTEEN GRANDMA LAID DOWN THE LAW: I HAD TO HAVE A BAR MITZVAH.

I DIDN'T COME TO AMERICA SO I COULD HAVE A GOY FOR A GRANDSON

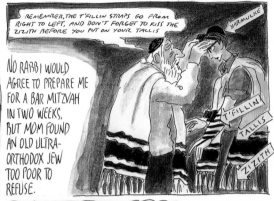

NO RABBI WOULD AGREE TO PREPARE ME FOR A BAR MITZVAH IN TWO WEEKS. BUT MOM FOUND AN OLD ULTRA-ORTHODOX JEW TOO POOR TO REFUSE.

REMEMBER, THE T'FILLIN STRAPS GO FROM RIGHT TO LEFT, AND DON'T FORGET TO KISS THE ZIZITH BEFORE YOU PUT ON YOUR TALLIS

YARMULKE / T'FILLIN / TALLIS / ZIZITH

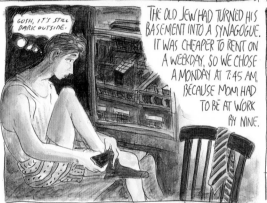

THE OLD JEW HAD TURNED HIS BASEMENT INTO A SYNAGOGUE. IT WAS CHEAPER TO RENT ON A WEEKDAY, SO WE CHOSE A MONDAY AT 7:45 AM, BECAUSE MOM HAD TO BE AT WORK BY NINE.

GOSH, IT'S STILL DARK OUTSIDE.

NO ONE CAN LEARN HEBREW IN TWO WEEKS, SO I WROTE OUT THE PRAYERS PHONETICALLY IN ENGLISH, AND HID IT IN THE PRAYER BOOK. MY GRANDPARENTS (THE ONLY GUESTS) NOW ACCEPTED ME AS A JEW.

DOESN'T HE KNOW THAT GOD SEES EVERYTHING?

BEFORE GOING TO WORK MOM GAVE ME $5 AND SAID I COULD SKIP SCHOOL. I DECIDED TO START MY DAY BY GOING TO THE PARAMOUNT.

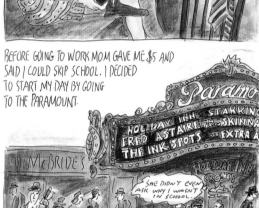

Paramo... / STARRING / HOLIDAY INN / FRED ASTAIRE / SKINNA... / THE INK SPOTS / EXTRA A... / McBRIDE'S / HOLIDAY INN CROSBY

SHE DIDN'T EVEN ASK WHY I WASN'T IN SCHOOL.

AFTERWARDS I TREATED MYSELF TO A HOT DOG AND FRIES. I STILL HAD $4 LEFT, AND DECIDED TO WALK DOWN TO THE USED-BOOK SHOPS ON 4TH AVENUE.

THESE ARNO CARTOONS ARE KINDA RACY... I WONDER WHAT MOM WOULD SAY IF I BOUGHT IT.

SPECIAL 50¢ / PETER ARNO / SPECIAL 50 / SPECIAL 50¢

I WALKED TO THE FACTORY WHERE MOM WORKED AND DROPPED BY SO WE COULD GO HOME TOGETHER. SHE SHOWED ME OFF TO HER CO-WORKERS.

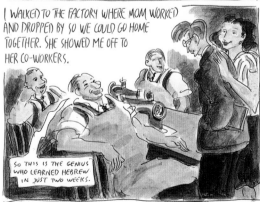

SO THIS IS THE GENIUS WHO LEARNED HEBREW IN JUST TWO WEEKS.

RIDING HOME TO THE BRONX WE LOOKED THROUGH THE BOOK OF ARNO CARTOONS. MOM THOUGHT THEY WERE AS FUNNY AS I DID. AND I STILL HAD $3 LEFT FROM THE FIVE.

PETER ARNO

competition, and it hung with other winners at McCreery's department store, on Thirty-fourth Street. On Saturday, Mom and I went to see the exhibit. Of course, she assured me that my picture was far superior to all the others.

Music and Art was in Harlem, another long subway ride away. It was at M&A that I learned that not everybody who lived in New York was poor. It happened one afternoon, at the end of a class trip to the Metropolitan Museum. As we prepared to leave, a classmate, Joan Greenberg, invited me to her apartment for milk and cookies. "I live just across the street," she told me. Joan spoke and dressed differently from the other girls, and although she wore glasses and had a lot of teeth, she seemed enormously pleased with herself. She intrigued me because she had original opinions about everything, while mine were borrowed from the last person I talked to.

Joan really did live on Fifth Avenue, right across from the Met. After the deferential elevator operator drove "Miss Greenberg" and me to her floor, the door to her apartment was opened by a maid who wore the exact same black dress and white cap that I always saw in screwball comedies about rich people.

But this residence did not have white telephones or Art Deco furniture. It had dark-red oriental rugs and huge nineteenth-century oil paintings. As I ate my cookies and admired my surroundings, my thoughts turned to the Class War that—according to Aunt Jeanette—was going to come as soon as the current war ended. Maybe a Class War really wasn't such a great idea, I thought. What would happen to Joan's plush apartment if Jeanette's comrades actually won the battle and took it over?

Fortunately for Joan and her family, there was absolutely no sign of a Class War on the horizon. With U.S. soldiers fighting on three continents, the country was united as it would never be again. Unlike the First World War, which socialists regarded as simply a war between imperialist powers, the Second World War seemed to be a fight for civilization itself. That year, 1944, Roosevelt was running for a fourth term and one of his campaign stops was going to be the Bronx. *The Bronx!* He didn't have to

worry about carrying the Bronx, but he would get a big enthusiastic crowd cheering as he rode down the Grand Concourse in an open car. It would play well in the movie newsreels and prove to everyone that, although he looked half dead, he was really in excellent health. Jeanette and her husband, Harry, urged me to join them in cheering on the Great Man.

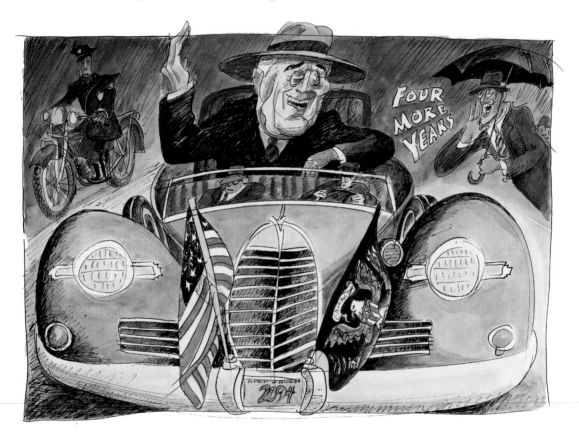

Years earlier, in 1939, after Stalin and Hitler had signed a non-aggression pact and carved up Poland between them, Jeanette and Harry were adamantly opposed to America's getting involved in the war. But after Hitler invaded Russia, they changed their minds. Now Jeanette and Harry—who went in and out of hating FDR, depending on what the Party told them—were FDR's biggest boosters. I went with them to the Grand Concourse and waited in the rain until the president rode by in an open car. When he smiled he didn't look like a man who was dying, and Uncle Harry shouted, "Four more years!"

Five months later, in April 1945, Roosevelt was dead and Harry S. Truman was president. Truman, following that most commanding of commanders in chief, seemed particularly puny. It wasn't just his thick glasses and short stature. His speeches sounded flat and uninspiring, and to the ears of New Yorkers they suggested that perhaps English wasn't actually his first language. Nevertheless, the team that Roosevelt had assembled to wage the war was still in place. It would be around to carry the battle to its successful conclusion. There was no need to panic. Even the Jews in the Bronx, who were suspicious of every politician who wasn't circumcised, felt confident that Truman would make a perfectly acceptable president, until we got a real one—like Roosevelt—after the next election.

What most reassured Jews about Truman was the news that he and a Jew, Edward Jacobson, were partners in a haberdashery store, Truman & Jacobson, in downtown Kansas City. They had become close friends while serving in the 129th Field Artillery in France during the Great War, and decided to go into business together when the war was over. So, as far as the Jews were concerned, "If a Jew is his best friend, how bad can Truman be?"

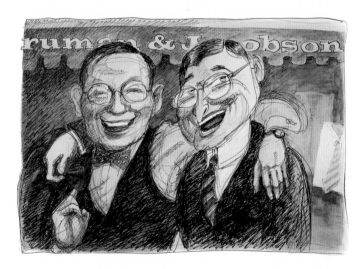

2

The Road Taken

I was a senior at New York City's High School of Music and Art in 1947 when Truman, caving in to exaggerated charges from Republicans that the Soviets had infiltrated our government, signed Executive Order 9835, creating the Loyalty-Security Program. Federal employees would now be sacked if there were "reasonable grounds" for believing they were communists, or socialists, or members of the National Negro Congress or the Abraham Lincoln Brigade. Soon university administrators and school boards across the country were demanding loyalty oaths from college professors, grade school teachers, school janitors, and anyone else who might corrupt young minds.

That year, Truman addressed Congress and asked for $400 million in military and economic assistance for Greece and Turkey, since if these countries fell, communism would likely spread as far south as Iran and as far east as India. This domino theory, labeled the Truman Doctrine, would guide U.S. policy for the next forty years. Its stated purpose was to "support free peoples who are resisting attempted subjugation by armed minorities or by outside pressures." What it actually did was prop up despots in Iran,

Cuba, the Philippines, and South Korea, and at the same time prop up the French in Vietnam. It also overthrew democratically elected governments in Guatemala, Iran, Chile, and other countries where the people were tired of being exploited by American corporate interests. Of course, this business of getting rid of governments not subservient to our wishes wasn't anything new, but after the war, these clandestine activities became the purview of the Central Intelligence Agency, which Truman created in 1947.

Truman's speeches about the threat posed by the USSR abroad and the Commies at home were heartily applauded in right-wing newspapers and Henry Luce's magazines. Now Truman, with the aid of his secretary of state and his secretary of defense, persuaded Congress and the public that the USSR was about to launch World War III with an invasion of Western Europe. Classified intelligence reports, later obtained, showed that the exact opposite was true. The Soviets were far too exhausted from World War II to even think of such a plan. But the military buildup that followed Truman's war-scare speeches of 1948 did succeed in bailing out the near-bankrupt aircraft industry. At the end of that year, Russia acquiesced to U.S. proposals for "a discussion and settlement of differences between us," and the war drums quieted. Walter Bedell Smith, our ambassador to the Soviet Union, took note: "Soviet 'war scare' has not been without advantages to USA as it has been a factor in evoking public support for necessary defense and aid measures."

That year, after having seen his favorable poll rating drop to 37 percent, the former haberdasher surprised all the political pundits by defeating Thomas E. Dewey for president. I wasn't eligible to vote in that election. You had to be twenty-one back then. I would have to wait until Dwight Eisenhower ran against Adlai Stevenson in 1952. Between those two elections I attended Cooper Union's tuition-free art school. I entered in 1949 full of hope. After four years of Music and Art, in which naturalistic drawing of any kind was discouraged, surely Cooper would be different. It wasn't. I won't say that my years there were the unhappiest of my life—

those were yet to come—but they did destroy whatever confidence I had in my ability as an artist.

Whether students planned to be architects, or sculptors, or painters, or designers, all of us at Cooper Union had to take the same basic course that first year. But of all the many disciplines that we were exposed to then, not one involved drawing. The class that I was obliged to take for three excruciating years was called Two-Dimensional Design. The idea was to get us to turn people, or buildings, or a bowl of fruit, or a locomotive, into an abstraction, using flat shapes with two colors—black and one other. The choice of the second color was up to you. (Thanks a lot.) I hated doing these abstractions, but I did them. I didn't save any of these creations, but here are two I made for record albums after I graduated. They will give you an idea of the aesthetic that was drilled into me.

In our sophomore year, we had to choose our major: painting, printmaking, or graphic design. Since no one on the faculty could teach figurative painting—they were all abstractionists—I chose graphic design, a euphemism for crass commercial art. Also in the graphic design program were Milton Glaser and Seymour Chwast (pronounced "kwast"). Those two had already proved in our first year that they could do everything more creatively than the rest

of us. Although they were the top students, and I was close to the bottom, we had one thing in common that drew us together. We all came from poor families.

Milton, who was large-boned and over six feet tall, lived in an apartment in the Bronx that was too small to afford him a room of his own, so he slept in the kitchen, with the lower part of his legs under the four-legged stove. Seymour and his mother lived near Coney Island. His father had split, which meant that his mother had to manage on the pitiful amount of money provided by New York State. It was called "relief" in the 1930s, later becoming "welfare." Aside from our shared impecuniousness and our left-wing political point of view, the three of us were joined together by the disagreeable prospect of being drafted after we graduated in 1951. The Korean War had broken out the year before.

Five short years after the end of World War II, most Americans, thanks to the Red Scare, were ready to accept the necessity of sending American troops to Korea to counter the "surprise attack" by communist North Korea, which had invaded "democratic" South Korea. At the time, the truth about the origins of that conflict was well hidden, despite the efforts of *I. F. Stone's Weekly,* which reported Stone's deep distrust of the official version. Later writers like Frank Kofsky and Howard Zinn were able to dig out documents that told the truth about how that war started.

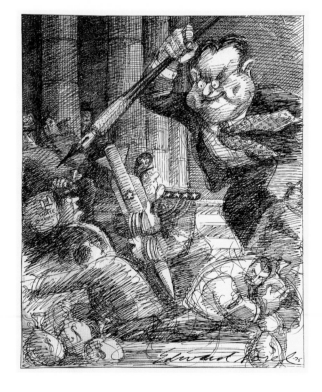

I. F. Stone became a hero of mine, and to me remains a prime example of a man who spoke truth to power. Here is a caricature I drew of him decades later for one of the many dinners that were given for him near the end of his life.

The seeds of the Korean War were planted the moment World War II ended in 1945. That's when American troops were sent to oversee the surrender of Japanese forces on the Korean peninsula. Our soldiers were told that the Koreans were to be considered enemies of the United States. Truman and the State Department planned to gain as much dominion over Korea as possible because of its strategic proximity to Japan, China, and the USSR. If it was necessary to bomb one or both of these communist countries in the future, we would need air bases there for our bombers. The majority of Koreans had their own vision for a democratic, independent, and socialist country, but those goals were in conflict with Washington's plans, so Americans allied themselves with both the existing Japanese administration and right-wing Koreans, who were against the popularly supported People's Republic of Korea.

The decision to divide the country in half was Washington's, when U.S. officials realized that controlling the south was the best they could get. In 1947 we pressured the United Nations to oversee voting in the south, knowing that all opposition had already been crushed. The north, the United States said, could create its own nation. Not only did the Soviets and the North Koreans oppose the U.S. voting plan, but so did Koreans in the south, since there was no longer a left-wing party they could vote for. An election was held anyway. K.P.S. Menon, the Indian delegate to the United Nations, charged with overseeing that election, saw that the election was illegitimate and planned to declare the results a fraud. Nehru, the Indian prime minister, phoned Menon and explained that the United States had threatened to back Pakistan in its dispute with India over Kashmir if Menon refused to accept the South Korean election results. Menon was forced to give in to the blackmail and declared the election valid.

The United States installed Syngman Rhee in power, and by 1949 he was making plans to march north and unite the entire peninsula. North Korea, now bolstered by troops returning from China's civil war, was eager to strike south, since dividing the country in half had no validity in its eyes either. Much evidence

suggests that it was Syngman Rhee who actually launched the first strike across the border, and not the other way around, as it was presented by Truman. The North, waiting for exactly such a move, responded, which gave the United States the provocation that it had been waiting for, and the war was on.

In 1951, when I reported for my army physical, I didn't know all these facts, but I knew that John Foster Dulles, Truman's under-secretary of state, was in South Korea just before the outbreak of war. I did not trust Mr. Dulles. I have always believed that if Hitler had won World War II, John Foster Dulles would have been placed in the White House. The cartoon strip on the next page, done exactly fifty years after World War II ended, will explain my reason for that belief.

I wasn't worried when I was summoned to go for my army phys-ical. I had suffered from asthma since I was eight, but of course I had to go through the humiliating examination anyway. When I got to the psychologist, he surprised me by asking me only one question: "How do you feel about fighting in the war?" I told him: "I'm rooting for the other side." He showed no sign of surprise, simply made a notation on my papers.

It is said that Truman grew in stature while in office, but to me he remained a narrow-minded nationalist who never shared FDR's worldview or Roosevelt's anti-colonialist feelings—as witness Tru-man's aid to the French in Vietnam. In the years that followed, his domino theory would get us into war after war. The thirty-seven thousand Americans who died in Korea were just the beginning.

Like me, Milton and Seymour were rejected by the army. Mil-ton had had rheumatic fever as a child, which left him with a heart murmur, and Seymour somehow persuaded the draft board that the country would be better served if he remained a civilian. After graduation, we lost track of one another, but before I leave Cooper Union behind, let me tell you about an incident there that led me to make an important decision. In our freshman year, all students were required to take the art history class taught by Dr. Paul Zucker. Zucker was a Jew who had managed to get out of Germany two years after Hitler took power. Although a victim

NOW THAT ALL THE HOOPLA ABOUT THE END OF WORLD WAR II IS OVER, LET ME TELL YOU WHAT REALLY HAPPENED.

IN 1939, WHILE EDWARD G. ROBINSON WAS CORNERING SUBVERSIVES IN "CONFESSIONS OF A NAZI SPY"...

JOHN FOSTER DULLES WAS MAKING BIG BUCKS AT SULLIVAN AND CROMWELL REPRESENTING GERMAN CARTELS LIKE I.G. FARBEN.

IN 1940, WHILE JAMES STEWART WAS FACING DOWN NAZI THUGS IN "THE MORTAL STORM"...

JOHN FOSTER DULLES WAS MAKING SPEECHES ABOUT HOW IMPORTANT IT WAS FOR US TO KEEP ABSOLUTELY NEUTRAL. WHAT WAS GOING ON IN GERMANY WAS NONE OF OUR BUSINESS, HE INSISTED.

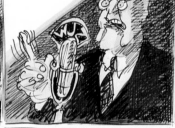

IN 1943, THANKS LARGELY TO JOHN GARFIELD'S SELFLESS HEROISM IN "AIR FORCE", THE TIDE OF WAR TURNED IN FAVOR OF THE ALLIES.

PLEASE GOD, DON'T LET THEM BREAK UP I.G. FARBEN.

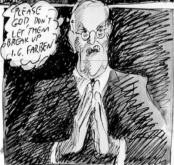

WITH AN ALLIED VICTORY NOW INEVITABLE, DULLES BEGAN A NEW SPEAKING TOUR. THIS TIME HIS CAUSE WAS A "CHRISTIAN PEACE" FOR GERMANY.

AFTER THE WAR, ROBINSON WAS BLACKLISTED, GARFIELD WAS BLACKLISTED, AND DULLES BECAME SECRETARY OF STATE.

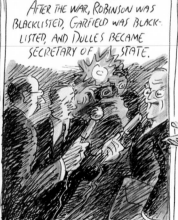

OF COURSE, IF THE WAR HAD GONE THE OTHER WAY, DULLES MIGHT HAVE DONE EVEN BETTER.

Edward Sorel

of Hitler's racial theories, Zucker had his own ideas about how physiognomy determined personality.

Specifically, Zucker was a follower of Dr. Ernst Kretschmer, who developed a classification system based on three main body types: "asthenic" (thin, weak), "athletic" (muscular, large-boned), and "pyknic" (stocky, fat). Kretschmer believed that pyknics were friendly and gregarious, but predisposed to manic-depressive illness, and that asthenics were timid and introverted. I'm not sure, but I think athletics were born leaders.

Zucker gave some examples of each type from the Hollywood movies popular at the time: Edward G. Robinson was a pyknic, Errol Flynn an athletic, and Fred Astaire an asthenic. Then Herr Zucker pointed to six seated students, male and female, whom he instructed to get up and stand in the front of the class. One was Milton Glaser, another was Eddie Schwartz (me). As we—three men and three women—stood uncomfortably before a smirking class, Zucker anointed Glaser the perfect athletic (gregarious), then labeled me and the thin, willowy girl next to me as asthenics (inhibited). I tried looking at the ceiling and pretending this wasn't really happening as Zucker jabbed his finger into my rib cage, saying: "Notiz ze narrrrow chest cavity."

What this pseudoscientific nonsense had to do with the history of art was never explained. Once we were back in our seats, Zucker gave us examples of different body types in literature. That was the first time I heard of a novel called *The Red and the Black*. Its hero, Julien Sorel, was, said Zucker, a perfect example of an asthenic. Of course, I sought out the book immediately. Julien, it turned out, was a sensitive young peasant who hated his father, was appalled by the corruption of the clergy in nineteenth-century France, and was catnip to every woman he encountered. I concluded that Julien and I had a lot in common—although clearly not *everything*. Five years later, when I decided to change my name, "Sorel" seemed like the perfect choice.

I never thought of changing my name while I was attending Cooper. What would be the point? My instructors there had made it obvious to me that I was going nowhere. Clearly I wasn't going

to accomplish anything that required a more uncommon name than Schwartz. And my first job after graduation, in the "bullpen" at the William D. McAdams advertising agency, pasting up type proofs, offered no hope for a distinguished career. It was a forty-five-dollar-a-week job requiring no talent, only neatness, and I was fired after three weeks.

The only reason I lasted that long was that the art director was a left-winger who couldn't bring himself to fire anybody. In fact, most of the people there were lefties, and here's why. By the 1950s, membership in the Communist Party had diminished to such an extent that the only ones left were the leaders, the members who had no outside job (and therefore didn't have to worry about being fired), and members who were actually FBI agents infiltrating the Party. It's safe to say the FBI knew the name of every single member of the Party, and it was J. Edgar Hoover's policy to have agents go to the places where Party members and former Party members worked and inform the bosses that they had Commies in their employ.

Most bosses, not wanting to be suspected of subversion themselves, fired any employee upon whom suspicion fell, but not the ones who ran the William D. McAdams advertising agency. As a result, a lot of talented, blacklisted copywriters and designers were grateful to get a job there, even though they were always paid smaller salaries than the ones they enjoyed before the FBI fingered them.

If I wasn't neat enough to do paste-ups, then perhaps I could pass myself off as a designer. I put printed proofs that others had done into my portfolio and got a number of jobs, but couldn't keep any of them. I was slow and indecisive. I was discouraged, of course, but couldn't help noticing that every time I got fired I got more money at my next job. In 1952 I landed a job at *Esquire* magazine for eighty-five dollars a week, and, much to my surprise, I found I could do everything that was required of me. Not only was I doing editorial layouts for *Gentlemen's Quarterly*—later sold to Condé Nast to become the monthly *GQ*—I was also doing promotion for *Esquire* and *Coronet* magazines, and none of this

(fortunately) required drawing. Thanks to my two art schools, I could no longer draw.

Now I not only had a job in a spiffy new building on Madison Avenue, but someone in the art department knew of an apartment only five blocks away that rented for a mere twenty-eight dollars a month. It was in an old tenement and had a bathtub in the kitchen and a communal toilet in the hall, but I grabbed it. What's more, I had a girlfriend! And she was a knockout—tall, willowy, with a gorgeous face and an easy laugh. I thought I might be in love. Martha wasn't Jewish, and after Mom learned I was dating a shiksa, she feared I would marry her.

For Mom's birthday, I got the two of us tickets to *South Pacific.* Mary Martin and Ezio Pinza were still in it. Mom was much moved by the subplot of the doomed love between the Tonkinese girl and the American lieutenant. Afterward we went to Toffenetti's for coffee, where Mom reprised her admiration for the song "You've Got to Be Carefully Taught." "So sad, that the lieutenant couldn't bring himself to marry that beautiful girl," sighed Mom. I immediately saw a connection between the beauty from Bali Ha'i and my beauty from St. Louis, and asked my mother why, if she believed that people should overcome their biases, she was against my marrying Martha. Mom looked at me in utter incredulity. "How can you compare your situation with theirs?" she asked. "Neither of them was Jewish!"

Mom needn't have worried. A man far more exciting than her son soon came along and swept Martha out of my arms. When I later ran into her, she was married and infuriatingly happy.

One morning when I walked into the *Esquire* art department, I was flummoxed to see Seymour Chwast sitting at the drawing table in front of mine. He explained that he had just been hired to do pretty much the same kind of layout work that I did. He didn't seem especially happy to see me. I think he was humiliated to find himself, two years after graduation, reduced to working side by side with one of Cooper's least talented. In the interval, Seymour had had a series of well-paying, prestigious jobs at *The New York Times,* Condé Nast, and Sudler & Hennessy, at that time the hot-

test design studio in the city. But S&H had just fired him, and he had to find a job fast because he was married now and living in high-rent Manhattan.

Seymour knew the *Esquire* job wouldn't be as creative as his earlier jobs, but he wasn't prepared for the utter lack of opportunity there was to do anything original or inventive. I was so pleased at keeping a job I barely noticed the hack nature of my work until Seymour showed up. Over lunch, when he began kvetching again about the job, I suggested we do a promotion piece that we could mail to art directors ourselves. Maybe we could pick up some illustration work on the side. The Eisenhower stock market was booming. What could we lose?

That evening we stayed late at *Esquire* and planned our promotion piece. I suggested illustrating a parody of a nineteenth-century almanac, and Seymour liked the idea. He quickly came up with a French-fold four-pager with colored stock for a cover. It would fit into a common number-ten envelope. The name I suggested for our comic publication was *The Push Pin Almanack,* using the seventeenth-century spelling for "almanac." We made *Push Pin* into two words because I was afraid that as one word it might be copyrighted by the Pushpin manufacturer. We also decided that the last page would be devoted to two advertisements. One for any typographer who would set up the type free of charge, and one for a printer, who would also do it on the cuff in return for the two-inch ad we would design for him. Since we and the printer and the typesetter were all going after the same clients—art directors in ad agencies—we were confident that we'd find some hungry small-timers to subsidize us. The United States Post Office was unlikely to give us free postage for an ad, but in 1952 first-class postage was still only three cents. Postage and paper stock would be our only cash outlay.

Because we planned to come out every month—we had big dreams—Seymour suggested we get Reynold Ruffins to do the third *Almanack.* Reynold, in addition to being the handsomest man in our class at Cooper, was also one of the most talented. He worked in a small design studio, but he was happy to join us in

the evening. While Seymour, Reynold, and Milton were at Cooper Union, they and other classmates had formed a design studio called Design Plus. They worked out of a small corner of a dance-rehearsal hall on Thirteenth Street, not far from the school.

There they designed place mats and greeting cards that they sold to Wanamaker's department store. That was when they were students. Now Milton was in Italy, and many of the original group were no longer in New York. Those who remained in the city—namely Reynold and Seymour—continued to pay the small rent on their underutilized space. That little corner of a rehearsal hall, with its three drawing tables, now became the headquarters of the *Push Pin Almanack,* house organ for the nonexistent Push Pin Studios.

Since I told you that upon leaving Cooper I no longer knew how to draw, you may wonder how I managed to illustrate this publication. I did it in the same stupid style that had been drummed into me for three years. Here are the *Almanack*s. Seymour designed the Push Pin logo on the cover, and the ads on the back page. He

even drew the tiny line drawings in the ads because I no longer could draw anything but shapes.

I got no assignments after my *Almanack* was sent out. No surprise. That flat, cubist style had zero commercial possibilities. What did come as a surprise, though, was how well our little promotion piece was received. When Seymour's issue came out a month later, illustrated with his distinctive woodcuts, several art directors left messages on the studio phone offering him assignments. And two months later Seymour and I got the luckiest break of all—although we didn't see it that way at the time—we got fired from *Esquire*. I know you'll assume it was because we were ignoring our job, but in fact the art director and most of the art department got canned as well. The higher-ups finally noticed that *Esquire* had become boring and dated and published corny cartoons.

Even before we were fired, I thought that the *Almanack* was something we could build a studio on. My admiration for Seymour's talent was unlimited. I didn't think I could contribute much at the drawing table, but I thought I could be the "outside man," taking Push Pin's portfolio to art directors, while Seymour and Reynold did the assignments. I would carry my flat designs in the portfolio as well, but I knew they wouldn't bring in any jobs. Seymour was hesitant about starting a studio, but finally agreed to chance it. Reynold, who had a job that he enjoyed and that paid well, could not bring himself to leave it for an endeavor that had little chance of succeeding. But he agreed to let us carry his drawings in our portfolio, and if assignments came his way he would execute them at night.

The first step in starting our studio was to apply for unemployment insurance. That would give us $35 a week until the jobs started to roll in. Today, when the subway costs $3 and *The New York Times* costs $3 and a movie costs $20, it may seem absurd to go to the unemployment office each week and stand in line for hours in order to collect so measly a sum. But in 1953, the *Times* cost five cents, and you could eat well at a restaurant with tablecloths and cloth napkins for under $5. I might add that leaving a

tip of just 10 percent was considered the norm. So, $35 was not an insignificant amount of money. Although prices were beginning to rise. That year the cost of a subway ride went up to fifteen cents. (Because the city couldn't figure out how to adjust the turnstiles to accept both a dime and a nickel, the subway token was created.)

The second thing Seymour and I had to do was find some cheap studio space that we didn't have to share with dancers or anyone else. On Seventeenth Street, just east of Fifth Avenue, we found a floor-through space in an old building. It had only a couple of inadequate radiators, and no hot water, but I was an old hand at living without such luxuries, so I left my twenty-eight-dollar-a-month apartment, and moved into our new studio. Aside from the drawing tables and lamps, and my bed, there wasn't enough furniture to require a moving van, so we enlisted all our friends with cars to move us into our new quarters.

Although the building seemed to be waiting for the wrecking ball, we had one noteworthy neighbor. The Emergency Civil Liberties Committee (ECLC) was on the floor below us. It had been formed in 1951 because the American Civil Liberties Union refused to accept communists as members and would not even defend many of them. The ECLC founder and chief financier was Corliss Lamont, who bankrolled a lot of leftist causes. He could afford it. He was the son of Thomas W. Lamont, a partner and later chairman at J. P. Morgan & Co. However, Corliss, unlike his father, thought that Stalin was the hope of the world, and gave generously to every communist cause. Judging by the dilapidated building in which he placed the ECLC, Corliss must have been running out of money.

The Push Pin loft had three large windows facing north, and that's where we put our drawing tables. There was a small room off to the side, large enough for a double bed and a chest of drawers, and an alcove containing a tiny refrigerator and an electric range with two burners. There was no shower and no hot water, but I could boil water for shaving. I can't recall any closets, but I know I had two suits—my only qualification for being the studio's representative—and they must have hung someplace. Needless to

say, most of my family took a dim view of the course my life was taking, but my mother never said a discouraging word. "As long as you're happy" was her refrain.

Getting to show art directors a portfolio was simple back then, since advertising agencies had art buyers. Some, like Young & Rubicam, had as many as three or four, and after looking at the kind of art you were peddling, they would send you to the art director whose advertisements could use that style. There was also a book called *Noble's List* that collected the names of all the art directors at magazines and book publishers. The easiest assignments to get were book jackets, record albums, and small spots for newspapers. There were ten dailies in New York City then, including *The Brooklyn Eagle* and similar smaller papers.

On an average day I saw as many as five art directors, and there was seldom a day when I didn't pick up something for Seymour or Reynold. Once, even I got an assignment, a series of spots for the *Times* travel section. I was shocked that an art director actually wanted that crazy Deco style that I hated. I kept telling myself I'd break away from it soon, but I didn't know how. When the ads appeared in print, I was in the absurd position of taking pride in being published in the Sunday *Times,* and yet being humiliated by the fact that those cold, unexpressive designs represented who I was. They were so very far from the kind of artist I imagined I'd be someday. I was a very long way from John Sloan or Reginald Marsh.

No matter how much we were billing, Seymour and I never paid ourselves more than sixty-five dollars a week, and the result was that our checking account soon hovered close to two thousand dollars. We now needed an accountant. And then we heard that Milton had returned from Italy.

It had never occurred to me that Milton would be part of the studio Seymour and I had created. And it had never occurred to Milton that Seymour wouldn't want him to be part of this new enterprise. There was a somewhat tense meeting between the three of us one night. I made it clear that I preferred to continue with just Seymour. We were doing well without Milton. He, on the

other hand, felt the partnership that he once had with Seymour was still binding, even though he had been in Bologna for a year on a Fulbright scholarship. Since it was Seymour's artistic talent that was at the heart of Push Pin, it was up to Seymour to decide whether Milt joined us or not. But Seymour refused to make a decision: "I've got to sleep on it." Then Milton asked him, "Don't you think I'll make a significant contribution to this enterprise?" Seymour said nothing.

After Seymour and Milton left, I knew that Seymour would decide to bring Milton in. Once Seymour thought it over he'd realize what a monumental difference Milton would make to the studio. And, sure enough, the next morning Seymour told me just that. What I couldn't foresee was the enormous positive effect that working with Milton would have on me.

Being able to put Milton's drawings in the Push Pin portfolio brought an immediate change not only in the number of jobs I brought in, but in what they paid. Milton had a drawing style for every occasion. One was a witty version of eighteenth-century crosshatch etchings. It became enormously popular. Within a few months, jobs were coming in without my even soliciting them. One of them was for a filmstrip for Pepperidge Farm bread, which was to be a history of the making of bread from ancient times to the present. It would need more than a hundred drawings, and it had a tight deadline. It paid big bucks. My partners told me to cancel all my appointments with art directors and get on my drawing board so we could get this job out on time.

I told them I didn't think I could do it: "I haven't drawn anything except that two-dimensional design crap in years." Milton assured me I wasn't going to have any problems. "All we're going to do is copy art that has already been done about the making of bread," he said. "It'll be a snap." And to prove his point, he handed me reproductions of ancient Egyptian paintings depicting people making bread. Anybody can do fake Egyptian art, even a schlemiel who has forgotten how to draw.

The ancient Egyptians outlined all their figures in black line, just as I did when I was a boy. Back then I would first draw my

images in pencil on paper, and then go over the pencil lines with pen and waterproof India ink. When the ink drawing was finished, I would erase the pencil lines with a kneaded eraser, and—presto!—have a neat line drawing, ideal for comic strips.

That was—and is—a perfectly good way to do a pen-and-ink drawing. It's the way Al Hirschfeld and David Levine did it. But Seymour and Milton used a different method. They would get a pad of translucent bond paper (16 lb. bond is best) and then start sketching in ink, not pencil. If all the elements weren't quite right—and they never were the first time—they would tear the top page off the pad and slip it under the new blank sheet. Able to see the previous sketch through the thin bond paper, they kept refining until they had a sketch they could copy to a finish. After they had copied it in ink, they mounted the finished drawing, which was on light bond paper, onto stiff paper or board, and added watercolor. This method is called slip-sheeting. And I found that my drawings were less stiff with this method than if I carefully followed a pencil outline.

(Caution to would-be illustrators: Do not use rubber cement to mount bond paper. It will yellow and bubble in a year. Buy a mounting machine that will adhere the bond paper to an acid-free board. If you prefer drawing on quality paper rather than thin bond paper, buy a lightbox that will allow you to see your sketch through the opaque paper.)

For the first time since before Cooper Union, I was drawing people again, not designing shapes, and it felt wonderful. By the time the Pepperidge Farm filmstrip was finished, I realized that I had produced almost as many drawings as my partners had, and that mine weren't so bad. The experience reminded me of how much I used to enjoy drawing—before I went to art school.

Soon it was necessary for us to hire help. One was an art school grad who could assist us with the mechanical aspects of our assignments. Another was an ex-girlfriend of Seymour's who could send out invoices, answer the phone, and do anything else we no longer had time to do. The salary we offered was too low, she said, but if we agreed to keep her off the books, so she wouldn't have to pay

taxes, she would take the job. Her name was Elaine. She seemed capable. She got the job.

Now that I'd proved to myself I could still draw, the job of showing our portfolio to art directors ceased to be something I looked forward to. Getting into a suit and tie every day was a nuisance. Remember, this studio didn't have a shower or a closet. Making myself presentable and odor-free wasn't easy—and dressing like a slob would not become fashionable until the sixties. More to the point, I wanted to be a full-time artist. One of my book jackets had gotten into the annual Art Directors Club exhibition. I no longer felt like a complete no-talent. Milton and Seymour were amenable to hiring a salesman to take over my job as rep, but who could we get?

Elaine said she had a friend who was in charge of promotion at the Royal Liverpool Assurance Company, and he might be able to give us some work. His name was Warren Miller, and he was impressed with what he'd seen in the Push Pin portfolio. I, in turn, was impressed with his clipped speech and sartorial elegance, as well as his way of holding his cigarette and his deadpan wit. He must be English, I thought.

It turned out he was from Pottstown, Pennsylvania, and by the time he had looked through the portfolio it was almost noon, so I impulsively invited him out to lunch. Another surprise was to discover that he was a published writer who was none too happy working at Royal Liverpool in order to support his estranged wife and two daughters. Here, I thought, was someone who could represent Push Pin far better than I could. Beguiled by his soft-spoken voice and privileged manner, no one would imagine that the Push Pin "studios" was a loft with insufficient heat in a run-down walk-up. I convinced him that working for us would not only be more fun, it could also mean more money. He came to the studio after five and met with Seymour and Milton.

As the elegantly attired applicant in his early forties sat down to face the sloppily dressed proprietors in their mid-twenties, the incongruity of the scene was not lost on any of us. Nevertheless, there was an almost immediate understanding that his joining us

would be advantageous to one and all. We agreed to meet Warren's salary demands and took a certain pride in knowing that Push Pin Studios had just outbid the Royal Liverpool Assurance Company—with offices in London, Dublin, and New York—for his services.

My career as Push Pin's representative was now over. And so were my evenings of being alone after Seymour and Milton left to go home. Elaine, our bookkeeper, and I had become an item. Most nights I ended up in her cozy apartment, which had a television set, a double bed, hot water, and a shower. Things were looking up.

3

The Crack-Up

I can't remember the year Warren Miller came to Push Pin and made it possible for me to work full-time as an illustrator, but it had to be after 1953, because Eisenhower was president. By now you know me well enough to know that I wouldn't have voted for any Republican, but I wasn't thrilled with Adlai Stevenson either. Ike's Democratic opponent wasn't a man likely to lessen the dangerous paranoia about domestic communism that gripped the country. I voted for the Progressive Party candidate, Vincent Hallinan, in 1952. He received less than one quarter of one percent of the national vote.

In the course of his presidential campaign, Eisenhower—a Mennonite by upbringing who never belonged to any organized church during his military career—met Billy Graham, and the two appeared to hit it off. Once Ike was in the White House, he joined the Presbyterian Church, becoming the only president to be baptized in office. When Graham began his campaign to add the words "under God" to the Pledge of Allegiance, he persuaded the president that such an addition was vital if our pledge was to distinguish itself from those recited in godless communist coun-

tries. Ike agreed. On June 14, 1954, Flag Day, he signed legislation formally inserting "under God" into the Pledge, declaring, "From this day forward, the millions of our schoolchildren will daily proclaim in every city and town, every village and rural schoolhouse, the dedication of our nation and our people to the Almighty." In his State of the Union message that year, Eisenhower went so far as to propose depriving communists of citizenship.

Two years later, Ike had another opportunity to show the Almighty how highly Americans thought of Him. He signed a congressional joint resolution to put "In God We Trust" on all United States currency. Never mind those Commies who charged that it violated the separation of church and state. When a Christian organization formed the annual National Prayer Breakfast for VIPs in Washington, Ike attended. His religiosity helped him form a strong bond with John Foster Dulles, his secretary of state, who was a prominent layman of the Presbyterian Church. The president stated publicly that he planned to make this country's "moral and spiritual values"—i.e., Christian values—the hallmark of his foreign policy. Here's how those moral and spiritual values manifested themselves.

After taking office, Eisenhower learned that when the democratically elected prime minister of Iran, Mohammad Mosaddegh, had to limit the profits that the Anglo-Iranian Oil Company gained from Iranian petroleum, and the company refused to cooperate, the Iranian parliament nationalized its oil industry. In talks, Winston Churchill and Eisenhower decided to overthrow Mosaddegh using British intelligence and the CIA, with money donated by Anglo-Iranian. With Allen Dulles heading the CIA and his brother, John Foster, in charge of the State Department, the coup was pulled off, Mosaddegh was trundled off, and Shah Reza Pahlavi was installed as dictator. (Twenty-five years later a popular uprising kicked out the shah and installed a regime of Muslim fanatics who hated America, and forty years later they are still in charge.)

The president and his secretary of state, buoyed by this triumph, duplicated it the following year in Guatemala, where they once again deposed a democratically elected president, Jacobo

Arbenz. He had angered the United Fruit Company by instituting minimum wage laws and land-reform programs that cut into the company's profits. The UFC began lobbying the State Department to overthrow the regime, concocting wild stories about communist influences in the Arbenz government. John Foster and his brother, Allen, again swung into action, and in June 1954 Guatemala's liberal democracy was replaced with a brutal dictatorship that made certain nothing ever again stood in the way of United Fruit Company's profits.

To justify its role in overthrowing Guatemalan democracy, the CIA worked hard to find the alleged evidence of Soviet influence among the documents left behind by Arbenz. Nothing was ever found. Later presidents imitated Eisenhower and Dulles by using the CIA to overthrow other governments. After Iran and Guatemala, the United States overthrew governments in the Congo in 1960; the Dominican Republic in 1961; South Vietnam in 1963; Brazil in 1964; and Chile in 1973.

By the time Eisenhower's second term came to an end in 1961, he had run out of time to put into operation the plan that he and the Dulles brothers had devised for invading Cuba and eliminating Castro. He left that for his successor, John F. Kennedy. Ike also left behind a stronger commitment to South Vietnam by adding more troops to the ones that Truman had dispatched. There were fifteen hundred stationed there by the time he left office. The escalation had begun.

Back in 1954, I had no idea where Vietnam was, but I knew that under smiling, pious Ike, skulduggery had become our foreign policy. There was nothing I could do about it, other than to renew my subscription to *I. F. Stone's Weekly*. I didn't have time to worry about the world going to hell, because my partners and I were working long hours to meet deadlines on all the assignments that Warren was bringing in. Sometimes we were still working when "The Milkman's Matinee," an all-night radio program, went off the air at four a.m. I was aware that my partners worked faster and brought in more money to the studio than I did. We all took home the same sixty-five dollars a week, but they said nothing. I

was working on book jackets and record albums by day, and then spending evenings with Elaine. Happy days, happy nights.

It didn't last. The trouble came from an unexpected source: our salesman Warren Miller. When Elaine first suggested that I go see Warren at Royal Liverpool Assurance, it never occurred to me to ask her how she knew him. But when, after many months working for us, he suddenly asked me, in an accusatory voice, what my intentions toward Elaine were, it dawned on me that he and Elaine had once been lovers. I had no idea how long they had been together, or why, if the affair was long over, he was now acting like an outraged Victorian father. It soon became obvious that he wanted Elaine back, although I gathered that it was he who had broken off their relationship. She assured me that her attachment to Warren was over, but that did little to defuse Warren's hostility toward me. There was a bit of yelling going on between us, which made things kind of awkward for Seymour and Milton, who tried to pretend it wasn't happening.

As this tacky little drama was playing out, Milton, Seymour, and I were looking for a new space for our studio. Push Pin had become the "hot" design group, and our accountant assured us that we were billing enough now to move uptown, although we were each still limiting ourselves to the same old salary. On Fifty-seventh Street just east of Third Avenue, in an elegant building with a uniformed doorman, we found a ground-floor apartment that would make a perfect studio. We signed the lease. There actually wasn't much to pack, except the four drawing tables and a lot of books.

Somehow I wasn't elated about the prospect of moving to the fashionable East Side. Maybe it was because I knew that the new location would simply offer Warren a fresh stage on which to act out his anger. Worse, I realized that Warren was now more valuable to the studio than I was. I still wasn't bringing in as much money as my partners. It was so long ago, I can't be entirely sure of what was going on in my head back then. What I do remember is the night before we were to move. Milton and I were alone in the studio sitting among all the folded drawing tables and boxes of books, utterly exhausted. Milton asked me if I had attended to

something I was supposed to do, and I realized I had forgotten all about it. Milton became cross, saying something like, "How can you be so irresponsible? We can't go on like this." And I heard myself say, "Well, you don't have to. I'm leaving."

After a few seconds of silence, Milton replied, "Well, if that's what you want." To me that response really meant "Good riddance."

I can't remember what happened after that. Was anything more said? Where did I sleep that night? Where did I move my clothes to? I also don't remember when or where I next saw Milton and Seymour. Maybe it was at their new studio. In any case, I remember that the meeting was amicable, with each of us trying to show that, although we were no longer partners, we were still friends. Nevertheless, there was the matter of what severance money I should receive. I asked how much money was in the studio's bank account, and was told $2,100. Not much. A lot of money had been spent on moving and on payments for the new quarters, where I would no longer be working. Also, money from jobs I had done was still outstanding. I ignored those facts, and suggested they simply pay me one-third of whatever was in the bank. They readily agreed. That $700 was hardly a golden parachute, but since these two friends had resuscitated the pleasure I once had in drawing, it seemed a fair severance package.

Try as I might, I can't remember where I was living at that time. I don't remember if I moved my few clothes into Elaine's apartment or moved back with my parents in the Bronx. It didn't much matter, since I was certain I'd find a job quickly and soon be on my own again. My portfolio of proofs was now impressive, and this time they were reproductions of my own work, not stolen ones. More to the point, I was one of the three founders of Push Pin Studios, which in less than two years had created a graphic style that magazines and advertising agencies were already imitating. I may have been the one least responsible for Push Pin's success, but William Golden, head of the CBS promotion department, didn't know that. He offered me a job as an art director at $175 a week.

Unless you are as old as I am, you will have a hard time imagining what an enormous salary $175 a week was in 1955. It meant

I was making close to $10,000 a year, at a time when the average yearly wage in the States was $4,713—yes, I looked it up. My mother, who was still working in a millinery factory, was earning between $50 and $60 a week, depending on how much piecework she was paid for in the "busy season" as opposed to her lower-paying "week work" salary. I was now making more than three times as much money as she was. And bear in mind, a lot of the apartments in New York City were still under rent control.

In my new job at CBS I had a large office, with a window facing the building that housed *Esquire,* the magazine from which Seymour and I had been fired two years earlier. In those two years I had relearned how to draw, but now I would be designing with type and photographs, and I was far from certain I could measure up.

When you got off at the floor where promotion art for television was created, you were confronted with immense images of the CBS eye, reminding you that you were working for the most prestigious television network in the country. That CBS eye was the work of William Golden, my new boss. He was born on the Lower East Side, the youngest of twelve children. His formal schooling ended with the Vocational School for Boys. On the basis of the few facts about him I'd gleaned from magazine articles, I visualized a short, dark-haired Jew, always in motion. In point of fact he was blond, movie-star handsome, and he had a laconic manner.

Each year the Art Directors Club of New York holds its annual exhibition for the best graphic work done that year. In the 1950s Golden's art department always took home the lion's share of awards. As a result, all the young designers tried to work at CBS. One of the lucky ones who landed there was George Lois, who worked in the office behind mine. George was two years younger than I was, but full of self-confidence. It was well deserved. He solved all the assignments thrown his way with wit and impeccable design, and because he never seemed to vacillate about how to approach a job, he always finished his assignments with surprising speed. George sensed my new-job insecurity and gave me all the help he could.

When I'd been there a few weeks I noticed that after work on Fridays, George and many on the staff went to the bar downstairs for drinks with Mr. Golden. Since I was still having a hard time addressing him as "Bill" and not "Your Majesty," I was relieved at not being asked to join in. But after a couple of months, George felt embarrassed at leaving me behind. One Friday afternoon he insisted that I come down with him to have a drink with "the guys." I gave in.

The bar was in the building, so I didn't have to put on my heavy winter coat. I just hung it on the coatrack when I arrived. Golden and the others made room for us on the banquette where they were sitting, but as soon as I sat down I realized I should not have come. Golden was surprised to see me, and he wasn't smiling. I sat silently listening to the banter, but when my discomfort proved too much, I blurted out that I had a previous appointment and left. It was freezing cold that night, and I hurried to the subway. As I sat on the train rattling home to the Bronx, I noticed that the sleeves of my coat were a good two inches above my wrist. Very odd. I put my hands in the coat pockets, but instead of the dozens of peanut shells that I had accumulated there, I found the most beautiful pair of soft leather gloves I'd ever seen.

I had taken Golden's coat! It was too late to go back to the bar. Almost an hour had elapsed since I had left, and it would take that long to get back there. He was going to have to wear my coat back to his home in Haverstraw, New York, and he'd look ridiculous with the hems coming close to his ankles and the sleeves covering his fingertips. Worse yet, he would find a pound of peanut shells in the pockets. And no gloves. Monday finally arrived. Golden's secretary came to my office holding my coat as though it were a dead rat, and said, "I believe this is yours." Yes, the peanut shells were still in my pockets.

Twenty-five years later, when I was doing a comic strip in *The Nation* on a regular basis, I recalled that humiliating episode, but gave it a happy ending.

I was not fired after the coat episode, and as time went on I surprised myself (and perhaps Golden) by designing a few things that

HOW I LOST MY JOB AND FOUND HAPPINESS
By Edward Sorel

were witty and out of the ordinary. Once I felt that my job at CBS was secure, I began seeking freelance work from book publishers. Most of them were in midtown, making it easy to get book jacket assignments by taking a very late lunch and seeing art directors after they returned from theirs. I missed drawing, and book jackets, although they paid only around $125 each, were a way for me to try out different drawing techniques.

Things were also going well for Elaine. Remember her? She left Push Pin shortly after I did, and was now working for an interior designer. We had been seeing each other for two years—maybe more—and neither of us had ever said a word about marriage. But now that I had a good job I must have seemed like a reasonable prospect, so she made it clear that she saw no point in continuing our relationship unless it was headed "somewhere." As Jane Austen famously observed, "It is a truth universally acknowledged, that a single man in possession of a good fortune, must be in want of a wife." And I had $175 a week.

I doubt if she was in love with me any more than I with her, but we got along okay, and we had a lot in common. We had both grown up in near poverty, and we were both lefties—she, in fact, had been a member of the Communist Party until they threw her out because she was seeing a psychiatrist, a no-no for members. Neither of us was well educated, nor were we voracious readers. We were just two New York Jews, living in a city where being Jewish, far from setting you apart, was a reminder of just how ordinary you were. Neither of us was given to introspection nor had we any notion of how we wanted to live our lives.

But I knew I wanted to draw. After a year at CBS it dawned on me that I didn't want to spend my life doing ads for *I Love Lucy* or *Amos 'n' Andy.* I found making layouts with type and photographs repetitive and formulaic. I knew that certain kinds of advertising allowed for wit and inventiveness—for instance the Volkswagen ads that were appearing at the time—but I didn't want to be a shill for a product. When I told Elaine that I couldn't think about marrying her because I planned to leave CBS and risk freelancing, she encouraged me to do just that. She was certain I'd make even

more money going out on my own. Elaine had a job, and there was room in her small apartment for my drawing table. So, what was holding me back? Once I convinced myself that I was one of those damaged people who was incapable of loving anyone, marrying Elaine, who came with a rent-controlled apartment, made perfect sense.

But marrying without love turned out to be a profoundly dumb idea. The marriage ended suddenly at the Adelphi Hotel in Saratoga seven years later. Nevertheless, some very good things came out of those years. Our union gave us Madeline and Leo, two creative, good-natured children, and it provided Elaine with a career as an artists' representative, which she enjoyed . . . for a while. And in those seven years I produced four books for children, two books of political satire, and hundreds of illustrations for magazines and advertising agencies. Elaine was right, I did make more money freelancing. Before long we were living in a wood-paneled seven-room apartment, with a nanny to help out with the children. However, I was also ten thousand dollars in debt.

I'll describe the French farce that ended my marriage in a bit, but first I must tell you about two of the books I did while Elaine and I were married. The first was based on *Riquet with the Tuft of Hair,* by Charles Perrault, the seventeenth-century author who adapted folktales to create the story of Cinderella and dozens of other fairy tales. Riquet is a homely king, but so wise and talented that his wife begins to see him as handsome. I gave the story a new title, *King Carlo of Capri,* and asked Warren Miller, my former adversary, to write it. (After I married Elaine, Warren and I became good friends.)

In the 1950s full-process color books for children were rare. In order to get color in a book, neophyte illustrators had to do separate overlays for each color. This was my first book, so I was lucky to get *two* colors in addition to black. The jacket, and the one illustration in the book that I drew freehand, without any kind of tracing are on the next page. It was the beginning of my lifelong obsession with doing drawings spontaneously whenever it was possible. I knew from the very beginning that if I was going

to be a comic artist, I would have to learn to make drawings that looked effortless. Labored drawings are never amusing—at least not to me.

The last book I wrote and illustrated before our marriage went kablooie was a political satire on the Cold War called *Moon Missing.* The premise for the book was that if the moon suddenly vanished, Russia and the United States would accuse each other of being responsible for its disappearance, and would then act accordingly. I thought it was a terribly original idea, and therein lay my problem. I wasn't used to having original ideas.

My children's books were merely variations on existing fairy tales. I was so certain I must have stolen it from something I had read, I went to a copyright lawyer to do a search to see if anything had ever been written about the moon disappearing. I was surprised and relieved to learn that there hadn't been.

Simon & Schuster had high hopes for *Moon Missing* and prepared a half-page advertisement to run in *The New York Times* on January 1, 1962. The ad contained glowing blurbs from writers who were popular at the time, and one from Ben Shahn, a hero

of mine ever since I discovered his paintings at the Whitney Museum when I was a boy. All was in readiness for me to be acclaimed the new Daumier, the new Art Young, or the new William Gropper. But at two a.m. on December 8, the long-threatened strike against all of New York's newspapers had begun. There would be no newspaper ads, no reviews, no nuthin' for the *next three months.* That strike, the longest newspaper strike ever, not only put the kibosh on all books published during that period, but also hastened the end of the *Herald Tribune,* the *Daily Mirror,* the *Journal-American,* and the *World-Telegram.*

Now let's get back to that summer of 1963. Seduced by lush photographs of Saratoga that I saw in a travel magazine, I suggested to Elaine that we go there in August when the horses were racing. My mother would take care of our children. My friend John, an illustrator who Elaine represented, would join us for the drive up. We checked into our hotel and enjoyed a jolly day at the races, but in the evening when Elaine and John suggested going to the casino to hear singer Vaughn Monroe, I begged off and returned to our room. At about three in the morning I awoke to discover that I was sleeping alone. I panicked for a few minutes, then realized that I had been handed the role of the cuckold in a bedroom farce. I did what cuckolds always do, I knocked on the door of the scoundrel. I heard frantic whispering behind the door, but it remained bolted. The man at the desk below witnessed me knocking loudly at John's door, and ordered me to stop. When I saw him reach for the phone to call the police, I made a dash to my car and drove back to the city. The marriage was over.

Another disaster that occurred that year was the death of President John F. Kennedy. It always seems like bad form to say unkind things about a president who has been assassinated, especially a president who was so young and glamorous when he was struck

down. I seem to hear the voice of Joseph Welch calling to me
from beyond the grave, "You've done enough. Have you no sense
of decency, sir, at long last? Have you left no sense of decency?"
I guess I don't. JFK's assassination was almost sixty years ago. I
should, after all these years, be allowed to state my case against
him, as I have against Truman and Eisenhower.

As you may remember, when last we left the White House, Ike
and the Dulles brothers had completed their plans for invading
Cuba, but they didn't have enough time to implement it before
the president's term in office expired. And so it was left to Ken-
nedy, two days after his inauguration, to okay Eisenhower's plan
to launch an invasion of Cuba to overthrow Fidel Castro. The
planners were confident that the Cuban people would rise up and
join the exiles in their counter-revolution. Assured by the head
of the CIA—still Allen Dulles—that the "invasion force could be
expected to achieve success," Kennedy authorized plans to invade
Cuba at the Bay of Pigs. Unfortunately for the president, news of
the impending invasion was leaked in several newspapers. That
didn't stop Kennedy from denying (three days before the inva-
sion) that the United States had any intention of overthrowing
Castro.

The entire operation was a botch. Only five of Castro's thirty-
six planes were destroyed by the eight CIA-supplied B-26 bomb-
ers, leaving the invasion force vulnerable to an air attack. When
the 1,400 Cuban exiles who made up the invading group landed,
they were met by a highly organized Cuban army. Three days
later it was clear that the mission had failed. Some 1,200 Cuban
exiles were captured and 100 were killed. The mind-boggling stu-
pidity of the Bay of Pigs invasion gave the communists a propa-
ganda coup, exposed Kennedy's promise of a new day in relations
with Latin America as bunkum, and pushed Castro further into
the arms of the Soviet Union. The blunder made Kennedy seem
too callow to be commander in chief.

Eager to wipe out this impression, Kennedy proposed that he
and Khrushchev meet for an informal exchange of views. He was
advised against rushing into a high-level meeting, but Kennedy

felt the need to appear as a major player on
the world stage. His meeting with Khrush-
chev in Vienna did not go well. The Rus-
sian, the grandson of a serf, and the son of a
coal miner, brutally berated this American
son of privilege for his antagonism to wars
of national liberation and for the Ameri-
can missiles in Italy and Turkey aimed at
the USSR. This "exchange of views," dur-
ing which JFK defended colonialism and
the military dictatorships his country was
propping up, ended acrimoniously. It was
followed by an accelerated arms race, the
building of the Berlin Wall, and eventually,
thanks in part to the American missiles still
pointing at Moscow, the 1962 Cuban Mis-
sile Crisis.

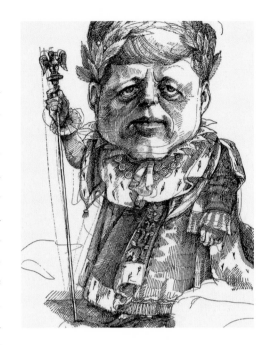

But none of Kennedy's blunders—not even escalating our com-
mitment to South Vietnam or ordering the assassination of the
South Vietnamese leader, Diem—so clearly reveal his recklessness
as his plan to bomb China's nuclear facilities before that coun-
try had developed its own atomic bomb. In the Averell Harriman
papers, referred to by Richard Reeves in his book on Kennedy,
are recorded conversations between Kennedy and Khrushchev
in which the American tried to get the Russian to agree to an
American-Soviet air strike. In Kennedy's plan, two planes would
have been sent, simultaneously, one from each superpower. One
plane would carry the real bomb, the other the dud, so every
man in both the American and Russian crews could tell himself
he wasn't responsible for the resulting devastation. Fortunately,
Khrushchev didn't go for the idea.

You'd think the dire results of his attempt to overthrow Castro
would have given Kennedy pause before trying to do the same
thing on the other side of the globe, but in 1963 he authorized a
coup against the pro-Soviet military leader of Iraq. Bumping off
people you don't like had hitherto been the modus operandi of

Chicago gangsters, but after World War II it seemed to become the unofficial foreign policy of the United States. That Iraqi coup put the Ba'ath Party in power, eventually leading to the rise of Saddam Hussein, who himself would be bumped off by a later president. I should, I feel, also tell you about JFK's disastrous domestic policies, but I really must get back to my own blunders and my seemingly hopeless situation in the fall of 1963.

Because my studio was in the apartment I no longer occupied, I now had no place to work. I was in debt, and I didn't have enough money to get even a tiny place of my own. Worst of all, I felt as though I was losing my children. My daughter Madeline, who was seven, was shaken by my suddenly not being home. Three-year-old Leo was confused. Thirty-four-year-old me couldn't see how I was going to work my way out of this abyss. I can't remember where I slept the night I drove back from Saratoga. I remember trying to get a room at the Ansonia Hotel at five in the morning, but I looked so distraught they wouldn't give me one. A designer I knew, Reba Sochis, took pity on me and let me use her studio for a week to finish the few deadlines I had.

It's true that the sudden end of my marriage took me by surprise, but in point of fact I had begun seeing a psychotherapist, Edmund Hilpern, a few months before its collapse. I guess a part of me knew that something was wrong. After the breakup, when I was unable to eat or sleep and lost a high-paying job because I couldn't finish it, it was Dr. Hilpern who saved me. And he kept seeing me even when I no longer had money to pay him.

He may have taken a special interest in me because he had seen my political cartoons in *The Nation* or *The Guardian* or some other left-wing magazine. Hilpern was not a Jew, but had been forced to escape from Austria after the 1938 Anschluss because of his communist affiliations. In me, I think he saw a comrade in need of help. After one visit, when I seemed on the verge of a complete breakdown, he suggested I join him on Sunday at the Morningside Quaker Meeting, which at the time was held in a building on the Columbia University campus. He explained that he, as a disillusioned former communist, now believed that the

Quakers were the best way to work for peace and social justice. To please him, I attended my first meeting of the Religious Society of Friends.

I'll tell you about my life-changing experiences there in a little while, but right now let me introduce you to Victor Navasky, the other man who helped me during that dark period. Victor in 1963 was publishing a satirical magazine called *Monocle*. Its motto was "In the land of the blind, the one-eyed man is King." *Monocle* was one of the many left-wing magazines that had sprung up in response to the cowardice of the mainstream press during the McCarthy period. Victor needed an art director and had heard that I needed a place to work. He made me an offer: if I worked as a designer and art director of his magazine without pay, in return he would give me an office. The art staff? There wasn't one. That meant the only time I'd be able to do my own work was at night, after everyone had gone. I had no choice. I took the job.

Monocle was in a scuzzy building on lower Fifth Avenue. I saw that the partitioned-off space that was to be my "office" was large enough for my four short metal file cabinets to be lined up side by side on the floor. When put together the surface would be long enough for me stretch out on them. I'd have a place to sleep when I had to work through the night. It would be a bit like being back in Push Pin's cold-water flat, although there I at least had a bed, and I wasn't approaching middle age.

Getting my drawing table, taboret, books, and art supplies downtown took some doing, but, luckily, I had a brother. Norman was fifteen years younger than I was, so he must have been about nineteen. It was Norman who did most of the heavy lifting. I could tell that he was very worried about me. Watching me arrange those steel filing drawers on the floor so they could serve as my bed caused him concern. "Are you really going to be able to sleep on that?" he asked. "I'll find out tonight," I answered.

I'm not sure again where I was living during this period. I remember a few nights with Aunt Jeanette and Uncle Harry, but I probably spent most nights at my parents' new apartment on the Upper West Side of Manhattan. I had found it for them when

they needed a space large enough so that my grandmother, now a widow, could live with them. It served as my port-in-a-storm until I could straighten out my life. How long that would take depended on how much work I could get done each night, after spending the day working on Victor Navasky's magazine, an alleged monthly that came out whenever he could raise the money to print it.

Monocle actually started when Victor was at Yale, where his classmates Calvin Trillin, C.D.B. Bryan, and Richard Lingeman wrote for it. Now, five years after they had graduated, these three (otherwise bright) fellows were still involved in Navasky's doomed enterprise. Apart from Betsy, the secretary, and "Beebes," the business manager, Richard was the only one who showed up every morning. His thankless task was to sell advertising for a magazine that few had heard of. Betsy served as the receptionist, telephone operator, and lunch-order-taker. She was, I think, the only one in the place who actually received a salary. Creative types knew better than to expect payment from Victor. When I asked him what fee I could offer illustrators for a full-page illustration in *Monocle,* he gave me a sheepish smile and said, "Twenty-five dollars."

With that kind of a page rate, how was I going to get anyone to work for me? Victor told me it wasn't going to be a problem. David Levine, Tomi Ungerer, and Ed Koren had already produced drawings for previous issues of *Monocle* for twenty-five dollars a pop, and Victor assured me they would do so again. I was stunned. To my mind these were three of the most brilliant cartoonists in the country. Levine's caricatures were appearing regularly in *Esquire,* Ungerer's illustrated books for children were award-winning bestsellers, and Koren's scratchy pen cartoons were just beginning to show up on the pages of *The New Yorker,* to the delight of the tree-huggers and whale-savers who were the butt of his cartoons. But because none of these three could get their drawings of political protest published in any of the glossy magazines, they accepted Victor's nominal fee so their viewpoint could at least be seen *somewhere.*

Clearly, Victor's leisurely monthly *Monocle* was underfunded, but that did not prevent him from also publishing a weekly news-

paper that had even less of a chance of success. It was called *The Outsider's Newsletter*, and when folded four times it had eight pages and was about the size of a number-ten envelope. Most of the issues were written by Richard Lingeman, but C.B.D Bryan wrote a few. For one of them I was asked to illustrate the cover.

It isn't a very good drawing, but it gives me pleasure to flaunt my blasphemy.

When David Levine was too busy to do a caricature for *Monocle,* Victor expected me to supply it. In truth, although I could do decorative illustration for record albums and book jackets, I was not any good at caricature. I could do likenesses, but caricature is something quite different. You have to know what facial features to exaggerate to make it comic. Some people have a natural gift for it. I didn't. If I was assigned to draw a politician whom David Levine had already drawn, I was saved. I simply did what he did. But when I had to caricature someone that David hadn't done, I was in trouble. Nevertheless, after a few weeks I got the hang of it.

And lucky that I did. By the early 1960s advertisers were putting their big bucks into television, not magazines. In time *The Saturday Evening Post, Coronet, Life, Look, The Saturday Review,* and *Argosy* would all go belly-up, and *Cosmopolitan,* which had once published esteemed literary writers and used the finest illustrators, would morph into a magazine that taught women how to have better orgasms. The nonfiction magazines that survived were devoted to either entertainment or politics, and if they were going to use illustration at all, it was probably going to be caricature. So although 1963 was the lowest point in my life, working on Victor Navasky's magazine turned out to be a lucky turn in the road for me. I became a caricaturist.

Little by little my chaotic personal life was calming down. I had found a lawyer who would handle my separation agreement and divorce for the little I could pay, and I signed up with an art representative who was confident she could get me a lot of assignments. Seeing Madeline and Leo every weekend assured me that I hadn't lost my children. On Sundays we went to Earl Hall at Columbia, where they played with other children under supervised care while I and the other parents attended Quaker meeting. Afterward I would take them to a movie, or a flea market, or the Museum of Natural History. I was still in debt, still worried, but now the weeks had a familiar routine, and with continued support from Ed Hilpern, who helped me piece together my emotional

life, and my mother, who made chicken soup and boiled chicken for me on Friday nights, I began to think that maybe I could dig myself out of my hole.

One weekend, Elaine asked to have the children on Sunday, because friends had invited her out of the city and she wanted Madeline and Leo with her. I didn't like upsetting the routine, but agreed to deliver the children to her on Saturday night. That Sunday I walked to Quaker meeting alone. Ed Hilpern would surely be there. Perhaps we would have lunch together afterward.

4

Love Walked Right In

The large room where Quaker meetings were held was sparsely filled that Sunday. I was puzzled, then remembered that this was the Sunday many members were going upstate for a retreat, Ed Hilpern among them. Of course I don't remember what was said at meeting that morning—this happened sixty years ago—but I know that it was the first Sunday of October, because on the first Sunday of every month we were asked to take turns standing and stating our names, and saying a bit about ourselves.

When my turn came I described myself as an illustrator, but couldn't resist adding that my book *Moon Missing* had just been published. (As you know, that book had actually come out in January, nine months earlier, but sometimes I . . . er . . . exaggerated.) After everyone had introduced themselves and various announcements were made, coffee, tea, and cookies were served. As I approached the table with the coffee urn, a smiling young woman offered me a cup. I accepted it. Her name was Nancy Caldwell.

Nancy had the kind of face that one often saw in illustrations

of Victorian romance novels—kind, unspoiled, and, yes, beautiful. She wore no makeup. Her dark, arched eyebrows and long, dark eyelashes required no pencil or mascara. She asked if this was my first time at a Friends meeting. She had been attending since she moved to New York, after spending a year in Austria working as a volunteer in a displaced persons camp for the United Nations. Home was in Kansas City, Missouri. We were so involved in exchanging personal information, we didn't notice that everyone was getting ready to leave until we heard the metal folding chairs slamming shut. She invited me to lunch in the apartment that she shared with another woman. It was only a couple of blocks away. I counter-proposed that we go to Rumpelmayer's for lunch. She accepted.

After all these years, I still can't figure out why I did that. Was it to show this out-of-towner that I knew the best places in town? Or was it to make myself feel like a big shot after the last few months had proved that I was a hopeless loser? The fact was, I

had never been to Rumpelmayer's, although I had walked by its elegant entrance in the Hotel St. Moritz many times. I had heard it had the best pastries and the best hot chocolate in the city. But how could I suggest going to such a pricey place when I was so broke? I didn't realize how shabbily dressed we were until I faced the maître d'. He eyed my corduroy jacket, bought at a flea market for fifty cents, and led us to a dark corner in the back, far from the fashionably dressed families who had come from church.

Over lunch we continued revealing who we were, and what our heritage was. Her father was a doctor, her mother a former teacher. Nancy had a twin sister, fraternal, named Sue, and a younger sister named Ginny. Her twin was blond and blue-eyed. On Sundays she and her sisters and parents attended the Presbyterian church, but Nancy had become a nonbeliever in college. (Thank God!) She had begun attending Quaker meeting when she was in Edinburgh, studying English literature. (Later on she would teach me all about the Great Vowel Shift.) After coming to New York she worked for the *Columbia Encyclopedia,* writing entries. Now that it had gone to press she worked at the United Nations teaching English as a second language while getting her master's in English at NYU at night.

Aside from the contrast between her educational background and mine, the way each of us spoke the English language should have made us incompatible. Her voice was soft, her speech clear, and her gentle manner suggested she was comfortable with who she was. My speech was an incoherent mumbling—called "fumpfering" in the Bronx—and the words that came out of my mouth betrayed cynicism, anger, and insecurity. We were an odd couple.

Our next meal together, days later, was a far cry from Rumpelmayer's. I took Nancy to one of those Tad's Steak joints that proliferated all over Manhattan in the 1960s. In big neon letters it advertised steaks for $1.19. That's all I could afford. Tad's was only a block away from the all-night chess parlor on Forty-second Street. That's where I had begun spending my nights alone that summer. I was never a good chess player, but being surrounded by other loners made solitude a little less frightening. Since Nancy

said she knew how to play chess, I thought we could go there after our steak and fries. It would give us a chance to talk, and it would be cheaper than seeing a movie. Nancy won the only game we played, and was astounded by her easy victory. We spent the rest of the evening there just talking and drinking coffee. I couldn't believe how beautiful she was.

Two years later, I received a telegram from Mexico. It read, "Happy Birthday—your ex-wife." Elaine had obtained a Mexican divorce. Nancy, now a member of the Religious Society of Friends, was finally able to tell our Morningside Quaker Meeting that we wished to be married at a meeting in May. Before the Meeting could grant permission, two Quaker women would have to meet with Nancy, and two Quaker men with me, to decide if we were prepared for marriage. One of the elders who was to question my readiness to marry was Ed Hilpern, so I knew this was one test I would pass. I don't remember all the questions he and the other Friend asked, but one was whether I had ever been engaged to be wed, and then called it off. I had not. The women had asked Nancy if she was aware of how risky it was to marry a freelance artist, one who would be unlikely to sustain a steady income. Nancy was aware. Our wedding date was approved.

The marriage was set for May 29, 1965, three days after Nancy would turn thirty. I had turned thirty-five a few months earlier. Dr. John Caldwell and his wife, Ruth, drove from Kansas City to attend. By this time Nancy had a tiny walk-up apartment on the Upper West Side. John and Ruth arrived a couple of days before our Sunday wedding in their enormous Chrysler sedan with its HONOR AMERICA bumper sticker. On one occasion it was parked directly in back of my beat-up 1953 Studebaker with its GET OUT OF VIETNAM sticker on the bumper. Obviously we never spoke about politics, but I assumed that both John and Ruth had serious misgivings about their beautiful, well-educated daughter marrying a homeless, jobless, Commie-Jew with only a diploma from an art school he had attended for three years. Who could blame them? But they treated me with kindness and hoped for the best.

Nancy had made reservations for her parents at a nice hotel a

few blocks away. I moved my one suit out of her closet so there would be no sign that I was living there, but we both forgot about the bar graph that was pinned on the wall behind the bedroom door. The bar graph was something that Nancy made shortly after we met, when she learned how much money I owed to various people. Each bar represented a person I owed money to, and as I paid them off she filled in the amount with a different colored crayon. It looked something like this:

When, on the day of the wedding, her mother came to the apartment to help her put on her simple white dress, she closed the door to the bedroom so John and I couldn't watch, and then Ruth saw the bar graph. I couldn't hear how Nancy explained it away, but no matter how worried her mother was about the man her daughter was marrying, it was too late to call it off.

Present at our marriage were my children, Madeline and Leo; my brother, Norman, now twenty and eligible to be drafted for the war in Vietnam; my grandmother Pauline Kleinberg, who agreed to come after I assured her there would be no crucifixes or statues of saints; my mother, who already had taken Nancy to her heart, and vice versa; Seymour Chwast, my former partner at Push Pin; Dr. John and Ruth Caldwell; and Edmund Hilpern, the man responsible for bringing me to Quaker meeting. Also present were many who attended the religious meeting that morning, and

decided to stay for our wedding. I didn't want my father there, and he obliged.

It had been raining all morning, but it stopped soon after everyone settled into the silence. When the sun suddenly came out, Nancy squeezed my hand, we both stood up, and I said the vow I had memorized. "I, Edward Sorel, take thee, Nancy Lee Caldwell, to be my wife, and promise to be, with divine assistance, a true and loving husband."

My atheist readers, upon learning that I asked for "divine assistance" in my marriage vow, will no doubt see a certain lassitude in my not sticking to my atheist beliefs under all circumstances. But since an atheist has no God to go to for forgiveness, I have given myself absolution for my total abandonment of principle on that one occasion.

Nancy and I took no honeymoon. I had deadlines. Nancy, now with a master's degree, had begun teaching English literature at Brooklyn Friends School. By 1965, the year we married, *Monocle* magazine no longer existed. My drawing table was now in a spacious room on the top floor of a walk-up that I shared with three other freelancers. It was there that I got a phone call from George Lois. Remember George? He was William Golden's favorite designer when George and I worked at CBS. Since that time George had become one of the most talked-about graphic designers in New York. In addition to being one-third of Papert, Koenig, & Lois, an enormously successful advertising agency, George was also designing the covers of *Esquire* magazine, then enjoying a brief renaissance thanks to the bold editorship of Harold Hayes.

George had a problem. He was unable to get Frank Sinatra to pose for the April cover of *Esquire.* When George told me what he wanted Sinatra to do, I wasn't at all surprised that Sinatra refused. The cover was going to hype a piece that Gay Talese had written about Sinatra when he was performing in Las Vegas. While there, Talese witnessed the battalion of flunkies and sycophants who catered to the star's every need. George wanted to get a close-up photograph of Sinatra with a cigarette in his mouth, while a variety of hands holding cigarette lighters eagerly tried to light it. Of

course Mr. Blue Eyes refused to present himself in such an unflattering light; in fact, he even refused to be interviewed by Talese. Now George was going to have to use an illustration, instead of a photograph, and *HE WANTED ME TO DO IT!!*

I tried to compose myself. Ever since my first marriage fell apart I had been taking any job I could lay my hands on—small-time clients with low budgets and out-of-town publications that no one in New York had ever heard of. Now suddenly, I was offered an assignment that would give me more visibility than I had ever had before. With the chance of a lifetime in front of me, I did what I always did in situations like that. I panicked. Instead of doing a portrait of Sinatra that showed my newfound skill for caricature, I spent days doing a realistic rendering of Frank's face that ended up looking like a rubber mask. George took one look at it, rolled his eyes, and told me I had until the next morning to do it over.

That night, alone in the studio, my adrenalin somehow made my hand turn out a terrific drawing of Frank Sinatra. It was full of energy and caught Sinatra's disdain for the flunkies that surrounded him. I brought it to George and he loved it. That *Esquire* cover changed my career. It gave me the courage to do more and more spontaneous drawings. It appeared on newsstands in April 1966. You can see the original at the National Portrait Gallery in Washington, D.C., and, a bit smaller, on the next page.

In 1964 I joined other Quakers in a march on Washington to protest the Vietnam War. The following year there was an even bigger march, but no matter how large the protest marches grew, nothing seemed able to stop the carnage that accelerated after Lyndon Johnson won a landslide victory over Barry Goldwater. Many draft-age men began fleeing to Canada to avoid the war, but Dan Seeger, who attended Quaker meeting in Earl Hall, took a different approach.

In the late 1950s he wrote to his draft board requesting exemption because of his pacifist convictions and was then sent a conscientious objector form to fill out. The first question on the form was "Do you believe in a Supreme Being?" This was followed by a checkbox for "yes" and another for "no." Having no wish to

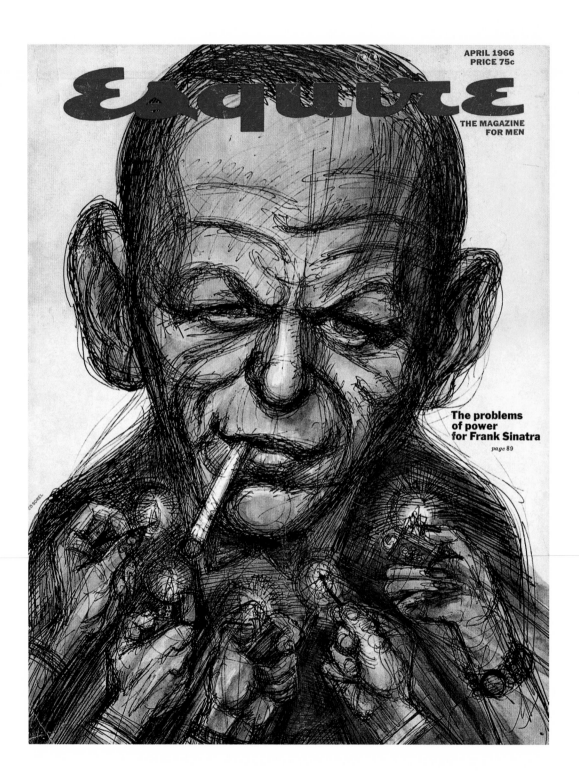

APRIL 1966
PRICE 75c

Esquire

THE MAGAZINE
FOR MEN

**The problems
of power
for Frank Sinatra**

page 89

dissemble, he drew a third checkbox, next to which he wrote, "Please see attached pages." When those pages explaining his nonsectarian opposition to all wars failed to earn him an exemption, he went to the American Friends Service Committee. There he was given an attorney (pro bono) and a defense fund was set up. The lawsuits that followed took six years to work their way up to the Supreme Court, but on March 8, 1965, a decision was reached in the case of the *United States of America v. Seeger*. The court ruled that one did not have to "belong to an orthodox religious sect" to gain conscientious objector status.

Dan became something of a celebrity at our Sunday meeting after that, but he remained the quiet, introspective person he would always be. Around that time I joined the Religious Society of Friends, refusing to recognize any conflict between my atheism and my wanting to do a bit of good—as long as it didn't take too much time away from my drawing.

A year or so after we married, Nancy became pregnant, and she informed me that she didn't "want to be a playground mother." Hmmm. That meant moving to the country just when I was finally out of debt and we were living in a five-room, rent-controlled apartment on the East Side for $97.14 a month. Of course, I bowed to Nancy's wishes. That's why these beautiful Gentile women from the Midwest come to New York and marry Jews. Jewish husbands—especially those who become Quakers—do as they're told.

Nancy and I found a house in Carmel, New York, sixty miles north of Manhattan. It had five acres, and we could have it for $37,500. Since neither Nancy nor I had any money, we would need to borrow some from everyone we knew. Nancy cashed in all the United States savings bonds her father had given her during World War II, and then she asked him to lend us $5,000. He did. In addition, I borrowed $500 from my former partners at Push Pin Studios, $500 from my grandmother, $2,000 from Uncle Jack, and $3,000 from my agent, Milton Newborn. We now had enough cash to get a mortgage for the rest of it.

The thought of living outside Manhattan had never occurred to me, but I told myself there were positive aspects to the move. The

previous owner of our run-down 1812 house had been a writer who built an office for himself and his assistants, so I now had a spacious studio all to myself. We were very close to Fahnestock State Park, which had swimming and skiing (not much of a plus for me, as I did neither), and only four miles away from the home of Robert Andrew Parker, an artist we knew and liked. We were, however, ten miles from the nearest town.

A few months after Nancy gave birth to Jenny, in December 1966, we moved into our new home. Nancy had loved being pregnant, and now loved being a mother. No matter how run-down our country house was, no matter how many times our old car broke down or the furnace needed repairs, Nancy stayed cheerful and optimistic. Her happiness was contagious; even I stopped being a grouch. We found the Bulls Head Friends Meeting House, thirty miles away, on the Hudson, and the Quakers there proved just as compatible as the ones we had left behind and just as politically active. When they learned that the United States postal system refused to accept medical supplies that Quakers wanted to send to both North and South Vietnam, the Meeting took action. They made plans to go to Buffalo and connect with other Quakers crossing the Peace Bridge into Canada, so we could send medical aid to both sides. Nancy cajoled me to forget work for a few days so we could join them. "But what about Jenny?" Jenny was only three months old. Her answer was, "We'll take her with us."

On a frosty March 25, 1967—Easter Sunday—we walked toward the Peace Bridge, with Nancy carrying a bundled-up Jenny. FBI agents greeted about a hundred of us and informed us we were breaking the law. But they allowed us to proceed across the bridge. Those among us who were carrying the packages handed them over to Friends on the Canadian side of the bridge. Or so I assume. I really don't remember everything that happened; the only reason I know the date it happened is because I Googled it. But what I do remember vividly is what happened the night our group of Quakers held a silent vigil in front of the motel we were staying at, each of us holding a candle.

I can't remember if this vigil took place the night before we

crossed the bridge or the night after, but I do remember a small group of us standing around an oval in front of the motel—I think it was called the Peace Bridge Motel—with Nancy at my side holding Jenny with one arm and a candle with the other. Before long, two or three beat-up sedans began circling us. Not only were they driving around us so fast that we heard their tires screech, but they also rolled down the car windows to yell "Love it or leave it" and shout the usual accusations meaning we were a bunch of Commies. I was scared enough to forget how cold I was, but we all stood silent and stationary, long after they sped away.

On the bus ride back I thought of Dr. Caldwell, and imagined what he would think after Nancy wrote to him about her adventure in Buffalo. I was sure he would think that it was I, the New York Commie Jew, who had turned his gentle daughter into an unpatriotic lawbreaker. I wished he understood who the *real* activist in the family was.

I'm beginning to regret promising an exposé of our last thirteen

presidents. I hate doing research. It takes up a lot of time, time I'd rather spend talking about myself. But a promise is a promise. I am now up to 1967. In another year Richard Nixon is going to be elected president. So I've got to get Lyndon Baines Johnson out of the way right now. I've been looking forward to tearing into him for all the unforgivable bloodshed he caused in Vietnam, but the incredible amount of enduring social legislation enacted during his presidency compels me to share my astonishment with you before I take a hatchet to him.

Thrust into the presidency by Kennedy's assassination, Johnson quickly succeeded in passing a series of far-reaching progressive laws by cleverly insisting he was merely carrying out the program begun by our beloved late president. In truth, LBJ succeeded in getting far more out of Congress than JFK ever could have, or would even have attempted. First Johnson championed the stalled civil rights bill that Southern congressmen had prevented from coming to a vote, and got it passed after seventy-five hours of debate in the Senate. It outlawed discrimination based on race, color, or religion in hotels, restaurants, and theaters, and barred unequal application of voter registration requirements. It also paved the way for the Voting Rights Act of 1965 and the Civil Rights Act of 1968.

He then passed a significant tax reduction bill that led to economic growth and reduced unemployment. He changed the country's immigration policy so that it allowed in more non-Europeans; signed into law the Economic Opportunity Act, which empowered the poor to transform their own communities; sent volunteers into low-income communities to provide vocational training; and began the Head Start program that provided poor children with education and nutrition. Johnson's overwhelming triumph against Goldwater in the 1964 election gave him a mandate for his Great Society program, and Congress responded by passing Medicare, which provided health services to the elderly and other laws that helped the environment, aided cities, funded education. *Johnson even found money for the arts.*

But Johnson's victory over Goldwater was based on a decep-

MAYBE THIS'LL SHUT UP THOSE DAMN NEW YORK INTELLECTUALS, BUT I DOUBT IT.

AND THEN I'LL SEND A COPY TO THE TIMES.

OH MY GOD! I'VE BEEN INVITED!

TO WIN OVER WRITERS OPPOSING THE VIETNAM WAR, LBJ INVITED THEM TO A WHITE HOUSE "FESTIVAL OF THE ARTS."

ROBERT LOWELL DECLINED THE INVITATION WITH A LETTER AGAINST THE WAR THAT WAS PRINTED ON PAGE ONE OF THE TIMES.

DWIGHT MACDONALD'S LETTER FOLLOWED URGING ALL TO BOYCOTT THE EVENT. THEN HIS INVITATION CAME IN THE MAIL!

I SHALL GO!

HE SAID HE WAS OBLIGED TO ACCEPT, "SO THAT AT LEAST ONE CRITICAL OBSERVER WOULD BE THERE TO REPORT."

HE ARRIVED IN SNEAKERS AND SPORT COAT WITH A PETITION AGAINST THE WAR. SAUL BELLOW AND RALPH ELLISON REFUSED TO SIGN.

YOU'RE LUCKY HE DIDN'T BOMB NEW YORK.

CHARLTON HESTON ASKED MACDONALD IF HE USUALLY BROUGHT PETITIONS "AGAINST HIS HOST IN HIS OWN HOME?"

SEEING WHAT WAS GOING ON, LBJ ENDED THE LONG EVENT WITH A FEW BRIEF WORDS, THEN STOMPED OFF.

DAYS LATER JOHNSON ORDERED SATURATION BOMBING AND 100,000 MORE TROOPS TO VIETNAM.

tion perpetrated by LBJ. In 1964, his generals had told him that unless American troops were sent to South Vietnam right away, South Vietnam would be lost. But Johnson couldn't send in troops before the election. *He was the peace candidate, for crying out loud!* He may not actually have told his generals "Just get me elected, and then you can have your goddamned war!" But that was his plan. Two months after he took the oath of office for the second time, he sent 3,500 troops to defend the American air base at Da Nang. Three years later, in

In June of 1965, Lyndon Johnson held a Festival of the Arts in the White House to ingratiate himself to those writers and artists who were critical of his escalation of the war in Vietnam. I recalled that event fifty-three years later when I began a feature in *The New York Times Book Review* with "The Literati."

1968, there were 548,000 U.S. troops in Vietnam, and the United States was a divided, angry, and confused nation. By the time the war actually ended in 1975, twenty years after lovable Ike sent in the first advisers, 58,220 American soldiers would be dead.

From the very beginning of his presidency Johnson felt trapped by the war that Kennedy had foisted on him. He told his aides that he would be crucified no matter what he did, that that faraway conflict would end up being his downfall. A year before he sent in the first American ground forces, he told McGeorge Bundy, his national security adviser, "I don't think it's worth fighting for and I don't think we can get out. It's just the biggest damned mess." To reporters, and in speeches, he projected optimism, but he always had a bleak view of the chances of winning and doubted that the outcome mattered at all to American security. Yet he couldn't give the Republicans a chance to accuse him of "losing" another nation to communism, as they had accused Truman of "losing" China.

Everything ran off the rails in 1968. In January the Viet Cong, South Vietnam's insurgents, and their allies in the North launched

This fanciful depiction of Robert F. Kennedy in conflict with LBJ about the Vietnam War appeared in *The Atlantic Monthly*.

the Tet Offensive, which proved to be a turning point in that con-flict. Television coverage brought to our homes the full horrors of the war. The weekly death tolls for Americans hit new highs. In March, Eugene McCarthy, a lackluster anti-war candidate running against LBJ in the New Hampshire presidential primary, came close to defeating the besieged president. This encouraged Robert F. Kennedy to challenge Johnson as well. Two weeks later John-son gave a television address saying, "I shall not seek and will not accept the nomination of my party as your president."

A somewhat less earthshaking event in 1968 was the debut of *New York* magazine, the creation of Clay Felker and one of my former partners at Push Pin, Milton Glaser. The fees it paid its artists were low, but now I had a publication where I could sub-mit my own ideas to editors who would welcome them. Before long, thanks to all the anti-war ferment, I was also able to sell my anti-war caricatures to magazines that heretofore had never bought drawings that ridiculed establishment figures. Not all of my drawings pleased me. I was taking on too many assignments to give all of them the time they deserved, but it was awfully nice to pass a newsstand and see my magazine covers displayed. In the 1960s and '70s these included *New York*, *The Atlantic Monthly*, *The Saturday Review*, *The Nation*, *Time*, *Fortune*, *Evergreen Review*, *National Lampoon*, *Esquire*, *The New York Times Maga-zine*, *Ramparts*, *Harper's*, *Screw*, and *The Village Voice*, the last a weekly newspaper that championed the avant-garde in the arts along with left-wing politics. The following pages have some of the covers and pictorial essays I did during that time period.

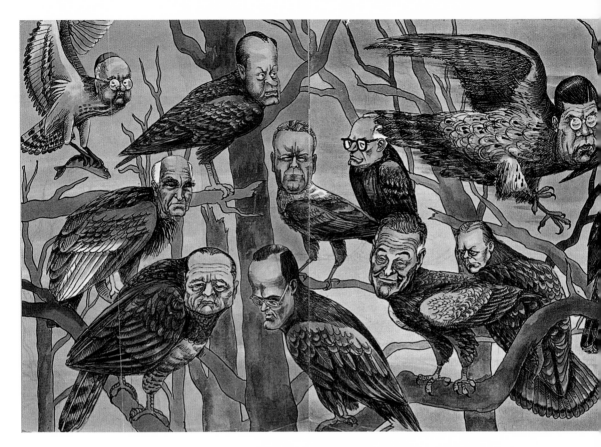

Because I had once done a monthly feature in *Ramparts* called "Sorel's Bestiary," I was asked to do a wraparound gatefold cover with many of the Vietnam war hawks. Among these birds of prey, you'll find Cardinal Spellman, Bob Hope, Robert McNamara, Dean Rusk, LBJ, Billy Graham, William F. Buckley, Barry Goldwater, Henry Luce, Everett Dirksen, and Curtis LeMay.

The Famous Writers School was founded by Bennett Cerf in 1961, promising the thousands who enrolled for lessons by mail that famous writers would read all their entries. In 1970 Jessica Mitford wrote an exposé of the school for *The Atlantic,* and the school closed up its then $48,000,000-a-year business soon after. My drawing of the world's greatest writers was an echo of the photo the school had used in its advertisements.

Murder in the Schoolroom, Part II

THE **Atlantic** JULY 1970 75 CENTS

"We're looking for people who want to write."

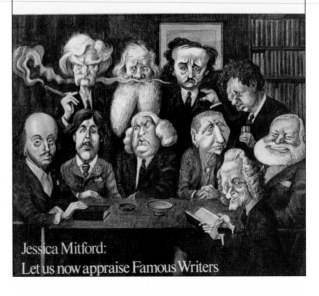

Jessica Mitford:
Let us now appraise Famous Writers

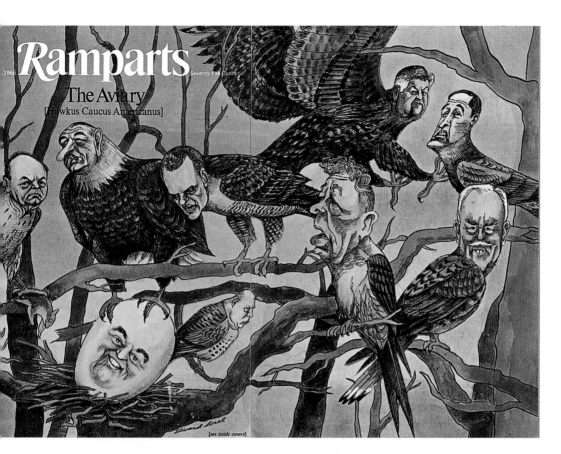

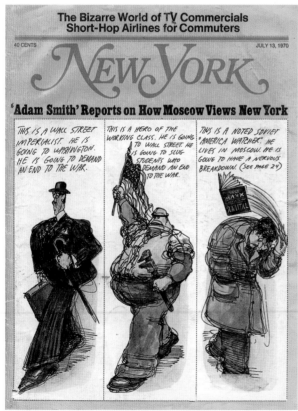

The paradox of New York's bankers and industrialists favoring peace with Vietnam while construction workers in New York City attack peace protesters caused Moscow to rethink its views about the American working class.

SPECIAL SEX & POLITICS ISSUE

"I Balled Henry Kissinger!" P.4 Honeysuckle Humped LBJ P.6

SCREW

75 CENTS

NUMBER 249

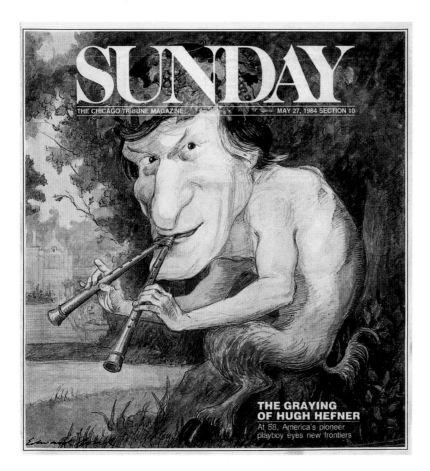

SUNDAY

THE CHICAGO TRIBUNE MAGAZINE MAY 27, 1984 SECTION 10

**THE GRAYING
OF HUGH HEFNER**
At 58, America's pioneer
playboy eyes new frontiers

ABOVE Hugh Hefner as Pan, from *Sunday*,
the *Chicago Tribune* magazine.

RIGHT My drawing of Rupert Murdoch as
Dracula taking over Chicago captured only
the beginning of his ambitions. Years later
he took over New York by grabbing *The
Wall Street Journal*, *New York* magazine,
and the *New York Post*.

OPPOSITE The Watergate Hearings were
taking place the week that Steve Heller
called to ask me to draw the first page of
Screw, the weekly porn newspaper sold
on the newsstand. I imagined Judge Sirica
listening to the Nixon tapes and hearing
a shocking exchange between Nixon
and Bebe Rebozo. The National Portrait
Gallery surprised me by buying the
original drawing, but it refused to hang it
when I had an exhibit there. (The *Screw*
logo, with its priapic *E*, was designed by
Milton Glaser.)

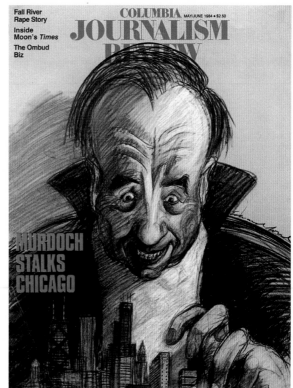

Fall River
Rape Story

Inside
Moon's *Times*

The Ombud
Biz

COLUMBIA MAY/JUNE 1984 • $2.50
JOURNALISM
REVIEW

MURDOCH
STALKS
CHICAGO

5

Things Are Looking Up

All those drawings for magazines, plus some lucrative advertising jobs that my agent brought in, put a lot of checks in my RFD mailbox. Five years after we moved to Putnam County as debtors, I owed not a cent to anyone, and I suddenly realized that I had enough money to pay off our entire twenty-year mortgage. I told the good news to my accountant, who then explained to me that because of runaway inflation (the Vietnam War again) the money in my savings bank was paying me more interest than the interest I was paying to my mortgage bank, and at the same time, in real terms, the amount that I owed kept getting smaller. When I looked puzzled, he put it more succinctly: "You'd be losing money if you paid off your mortgage."

We now had disposable income, and I thought (for only a moment) of disposing of some of it by buying a 1936 De Soto Airflow. I always admired that odd-looking Art Deco automobile, but when Nancy saw me reading the Hemmings guide to classic cars, she decided that if I had enough money for an antique car, I had enough money to tear down the shabby lean-to structure that served as our kitchen. Shortly after Nancy gave birth to Katherine, our second daughter, work was begun on our new kitchen.

It was completed before Thanksgiving, in time to become the annual gathering spot for my grandmother, brother Norman and girlfriend, aunts, uncles, and cousins, my mother, father, and even my ex-wife, Elaine. Nancy managed to feed this gathering pretty much by herself and seemed to love doing it.

As much as she enjoyed playing hostess to my large family, Nancy was also eager to return to writing. Knowing this, I suggested we do a book about people whose names had become part of the English language. Nancy doubted there would be enough eponymous men and women for a book, but when she went into New York to research the idea at the Forty-second Street library— there was no Google then—she found there were more than a hundred. We knew about *sandwich, pompadour, maverick,* and *zeppelin,* but we were surprised to find that *dunce, pickle, tawdry,* and many more were also derived from people's names.

In the course of doing research Nancy was puzzled to find that in most dictionaries the etymological source for the word *lynch* was attributed to a Quaker named Charles Lynch. This had to be an error, she reasoned: Quakers are pacifists. And it was indeed an error. Nancy unearthed a contemporary of Charles Lynch, William Lynch, who had formed a group of extra-legal law enforcers to punish ruffians and robbers in the 1780s. That made more sense.

We thought of calling our book *Let Us Now Praise Eponymous Men,* but considered that a lot of people wouldn't know what eponymous meant, so we called it *Word People.* Working together on our first collaboration was great fun. We threw a big outdoor party in the summer of 1970 to celebrate the book's publication. That party was particularly memorable because on the morning of the Saturday that the party was to take place, the machinery that pumped water to our house conked out. *We had no water.* We called Mr. Savnick, our plumber. He could see the part that had broken, but he couldn't buy a new one until Monday. Fortunately most of the finger food required no cooking and we had bottled water for drinks, but there wasn't going to be any water for our guests to flush the toilet. As a result I had to be on the alert for anyone who went into a bathroom. As soon as somebody did, I

The fact is Joseph-Ignace Guillotin did not invent the guillotine. The instrument had long been used in China, Italy, and Germany. What Dr. Guillotin did was advocate for the machine's adoption at a particularly vulnerable moment in French history. Because Dr. Guillotin helped victims whenever he could, he himself was arrested, but saved from death by Robespierre's timely execution.

Louis Galvani, a professor in Bologna, placed half a frog near a machine that produced static electricity, and when his knife touched the brass conductor and then the frog's sciatic nerve, its legs kicked. They had been "galvanized" into action.

ran down to the pond on our property, filled up a pail with water, rushed back to the house, and as soon as they were finished, flushed the toilet. I spent the entire party doing that routine.

After the party was over I began wishing I was back in New York. In the city water *always* came out of the faucet. In the city I called my plumber Miguel, and he called me Mr. Sorel. In the country I called my plumber Mr. Savnick and he called me "Eddie," a name I always associate with movie gangsters. In the city my clients sent a messenger to pick up my finished drawing. In the country I had to take a train into the city to deliver one, and lose a whole day's work. There was no FedEx back then, and we were decades away from having personal computers that could scan and deliver sketches. Furthermore, in the country, I was lim-

ited to whatever friends I could find within a ten-mile radius. In Manhattan, chances are you would find a kindred spirit on the same block, if not in the same building. However, I knew I was happier living with Nancy in the country than I had ever been before. So I stayed put.

Being happy, I believed, was one of the reasons my drawings were getting so much better. My pen-and-ink illustrations for *Word People,* although still echoing the pen-and-ink work of David Levine, were a big step forward for me. They are far from the more spontaneous, self-assured caricatures I would be doing in the years to come, but at least some of them were honest-to-god drawings.

Others, such as the drawing of Joseph-Ignace Guillotin, were traced. That's because there were too many elements in the drawing that needed to be clearly defined, and I had to know where those elements would be before I drew them in pen and ink. Pen and ink is an unforgiving medium. With pencil you can draw light and heavy, with charcoal you can erase easily, but once you've put pen and ink on paper it's there to stay. My method of tracing, as I mentioned, is the one Milton showed me: put an outline of the scene you are going to draw under a sheet of 16 or 18 lb. bond paper, then draw it in pen and ink.

And here is Count Ferdinand von Zeppelin, a Prussian officer and engineer, who conceived of the idea for an airship while aloft in a balloon. His dirigible made its debut in 1900.

Following the drawings that I did for *Word People,* I've placed this blowup of a drawing I did of Frank Sinatra for *New York* magazine a few years later. You see how much looser my pen-and-ink work had become in a short time. I never would have gotten that kind of spontaneity if I had traced over a previous sketch. It was nervous energy that produced that wonderful frenzy of lines. What I can't show you are the earlier attempts at drawing Sinatra that either failed to look like him or were too stiff—another way of saying they had no joy in them. Those ended up in the trash.

Illustrating amusing oddballs for *Word People* offered a welcome respite from caricaturing hateful war hawks during the 1960s. By the time Richard Nixon ascended to the White House in 1969, the Vietnam War had motivated other illustrators to turn to political satire. Tricky Dick had a face born for caricature. We had a field day.

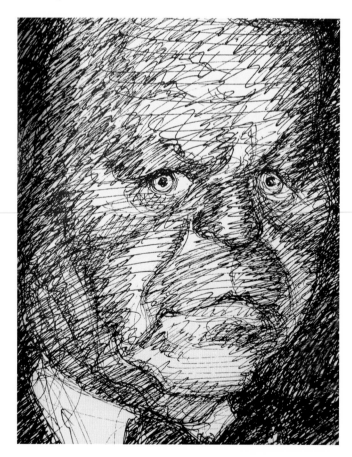

After becoming the Republican candidate for president in 1968, Nixon promised voters that he had a "secret plan" to end the war in Vietnam, one that of course he couldn't divulge until after he was elected. His Democratic opponent was Hubert Horatio Humphrey, who, as Johnson's vice president, had echoed all of LBJ's justifications for carrying on the unwinnable war. As a result, the anti-war faction in his own party despised Humphrey as much as they did Nixon.

I was one of those. In early 1968, Martin Luther King, Jr., and Robert F. Kennedy were assassinated. The main choices we had in the voting booth that year were Nixon or Humphrey, or the white supremacist George Wallace, running on the American Independent Party ballot. I could also vote for whoever was running on the Socialist Labor Party or the Socialist Workers Party lines. I think I voted for the Socialist Workers guy. I chose not to vote for the woman running on the Communist Party line or for the pig named Pigasus, a write-in candidate put up by the Yippies who believed that "one pig's as good as any other." It was that kind of year.

Nixon started way ahead in the polls, but by October Humphrey was rising, and he began distancing himself from Johnson on Vietnam, calling for a bombing halt. When Johnson did exactly that the weekend before the election, amid reports of a possible peace agreement, Humphrey's campaign got a big boost. By Election Day, polls suggested the race was too close to call. We now know, thanks to a cache of notes left behind by Nixon's closest aide, H. R. Haldeman, that Nixon used Republican lobbyist Anna Chennault to be his channel to Nguyen Van Thieu, president of South Vietnam. Her job was to advise him to refuse participation in the talks because he would get a better deal under a Nixon administration. Johnson regarded Nixon's actions—discovered by means of wiretaps—as treason, and the Republican minority leader in the Senate, Everett Dirksen, agreed, but Tricky Dick's treachery was not revealed to the public before the election, and Nixon squeaked through to win.

This covert action by Nixon laid the foundation for the skuldug-

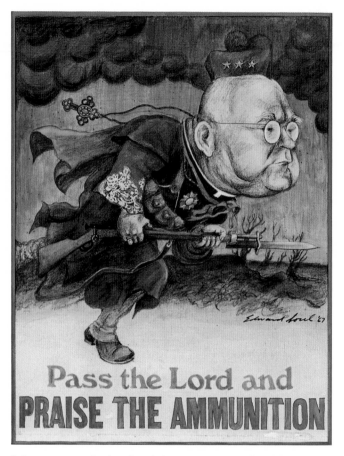

Pass the Lord and
PRAISE THE AMMUNITION

I painted this poster at the height of the Vietnam War, hoping *Ramparts* would buy it. They didn't, neither did *The Nation* or *New York*. It was, however, published by Personality Posters. Unfortunately Cardinal Spellman died on the very day it was printed. I was told that there was only one store in Chicago brave enough to carry it, and it had its windows broken as a result.

gery that was to follow during his presidency. Obviously, he had no secret plan to end the war. On the contrary, he pursued the war in blatant disregard of his promise to end it. His secret bombings of neutral countries and his wartime lies proved to millions of Americans, yet again, that you couldn't trust *any* politician. Prolonging the war led to 21,000 additional Americans dead, and another half million Vietnamese. When a settlement was finally reached in 1973 it was no better for South Vietnam than the deal Johnson had offered in 1969. The Americans got out, and in 1975

South Vietnam fell to the communists, leaving the United States, after thirty years of unceasing anti-communism both at home and abroad, a nation at war with itself.

By extending the war into neighboring Cambodia, Nixon was also responsible for unleashing the unspeakable horrors committed by Pol Pot and the Khmer Rouge, which resulted in two million Cambodians being slaughtered. Nixon, together with his national security adviser, Henry Kissinger, masterminded other criminal incursions elsewhere. In 1970, when Salvador Allende and his left-wing coalition won a plurality in the Chilean presidential election, Nixon ordered the CIA to foment a coup d'état. They got what they wanted when a fascist strongman named Pinochet succeeded in overthrowing Allende in 1973.

Sometime around 1969, I did a series of caricatures in *The Atlantic Monthly* mocking our political leaders, and *Time* magazine took note of them and ran a short profile on me. This bit of puffery led to a phone call from the King Features syndicate, asking if I would be interested in doing a weekly feature to be distributed to a number of papers across the country. I knew King Features was owned by the right-wing Hearst organization, but I jumped at the chance anyway.

I called my feature "Sorel's News Service." Each week I would find a quote from a politician and comment on it. My point of view was not welcomed in many of the papers, and each week another newspaper canceled. In October 1970, when I did a picture of Richard Nixon as a vaudevillian juggling the skulls of Americans killed in Indochina, I was dropped by almost all the papers. It seems awfully heavy-handed to me now, and the other News Service drawings don't look so hot either.

In 1972, with the Vietnam War as

I'm not proud of my News Service drawings, they all look overworked. One of the better ones is this 1970 caricature of William F. Buckley, Jr., who was opposed to the United States recognizing Red China. "We are hardly ignoring a country by failing to recognize it. As a matter of fact, we are sort of *super*recognizing it . . . If you *don't* recognize, you're giving it very special attention."

unpopular as ever, Nixon worried about his chances for reelection. The national chairman of the Democratic Party, Lawrence O'Brien, was of particular concern to the president. O'Brien had been a lobbyist for reclusive billionaire Howard Hughes, and Nixon feared O'Brien had discovered that Hughes had given him a hundred thousand dollars as a gift. (Hughes, a builder of airplanes, got lucrative contracts from the government.) To find out what O'Brien might know, Nixon ordered John Mitchell, his attorney general, to use G. Gordon Liddy's plan for breaking into the headquarters of the Democratic National Committee in the Watergate complex.

The White House incompetents who broke into the DNC offices were caught, and Nixon's attempts to cover up his involvement led to impeachment hearings, and to his resignation. On the audiotapes that he was forced to surrender, we can hear him giving instructions to his assistant for domestic affairs, John Ehrlichman, to have the IRS investigate O'Brien's tax returns, and later angrily shouting to Haldeman that he wanted all the Democrats' big donors audited, especially the "Jewish contributors . . . the cocksuckers."

I think I'll end there, although I should really have included how he almost destroyed the U.S. economy by instituting wage-price controls to cure a relatively low level of inflation. And I should have added that when he ended the gold exchange standard, he created a decade of stagflation—high inflation, high unemployment, and stagnant demand—that was cured only by double-digit interest rates. That, in turn, caused the disastrous recession that followed after he was forced from office. His getting us off the

gold exchange standard allowed the Treasury to print more and more dollars to solve our economic shortfall that in turn ensured that the dollar's value would fall. That's when everyone started to hoard gold.

Very soon I'll reveal some of my favorite Nixon cartoons, but first I'll tell you about my idiotic trip to Miami to cover the 1972 Republican National Convention that nominated Nixon for a second term. It came about when Clay Felker spotted me near his office at *New York* and yelled out, "Hey, Ed, c'mon in here. I've got an idea for you." His idea was for me to take a sketchbook to the convention and do on-the-spot drawings. I explained that I had never done on-site sketching before. "Ed," he said, "sometimes an artist has to try new things. This would be a good stretch for you." I was flummoxed by his sudden interest in my career, but when he told me I would have a room at the Fontainebleau Hotel and a press pass that would get me close to the action, I agreed to go.

When I got to the Fontainebleau, I found that I didn't have a room. I was *sharing* a room with Richard Reeves, a young writer for the magazine. He wasn't welcoming. The next day when I went to the convention center, I found that my press pass did not entitle me to roam the main floor where the action would take place. It only allowed me to be up in the balcony, where there was nothing to sketch. I went back to the hotel and booked a flight home.

Reeves, now quite cordial, suggested drinks in the lounge before I had to leave to catch my plane. During our conversation I mumbled, "I don't know why the hell Felker sent me down here." Reeves replied, "I think I can answer that." His explanation involved one of the pretty writers on the magazine—let's call her Molly Malone—who was also staying at the Fontainebleau to cover the convention. Felker, according to Reeves, had a room to himself at the Jockey Club and was hoping that Molly would spend the night with him. Sending me to Miami to room with him, Reeves suggested, was a way of eliminating Reeves as competition. Was that really why I was sent there? Who knows? All I knew was that I had lost three days I could have put to better use.

Here, as promised, are some of my Nixon cartoons and carica-

tures. But no drawing of Nixon can reveal the man as clearly as this tape transcript from Daniel Ellsberg's book, *Secrets: A Memoir of Vietnam and the Pentagon Papers:*

NIXON: . . . I still think we ought to take the [North Vietnamese] dikes out now. Will that drown people?
KISSINGER: About two hundred thousand people.
NIXON: No, no, no . . . I'd rather use the nuclear bomb. Have you got that, Henry?
KISSINGER: That, I think, would just be too much.
NIXON: The nuclear bomb, does that bother you? . . . I just want you to think big, Henry, for Christsakes.

Whenever Richard Nixon needed some positive thinking, he could always count on Norman Vincent Peale and Billy Graham.

This drawing accompanied the words of Reverend Ezra Ellis of the First Friends Meeting of Whittier, California: "He has his mother's deep moral integrity, and in this sense I would call him basically devout."

TOP This appeared in *The Village Voice* in 1975 when everyone was "coming out of the closet."

BOTTOM Nixon's campaign for governor of California in 1962 was struggling because a secret two-hundred-thousand-dollar loan from the defense contractor Howard Hughes to Nixon's brother Donald was no longer secret. Everywhere the candidate went he was asked about it. His nerves were already shot when he arrived in San Francisco's Chinatown to do more campaigning, and he nearly had a meltdown when he opened a fortune cookie to discover the message "What about the Hughes Loan?" It had been placed there by prankster Dick Tuck.

TOP The superpatriot in this poster is Spiro Agnew, Nixon's vice president, who got caught taking bribes in the White House. No one had told him that that sort of business had to be done elsewhere. It appeared in *The Atlantic*.

BOTTOM "The Watergate Shootout" appeared in *Ramparts* in June 1972, two years before the coppers finally got Nixon. In case you've forgotten the name of the gang members, they are (clockwise from Nixon) James McCord, Jeb Magruder, John Ehrlichman, Patrick Gray, Richard Kleindienst, Maurice Stans, John Mitchell, H. R. Haldeman, and in the center, John Dean.

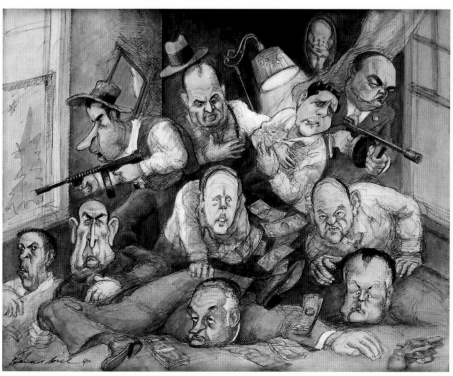

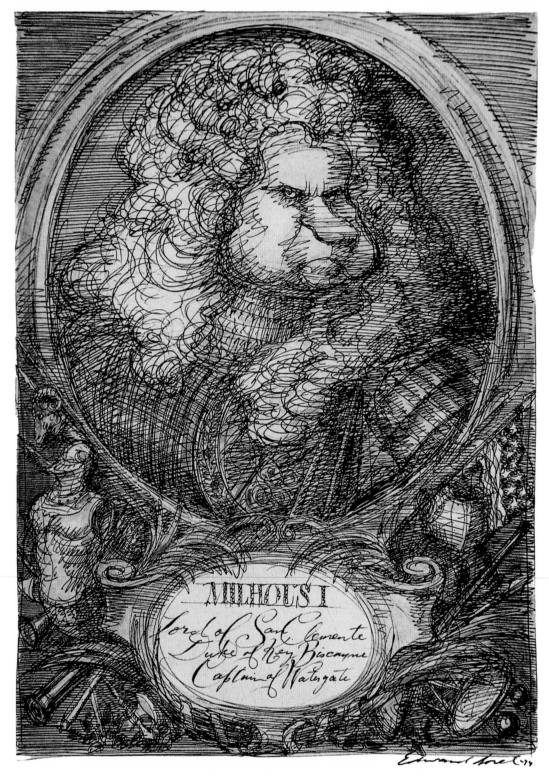

MILHOUS I

Lord of San Clemente
Duke of Key Biscayne
Captain of Watergate

An illustration for an article on the imperial presidency of Tricky Dick. It appeared in *Rolling Stone*. It was purchased by the Library of Congress.

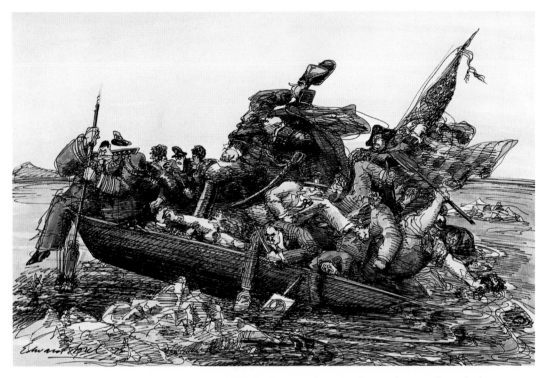

I know this appeared in *The Saturday Review,* and it may have had something to do with the Bicentennial, but all I can be certain of is that, judging by my picture, the country was already being torn apart.

A month after Nixon resigned in 1974, he was pardoned for any crimes he may have committed against the United States by Gerald Ford, who became the first president of the United States not elected as either president or vice president. In case you've forgotten, when Nixon's first vice president, Spiro Agnew, was forced to resign for taking bribes, a new amendment to the Constitution allowed Nixon to nominate his own vice president, and he chose Ford. As Bicentennial celebrations began in the summer of 1976, and we listened to the platitudes delivered by President Ford, some of us were forced to admit that this country's experiment in democracy hadn't been entirely successful.

Many months before that significant July 4, Nancy and I were at a gathering in Donald Barthelme's Greenwich Village apartment, when he surprised me by suggesting that I illustrate an idea he had for the Bicentennial. Don at the time was the most talked-

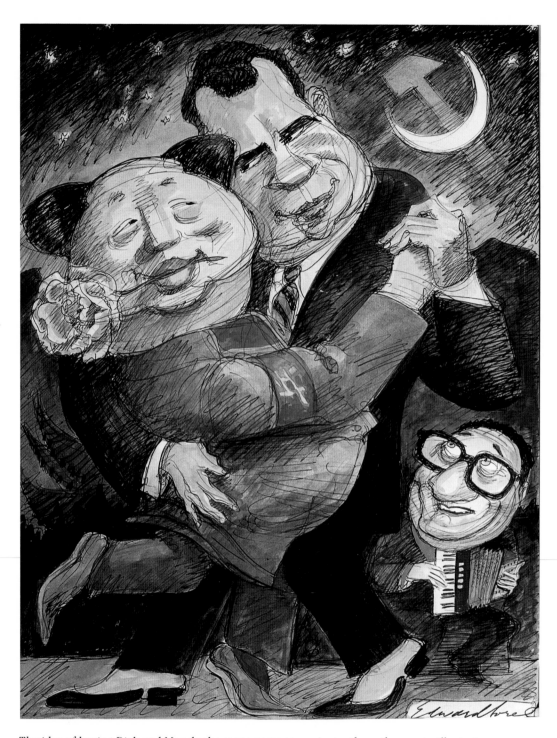

The idea of having Dick and Mao do the tango came to me instantly as the way to illustrate an article in *The New Yorker* about Nixon's first trip to China. There is no way of figuring out why some drawings with a tight deadline turn out well and others don't, but a really funny idea seems to make the pen work faster.

about writer at *The New Yorker*—the one magazine that got along very well without my golden hands. Illustrating anything he wrote could finally put me into the magazine's august pages. Don's short fiction was often described as "postmodernist," but to me he was simply the wittiest writer around, even when I didn't understand everything he wrote. What Barthelme wanted me to do was draw "Monuments for the Bicentennial." A week or so later he sent me his odes to *Progress, Disaster, The Tax Loophole, Valium, Nostalgia,* and *Divorce.* I immediately went to work creating monuments for each.

Much to Barthelme's chagrin, *The New Yorker* turned the project down. I was not surprised. I always regarded my drawings as too "overworked" for them. They preferred a looser, more effortless style, but they did send me a note saying they would deign to consider future submissions. My rejection by *The New Yorker* turned out to be all for the best. *The Atlantic Monthly* bought our "Monuments for the Bicentennial," devoted six pages to them, and gave me the cover for a full-color drawing of "Progress." It was the beginning of a happy twenty-five-year association with that magazine.

Here is one of those six monuments, together with some of Barthelme's still fresh and witty stream-of-consciousness text.

I vividly remember July 4, 1976, for another reason as well. Clay Felker and Milton Glaser had reserved the entire floor of Windows on the World, the grand res-

In his musings on divorce, Donald Barthelme asks the question "Without the sacrament of Divorce, who would be silly enough to get married? Nobody, except for people who don't care one way or another, the 15 percent who are always, in America, 'undecided,' those clunks." Noting that lawyers have made the whole process of divorce unpleasant, he proposes that plumbers do the job. "Plumbers know all about joining and unjoining and are slightly cheaper."

taurant atop the World Trade Center, to celebrate the success of *New York* magazine. In eight short years it had surpassed the circulation of *The New Yorker* in New York City, and we writers and artists who had played a part in its becoming the hottest magazine in the country were ready to drink up and congratulate ourselves. For Nancy (from a suburb of Kansas City), and for me (from the Bronx), looking out of those elongated windows on the 107th floor of the World Trade Center was a heady experience. Below us were the "tall ships," eighteenth- and nineteenth-century vessels sent from various countries to help the United States celebrate the completion of its second century, and around us were some of the brightest, most amusing, and most powerful people in the city. To top it off, I had Nancy in my arms as we watched the fireworks. I was a very happy man.

Later, amid the bubbly excitement, I noticed a worried group huddled in a corner, whispering about something serious. I saw my friend Walter Bernard, the art director of *New York,* among them. I left Nancy and eased my way into Walter's circle. At first I couldn't believe what I was hearing: someone was saying that Clay and Milton were in real danger of losing their magazine to Rupert Murdoch. It seems that when Clay bought a controlling interest in *The Village Voice,* a weekly newspaper, from the patrician playboy Carter Burden, Clay paid him partially with stock in *New York* magazine. Now Burden, angry because Felker refused to make him an editor at *New York,* was said to be ready to sell his *New York* shares to Murdoch. How could this happen at the very moment when we were celebrating Clay's success? The festive mood in the rest of the room made such rumors seem absurd.

It seemed inconceivable that there could ever be a *New York* magazine without Clay and Milton at the helm, but in the months that followed, Murdoch got other shareholders to sell him their stock, and by January 1977 he owned both *New York* and *The Village Voice.* Richard Reeves's comment, after we knew for certain that the magazine was lost to us, summed it up beautifully. He said, "We all thought the power was really with the writers, with the creative people, and in a way we learned what they learned

in Hollywood: That's not the way it is. The power is with the money."

Almost everyone I knew at the magazine resigned. In my case it meant not only quitting *New York,* but also giving up the weekly newspaper cartoon I was doing for the *Voice,* since Murdoch owned that publication as well. Having the same space in the paper every week where I could comment on anything that struck my fancy was a dream that came to an end too soon. I would never have that again. Here, rescued from oblivion, are my favorites pieces from *New York* magazine.

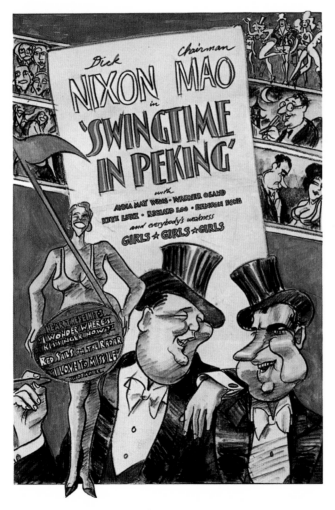

One of several "movie posters" I did for *New York* to comment on the headlines of the day. They seemed funny at the time, and some did have a political point to make, but this one amused only movie buffs who recognized the names in the supporting cast as those Asians who played the villains in World War II movies.

STATEHOOD IS NOT ENOUGH

In 1969 Norman Mailer ran for mayor of New York, proposing that the city secede from New York State. I believed the city would be better served if it seceded from the entire United States, and Clay Felker gave me some pages to make my case. I predicted that the very next subway fare increase would so enrage citizens that they would jump the turnstiles rather than pay to ride.

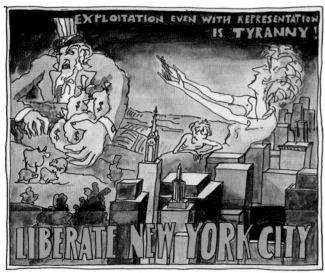

This act of civil disobedience, like the storming of the Bastille in Paris, would, I believed, spark an insurrection that would lead to independence. I foresaw artists from all five boroughs creating posters showing how the federal government has been robbing us blind for decades. Soon thousands would be marching to Washington and shouting, "EXPLOITATION EVEN WITH REPRESENTATION IS TYRANNY!" Some militant environmentalists would insist that both gas-fueled and electric autos be banned. While admitting that leg-powered taxis would be slower, they'd point out that riders would now have more legroom than ever before. As you can see from the picture opposite, I assumed many countries would be sympathetic to our cause and provide us with aid, even before our secessionist leaders decided on our new nation's form of government. Many favored an absolute monarchy if only to boost tourism and to finally put an end to recorded phone calls from candidates. Look closely at the Hudson River: you'll see a wall separating New York City from New Jersey. It's only in the planning stage, and let's hope it won't be necessary.

The Golden Age of Yiddish Theater, by Irving Howe
A Critical Guide to Indoor Tennis Clubs
Options: The Hottest Game in Town, by Dan Dorfman

75 CENTS

FEBRUARY 9, 1976

NEW YORK

Capote Bites the Hands That Fed Him
Why the Jet Set Is Outraged by Their Favorite Author. By Liz Smith

When Truman Capote, because of drink and drugs, was unable to finish his novel *Answered Prayers,* he sold some of it to *Esquire.* In these excerpts he betrayed secrets his high-society friends had confided to him. After they were published, one of these ladies committed suicide and the others ostracized him. Liz Smith, who wrote the story, liked my cover drawing so much she bought it.

The 1970s are now almost over without a word about Gerald Ford or the man who defeated him in 1976, Jimmy Carter. I can get them out of the way very quickly.

As soon as Ford pardoned Nixon, his approval rating plunged from 71 percent to 50 percent. Later we found out that Nixon's chief of staff, Alexander Haig, had told Vice President Ford that Nixon would resign as president if Ford would promise to pardon the "law and order" president after he left office. Ford signaled to Haig he would, and Nixon, now certain he would not end up in the slammer, announced his resignation in a televised address, admitting nothing. *The New York Times* called the pardon that

Poor Gerald Ford was probably no stupider than most of his fellow congressmen, but he looked as if (in the words of LBJ) he couldn't both chew gum and walk at the same time. He made a perfect Frankenstein monster, however.

In dealing with the newly hostile and vengeful regime in Iran, Carter found his old allies had no intention of helping him out. His situation was somewhat like that of Gary Cooper's in *High Noon*, but Cooper had a script to follow. Carter didn't.

followed a "profoundly unwise, divisive and unjust act" that in a stroke had destroyed the new president's "credibility as a man of judgment, candor and competence." After the pardon you would have thought that Ford would lose in a landslide when he ran for a full term in 1976, but in fact he lost by only two percentage points. He was narrowly defeated by the ever-smiling Democratic governor of Georgia Jimmy Carter, who made much of the fact that he was a born-again Christian. Nancy liked him in spite of that, but I couldn't warm up to a man who smiled all the time.

He took office at the precise moment when, thanks to Nixon and Ford, the country was beset by inflation, slow economic growth, an energy crisis, a welfare system out of control, health care in shambles, and, as usual, an unfair tax system. Nothing Carter did in the next four years improved anything. As a devout "Christer," he seemed earnest at first in wanting to reorient our foreign policy to be concerned with human rights. But in practice, he really didn't care about human rights as much as he claimed he did.

In December 1977, Carter visited Tehran and toasted Mohammad Reza Pahlavi, the shah of Iran, for making Iran "an island of stability" and for "the admiration and love which your people give you." Carter had to know that since 1953, when the CIA organized the coup that overthrew Mosaddegh, the shah had ruled Iran with an iron fist. Some four thousand political activists were arrested as soon as he took power. Opposition political parties were outlawed. Torture was used to keep the people fearful and obedient. And if the one being tortured didn't supply the information wanted, a child of the suspect was brought in front of the father so that the father could witness his offspring being tortured.

One short year after Carter had offered his toast, the shah was overthrown by followers of Ayatollah Khomeini. Carter offered the shah access to a private estate in California, but Reza Pahlavi declined the offer, preferring Morocco as a good place to devise a plan to get his throne back. With Khomeini, a religious zealot, now in charge of a country with a hell of a lot of oil, Carter suddenly realized that his chumminess with the shah might not have been

a good idea. American diplomats in Tehran tried to stabilize relations with the new regime, but hatred for the shah, and the United States that had put him in power, was too white-hot for a reconciliation. On the advice of our ambassador in Iran, Carter withdrew his offer of asylum. But after hearing that the shah had cancer, and being pressured by Republicans like Kissinger and David Rockefeller (chairman of Chase Manhattan, which was deeply involved in oil finance), Carter wavered, then finally authorized the shah to enter the United States.

In spite of being warned by the Iranian prime minister that he could no longer guarantee the safety of the U.S. embassy in Tehran, Carter did absolutely nothing to beef up security at the building or to evacuate all personnel before the shah showed up on American soil. Carter also declined the suggestion from Tehran that he allow Iranian physicians to examine the shah, so as to remove the widespread suspicion that Pahlavi's arrival in New York was the first step in returning him to power. After the shah landed in the United States, a mob attacked our embassy in Tehran and seized sixty-six Americans as well as top-secret intelligence information and technology. Fifty-two officials were taken hostage and held for 444 days, a crisis that strained American-Iranian relations from that moment to the present day.

After promising that I'd deal swiftly with the ineptitude of Ford and Carter, I see I've already spent two pages on just one of Jimmy Carter's screw-ups. There were others. However, he did fulfill his campaign promise to give unconditional amnesty to Vietnam War draft evaders and he did put solar panels on the White House roof to show the American people that we didn't have to depend on those ill-tempered people in the Middle East for our oil and that alternative energy would perhaps help the planet stay green.

It goes without saying that after the Iranian botch, our first born-again president lost the election when he ran for a second term. And to add to the pain of losing, he lost to Ronald Reagan, a man who *never* went to church. Ron's first act after moving into the White House was to remove the solar panels that Jimmy had put in.

6

Autumn in New York

In the fall of 1982 Nancy and I moved back to New York City. We did so because our youngest daughter, Katherine, was ready for high school and (according to Nancy) there wasn't a good one anywhere near Carmel. When Jenny, her older sister, was ready for high school she chose to go to boarding school rather than have us all move back to Manhattan. She had once had an unnerving experience in Central Park with an older man who tried to pick her up, and it soured her on the city. Katherine, on the other hand, loved New York. We took her to look at several private schools, in case she didn't pass the highly competitive entrance exam for Stuyvesant High School. When we were informed that Katherine had indeed been accepted, Nancy and I were much relieved, but I think Katherine had her heart set on one of the private schools. Though we were spared that expense, finding a place we could afford wasn't going to be easy, since we planned to keep the country house that we had grown to love. Nancy and I started looking for a place in what at the time was one of the most run-down parts of Manhattan, the lower West Side below Canal Street. Some brave souls were beginning to turn the

area's abandoned factories and warehouses into living quarters in defiance of city ordinances.

On Franklin Street we found an 1,800-square-foot loft in a seven-story building that was once a fur warehouse. It was empty space, with no walls. The only closed-off area was a grungy bathroom, but even that had walls that stopped two feet short of the ceiling. If we could come up with just a bit of cash toward the $147,000 asking price, the owner would give us five years to pay off the rest. The monthly maintenance wasn't much, but we'd be living there illegally because the building had a freight elevator that required an operator we didn't have. Nancy's father came through with another loan, and so did my agent, and we bought the loft.

The first thing we had to do in this bare open space was to build a bedroom for Katherine and Jenny. Nancy bought a Japanese folding screen that we put at the foot of our bed to give us the illusion of privacy. If you didn't have big bucks to fix up a loft, living without rooms presented problems. Nancy and I had to get used to making love in the afternoon while Katherine was at school, or very quietly in the evening. But I was happy being back in the city where I had old friends, and Nancy liked the idea of being a pioneer in this forgotten section of Manhattan. The only market was many blocks away and the only restaurant nothing to brag about. Because this neighborhood was in the southern tip of Manhattan where the boundary streets formed a triangle, people were beginning to call it Tribeca, an acronym for Triangle Below Canal Street.

The city had changed a great deal in the sixteen years since we moved to Putnam County. For me the most unfortunate change was the disappearance of the roomy Checker taxis, which had two additional jump seats so five passengers could ride together. The company that produced Checker Cabs in Kalamazoo, Michigan, stopped making them in 1982. Now there were only two taxi models to choose from: uncomfortable or unbearable. To protest this diminished comfort in transportation, I went to *New York* magazine and asked to do a short history of cabs in the city to

show what we had lost, and they gave me three pages for it. Years later, Richard Snow, the editor of *American Heritage,* asked me to do a more historical approach to the American taxicab, and gave me six pages and the cover to tell its story.

In contrast to small yellow vehicles that left no room for legs, there were now obscenely long stretch limos dotting the streets of midtown Manhattan. Midtown was where the young son of a Queens real estate developer planned to make his mark. Don-

The first motorized taxis at the turn of the century retained much of the look and feel of horse-drawn hansoms, including the privacy of having the driver outside the cab. A promising beginning.

Some chose to call Prohibition a "noble experiment," but most Americans wished it had been tried out first in some other country. In New York City three of the best hotels went belly-up in the 1920s when their bars were closed. Taxi drivers soon learned to cruise by the speakeasies instead of the hotels.

Sunroofs were standard in Europe by the time DeSoto brought out this version in 1936. New Yorkers called them "sunshine cabs" because the largest fleet of them was operated by Sunshine-Radio Systems, Inc.

In 1922 the Fifth Avenue Association, Inc., as an act of "civic statesmanship," presented seven of these bronze traffic signal towers to the city of New York. They cost $125,000 and helped make that thoroughfare synonymous with elegance and wealth. Taxi drivers were required to wear a cap, jacket, and tie.

During the Red Scare of the 1950s many cab-drivers looked suspiciously at any passengers who sounded too well educated and would engage them in conversation to see if they were Commies or Pinkos, and then give them a piece of their patriotic mind.

And this is where we are now—all dressed up and ready to get scrunched into the backseat of a vehicle that gives all the legroom to the driver. Only old-timers remember the roomy Checker Cabs with two jump seats in the back.

ald Trump, after pressuring the Department of City Planning and the Board of Estimate to rezone the area on Fifth Avenue and Fifty-sixth Street so that he could put up a fifty-eight-story hotel and shopping center, succeeded in opening his Trump Tower in 1983. *The Village Voice,* angry because Bonwit Teller's beautiful Art Deco building had been torn down to make room for it, protested that Trump "turns political connections into private profits at public expense."

That same year a name was finally given to a mysterious, devastating new disease that had been killing people for at least a decade: AIDS (Acquired Immunodeficiency Syndrome). Those stricken (mostly homosexuals) now became the new Untouchables. When the city allowed a second-grader with AIDS to attend regular classes, panicked parents in the borough of Queens organized a boycott that kept eleven thousand students out of classes. In 1986, columnist and homophobe William F. Buckley wrote an op-ed article in the *Times* demanding that those detected with AIDS be tattooed on the upper forearm and on the buttocks to warn the unsuspecting. He went on to spread the falsehood that AIDS was transmitted by "tears, saliva, bodily fluids and mosquito bites."

One thing in the city had not changed. It was still drowning in graffiti. Nancy and I had returned just when it was at its peak. The bizarre bubble-style lettering was now outside and inside every subway car, on buildings, on bridges, and on highways. Some argued that it was a "medium for voices of social change" and "a serious form of political participation." Others called it "street art," but to me using aerosol paint on buildings in your own neighborhood seemed like fouling your own nest. Happily, a few years after we moved into our loft, the Clean Train Movement got the subway cars either cleaned or replaced, and laws were passed to outlaw the selling of spray paint to those under eighteen and to levy a fine of $350 on those who defaced buildings. In time the young nihilists found they could satisfy their need to create by playing video games.

The mayor at the time was Ed Koch, a Democrat who was pop-

ular with Jews, whites, and Republicans. The Republicans even endorsed him when he ran for a third term. After he handily won that election the graft that had been cleverly hidden during his first two terms exploded over the front pages and nightly news broadcasts. The Queens borough president committed suicide after he was exposed for taking kickbacks, Democratic bosses were revealed to have appointed grafters to several city departments, and Koch's cultural affairs commissioner, Bess Myerson, was indicted for fixing a divorce case in favor of her mob-linked lover. These Koch scandals coincided perfectly with President Reagan's Iran-Contra scandal, so I imagined these two smiling wiseacres linking up as a comedy team. I called this strip "Kotch and Botch." It appeared in *The Nation,* and here on the overleaf.

Back in 1974, when Clay Felker bought *The Village Voice,* one of the first innovations he made in the paper's format was to give me a corner of page 3 for whatever I chose to comment on. This meant that from then on I would be appearing two pages away from the cartoonist I most admired, Jules Feiffer, who regularly appeared on page 5. I could barely believe my good luck.

This good luck lasted until Rupert Murdoch stole *New York* magazine and *The Village Voice.* On the pages following "Kotch and Botch" are a few of the things I contributed to the *Voice* before the Darth Vader from Australia descended on us.

Another perk of being back in the city was taking Nancy and Katherine to my mother's apartment every Friday night for her chicken soup and chicken. Mom wasn't the only one happy to have me back in town. My agent, Milton Newborn, was enormously pleased to have me near at hand so he could accept the rush assignments that I couldn't handle when I lived upstate. Those overnight jobs paid a lot more.

Now that I was a New Yorker again, I saw Milton Glaser and Seymour Chwast often. Almost twenty years had passed since I left Push Pin, and many things had changed for the three of us. For one thing, Glaser was rich. When Murdoch took control of *New York* in 1977 and Milton was forced to sell his large bloc of stock, it made him a multimillionaire. With some of that cash he

Kotch and Botch

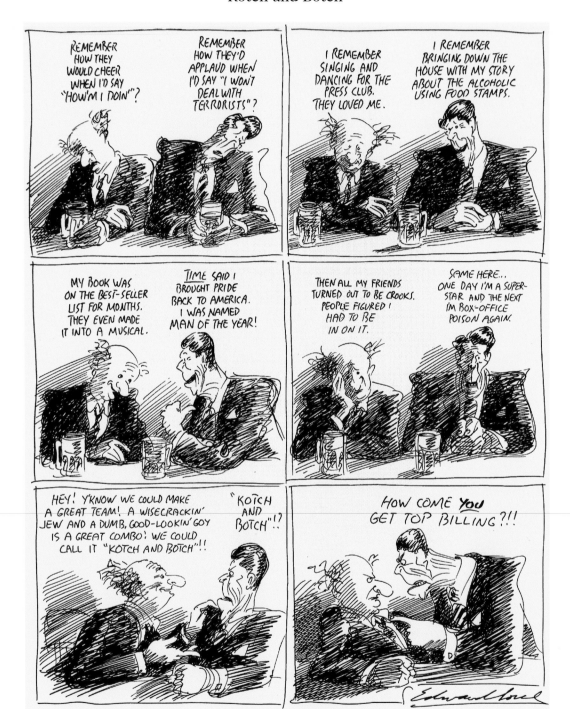

AIDS: AN ANTIDOTE TO FEAR (FAIN, P. 35)

the village **VOICE**

Flour Power

Jan Hoffman Aboard the
Farm Aid Express (P. 29)

VOL. XXX NO. 40 THE WEEKLY NEWSPAPER OF NEW YORK OCTOBER 1, 1985 $1.00

FEAR AND FAVOR AT 'THE NEW YORK TIMES'

Pete Hamill on the Zapping of Sydney Schanberg and Other Atrocities (P. 17)

IN VOICE ARTS: Stephen Harvey on David Hare (P. 49) • Deborah Jowitt on Trisha Brown (P. 89)
Stuart Byron & Anne Thompson on Hollywood's Bad B.O. (P. 68) • Tom Ward on the Kinks (P. 77)

The tank is A. M. Rosenthal, editor of *The New York Times*. The headless man is Sydney Schanberg, a columnist who put his integrity ahead of his job. The *Times* had come out editorially in favor of the city building the West Side Highway, but Mr. Schanberg kept writing that the highway was a boondoggle to profit real estate interests. Abe warned Sid to stop, and when he didn't, Abe fired him. (The *Times* owns a big chunk of Manhattan.)

I imagined that it took a while before Ford grasped the idea that he was going to be president.

When Liz and Dick married for the second time, I couldn't resist turning the event into a movie poster for a screwball comedy.

In my version of a Reagan-Gorbachev summit, it really did end with a "frank exchange of views."

bought back the building that he had sold to Seymour when their partnership ended.

Seymour, the sole proprietor now of Push Pin Studios, moved to smaller quarters and had to adjust to a changed graphic arts field in which photography replaced illustration in many areas, and less and less design work was farmed out to studios. Milton Glaser, Inc., however, had Milton Glaser, the celebrated designer of posters, newspapers, theaters, restaurants, beer labels, magazines, typefaces, and supermarkets. He was thriving. Milt exuded calm confidence, and, when talking to CEOs of large corporations, could throw in just a bit of condescension, so that CEOs were begging him to take on their project.

Aside from not being the inventive, playful designer that Milton was, I am temperamentally unsuited to run a studio. I'm not good at being a boss or working for one. Once, back in 1965, when I was deep in debt and about to marry Nancy, Harold Hayes, the editor of *Esquire,* offered me the job of art director—for reasons I never figured out. I accepted, but after a sleepless night, called him back the next day and said I couldn't do it. I enjoyed making pictures,

not designing layouts. I was also beginning to harbor fantasies of using my drawings for social commentary, the way Jules Feiffer was doing.

Now that Nancy and I were again sharing the same work-space—in the country I had a separate studio—I could see Nancy writing without a stop. It kept me from lying down on the sofa or opening the refrigerator every few minutes. I got a lot of work done. I took on fewer jobs from advertising agencies and sold more of my own ideas to magazines. And to top it all I had Nancy at night to play Scrabble with. While she moved her tiles looking for a seven-letter word, I quietly eyed her, and was reminded that I had married the prettiest girl in town. Actually, she was more beautiful than pretty, but that cliché reflects the enormous plea-sure I felt in having Nancy for my wife.

At this point I'd better tell you what my children were doing in 1982 or you'll think I'm avoiding that topic because they were on drugs or had joined a religious cult—none of that. Katherine was enjoying her freshman year at Stuyvesant, and I enjoyed being asked to give my opinion on whatever color scheme she had cho-sen to wear to school. Jenny was a sophomore at George School, a Quaker prep in Pennsylvania, where she proved to be excep-tionally good at French. Leo was a sophomore at the University of Wisconsin, working summers at Camera Mart in preparation for his career as a photographer. And Madeline, who loved draw-ing, had just graduated from the Rhode Island School of Design. She was working as a cook for the volunteers at Covenant House, a Catholic shelter for runaway children, while at the same time illustrating articles for *The New York Times.*

So, you see, my children were doing just fine that year and so was Nancy. No longer obliged to chauffeur our daughters to ballet lessons, horseback lessons, and school, she thought up an idea for a book, got an agent, and then a contract from Oxford University Press. The book was called *Ever Since Eve: Personal Reflections on Childbirth,* and it contained the stories and reac-tions of a wide array of mothers—rich and poor, famous and not-so-famous. Some stories were told in the women's own words,

some by Nancy. The variety of experiences from historic figures, contemporary celebrities, and people from other cultures made for a most entertaining book.

I'm now going to tell you about a phone call that changed my life—changed both our lives—in the most wonderful way. Actually it happened a year or two earlier, while we were still upstate, but I was so eager to get to our exciting New York City life that I passed right over it. The phone call was from Walter Bernard. You remember Walter—the art director of *New York* magazine, and later of *Time.* He had just been hired by William Whitworth, the new editor of *The Atlantic Monthly,* to redesign that magazine. Walter was calling to ask if I had any ideas for a full-page regular feature. An idea? Of course—in fact I had been carrying this idea around in my head for a long time.

In the 1930s, *Vanity Fair* ran a feature called "Impossible Interviews." Each had a single short paragraph of invented dialogue between two incongruous personalities in the news. One pitted Greta Garbo against Calvin Coolidge, another had Joseph Stalin telling John D. Rockefeller about his Five-Year Plan. What made the series immensely popular were the caricatures by Miguel Covarrubias. They were in an Art Deco style that was a perfect complement to the surreal conversations between the two protagonists. Why not, I thought, do a series of *actual* encounters between *real* people, and why not make it their *first* encounter, which held out more promise for something amusing or significant to happen?

I explained the concept to Nancy, and she said, "What a wonderful idea. I'd like to write it." I had planned to write it myself, but after she claimed it I realized that her graceful writing with its quiet wit was far better suited to *The Atlantic Monthly* than anything I could do. We both agreed that the feature should be called "First Encounters," and we decided to start off with George Sand and Frédéric Chopin. I did a sketch of how it might look, and William Whitworth bought it.

Drawing those comic encounters for the next fourteen years made me the artist I always hoped I would become. With each new

In 1836 Franz Liszt invited Chopin to his apartment at the Hôtel de France for a small soirée. There Chopin was introduced to the celebrated novelist George Sand, who smoked cigars (in spite of knowing Chopin had TB) and wore trousers (despite being quite short and having a rather large derrière). Nevertheless a romance ensued.

illustration I had the opportunity to experiment with different mediums: pen, ink, and watercolor one month, pastel the next, and then pencil and watercolor for a third. Cullen Murphy, the managing editor whom Nancy and I dealt with, never questioned our choice of subjects and was wonderfully supportive of our work. He told us our feature was enormously popular with the magazine's readers. Here's our first "First Encounter," Chopin meets George Sand, followed by my personal favorite, Degas meeting Mary Cassatt. Of all the drawings that I've sold in gallery exhibits, I miss this one the most.

There was another advantage to doing this feature for *The Atlantic:* it only appeared every other month. That gave us time to pursue other projects. Nancy helped out the Religious Soci-

ety of Friends by writing a history of Quakers in New York State. Later she began work on a book about women war correspondents in World War II. She called it *The Women Who Wrote the War;* published in 1999, it became the definitive book on the subject, and later enjoyed a second and then a third printing.

I, too, was writing books in the 1990s. Two of them were children's books.

Mary Cassatt traveled to Paris to study art and, after continuing her studies in Italy, had no intention of returning to America. By 1877 Cassatt's work had become more and more Impressionist, and Edgar Degas felt an instant affinity to her work. He paid a call at her studio on the edge of Montmartre, and before he left invited her to exhibit before the Independents. Thus began their forty-year friendship.

The first was for Warner Books, which was starting to publish for children, and offered me a contract to do anything I pleased. Because I loved Art Deco I dreamed up a story that takes place in the 1930s. It's about Max, a French zillionaire, and his little daughter, Claire, who take a trip to New York on his new luxury liner. It was called *The Zillionaire's Daughter.*

The ZILLIONAIRE'S DAUGHTER

WRITTEN & ILLUSTRATED BY EDWARD SOREL

A French zillionaire, Max, takes his daughter, Claire, on his luxury liner to New York so that they can see the 1939 World's Fair together. At dinner they meet Countess Von Zeller, a fortune-teller who reads Claire's palm and sees that she is going to marry a saxophone player.

While taking a stroll both
 starboard and port,
They happened to pass a
 shuffleboard court.
Claire won seven games before
 Max said, "Now listen
I just can't go on dear, I'm not
 in condition."

They lindy-ed and boogie-ed the
 crowd begged for more,
But Charlie had other surprises
 in store.
He jumped on the bandstand and
 borrowed a sax,
And everyone cheered (except,
 of course, Max)—

The Saturday Kid is a surprisingly autobiographical picture book. Like its hero I always went to the movies on Saturday afternoon, and did play the violin when I was a boy. But I made one change. The boy didn't have a father.

In this scene my mother and I are walking up the staircase at the Loew's Paradise, where I bump into the class bully and his family. We will all be shocked when I suddenly appear in the newsreel playing my violin for Mayor La Guardia.

Taking the Third Avenue Elevated was always a treat for me, until they tore it down in 1955. In this scene I'm taking the El to see my violin teacher, but imagining that I'm flying in a World War I Jenny biplane.

My nemesis in the story is a boy named Morty. In this scene he starts shooting at the gangsters on screen with his loud toy gun. When I wrest it away from him, the usher thinks that I'm the culprit, and I'm ejected from the theater.

The Saturday Kid was another book for children that takes place in the 1930s, but this one was not about the very rich, it was about a poor family in the Bronx, and the young boy in the story was very much like me. Like me he played the violin, and like me he spent each Saturday afternoon going to the neighborhood movie theater where they showed cartoons, newsreels, a Dick Tracy serial, a Laurel and Hardy short, and two main features.

One night in 1993, I multiplied the number of "encounters" Nancy and I produced every year (6) by the number of years we had been doing them (14), and it came to 84. Double the 84, because each entry would require two pages for picture and text, and we had enough for a book. We gave a collection of our *Atlantic* pages to our literary agent, Irene Skolnick, and asked her to find us a publisher. My first choice was Alfred A. Knopf, because they not only produced books with great attention to paper stock and typography, they seemed to be the only publisher that knew how to bind a book so that it would lie flat when opened.

Irene sent our tear sheets from the magazine to the head man at Knopf, Sonny Mehta. He liked it and asked one of Knopf's editors, Ann Close, if she would take it on. Nancy was ecstatic, especially when she learned that Ann was also the editor of Alice Munro, her favorite author. I, too, rejoiced, but then began to worry about how the book would be designed. Knopf had very good book designers, but my favorite designer was Marcus Ratliff. I asked Ann if he could design *First Encounters*. No, that wasn't possible. "But I'll pay for it myself," I pleaded. That did the trick. Ratliff did the superb design job I knew he would, and Knopf's reproductions of my drawings were beyond praise. *First Encounters* came out in November 1994; it quickly sold out, and because it was printed in Italy, there wasn't time to get a second printing into bookstores until after the holiday. But Nancy and I consoled ourselves with the fact that this was the one year we didn't have to worry about what to give friends and relatives for Christmas.

Three years later, in 1997, Ann edited *Unauthorized Portraits,*

a collection of my best caricatures. I have done many books since then, but it remains the most exquisitely produced of all my books. I'm enormously proud of it.

In the late 1980s my agent, Milton Newborn, was still bringing in commercial jobs for me to do, and at that time I couldn't afford to turn any down. I had three children in college *at the same time.* One of the commercial assignments that put my children through school was a print campaign for the Manufacturers Hanover Bank (later gobbled up by JPMorgan Chase). My drawings for them were plastered all over the city in posters and newspapers. To convince myself that I wasn't a complete sellout, I once again offered my services to *The Nation,* a left-wing magazine. The editor there was none other than Victor Navasky, who had given me working/sleeping space at *Monocle* when I was stone broke. Now that I was riding high (by my modest standards) I returned the favor by offering to do an illustrated commentary for Victor every week for their piddling $125 a page. He balked at giving me a page every week, but agreed to one every three weeks and promised to give me the same latitude of expression that he gave his columnists.

He kept his word, and once again I enjoyed the freedom I had had at *The Village Voice.* All went well until I took on Frances Lear. Ms. Lear was the divorced, sixty-seven-year-old wife of Norman Lear, the television writer and producer, and she had received a settlement of $112 million from her former husband. She used $25 million of that to start a magazine especially directed at middle-aged women. She named it *Lear's,* and then went on radio and television to promote her first issue, explaining that she had created the magazine to help middle-aged women do the same exciting, creative things that she had done late in life. It struck me that women who did not get $114 million in a divorce settlement were not in a position to follow her example, so I did a strip ridiculing her.

When a certain editor at *The Nation* saw the strip, she regarded it as sexist and determined that it should not run. At the weekly editorial meeting that takes place before an issue goes to press, this editor (who I was later told was trying to get a job at *Lear's*)

made her views known. Victor explained that I had the right of all columnists to state an opinion, whether he or anyone else thought it was right or wrong. During the shouting match that ensued, Victor received a phone call telling him his father was in a hospital emergency room. Running out of the office, he left the managing editor, Richard Lingeman, in charge to adjudicate this conflict.

Richard is a gentle, soft-spoken man, and a rarity among the *Nation*'s staffers. He wasn't an African American, wasn't a Jew, wasn't a Latino, wasn't a woman, wasn't gay, and wasn't even a Catholic. As perhaps the only white Protestant straight male at the table, Richard was eager to make amends for the sins of his tribe. But Victor had made it clear before he was called away that my strip had to run. So the best that these angered feminists could get was a disclaimer to appear in a typographic box on the page preceding my cartoon strip. It said:

ENTER SEXISM, VINDICTIVE
Readers should know that Edward Sorel's cartoon in this issue appears despite the strong protest of thirty-four staff members. We are outraged that sexism is still a respectable prejudice, especially in a left magazine.

I have no idea what the word *vindictive* means in this context, but the mainstream periodicals were amused that a staff mutiny would be openly described in *The Nation,* and *The Washington Post* and other papers called me for comment. I was too stunned by the flap that my strip was causing to say anything memorable. When dozens of letters from angry feminists were printed, I answered only the letter that asked why *The Nation* was giving a page to a hack who does drawings for banks. I replied: "My friends on the left think it's shameful for me to work for banks. My accountant, who knows what this magazine pays, thinks it's shameful for me to work for *The Nation*."

My page in *The Nation* continued another year, after which I only submitted work when asked. What follows are a version of Moses leading the Jews out of Egypt and a few autobiographical cartoons.

This drawing of Moses leading the kvetching Hebrews out of Egypt was originally drawn in pen and ink without color. It appeared in *The Nation*, which paid me their customary $125. I later added watercolor to it and sold it to *Penthouse* for their customary $3,000.

Me and Marlene

YES, I KNEW HER. NO, NOT IN THE BIBLICAL SENSE, BUT FOR A BRIEF TIME — TOO BRIEF — WE WERE VERY CLOSE.

I WAS WORKING AT MUSICRAFT RECORDS AND LATE ONE DAY WAS TOLD TO PICK UP A PACKAGE FROM A MRS. SIEBER AND BRING IT BACK IN THE MORNING. THEN THEY TOLD ME WHO "MRS. SIEBER" WAS.

THE DOORMAN LET ME UP, AND WHEN I RANG THE BELL <u>SHE HERSELF</u> CAME TO THE DOOR. SHE WAS SHORTER THAN I EXPECTED AND I COULD SEE SHE USED LOTS OF MAKE UP. AS I SAID, WE WERE VERY CLOSE.

I COULDN'T RESIST OPENING THE PACKAGE. IT CONTAINED A RECORD SHE MADE IN GERMANY BEFORE COMING TO AMERICA. BECAUSE I UNDERSTOOD YIDDISH I WAS ABLE TO MAKE OUT THE LYRICS. VERY SEXY.

AFTER THAT ENCOUNTER I WENT OUT OF MY WAY TO SEE HER EARLY MOVIES, AND I READ EVERYTHING I COULD ABOUT HER. OF COURSE I NEVER MET HER AGAIN...

... BUT I SOMEHOW FELT HURT WHEN HER OBIT IN THE <u>TIMES</u> FAILED TO MENTION MY NAME.

Redemption

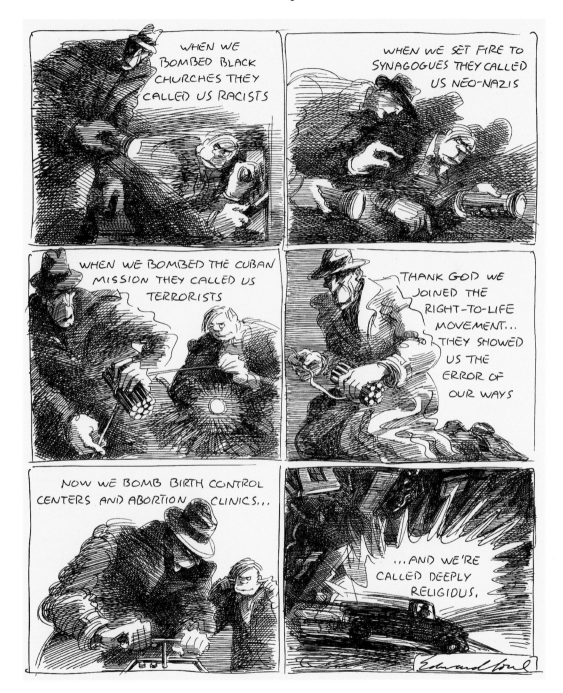

Music Man

JUST BECAUSE I'M IMPATIENT WITH FRIENDS WHO DON'T KNOW HOW TO SAY "GOOD-BYE"...

...AND I'M NO GOOD AT HIDING MY BOREDOM WHEN FRIENDS GO ON AND ON ABOUT THEIR PROBLEMS...

...AND BECAUSE I HATE PHYSICAL DEMONSTRATIONS OF AFFECTION— ESPECIALLY FROM MEN...

...PEOPLE SEE ME AS A COLD FISH...SELF-ABSORBED AND UNFEELING.

YET AT THE MOVIES I CRY AT ANYTHING SENTIMENTAL OR INSPIRATIONAL...

...AND AT MUSICALS I ALWAYS CRY AT THE FINALE WHEN THE LOVERS ARE REUNITED...

...I EVEN CRY AT THE COMMERCIAL WHERE THE MUSIC SWELLS AND THEN THE SON TELEPHONES HIS MOTHER

...IF ONLY REAL LIFE HAD MOOD MUSIC IN THE BACKGROUND TO TELL ME WHAT TO FEEL...

...THEN YOU'D SEE WHAT A WARM, CARING PERSON I REALLY AM.

Dereliction of Duty

WHEN I WAS YOUNG I'D WALK THE CITY STREETS FOR HOURS DREAMING ABOUT WHAT I WOULD DO WITH MY LIFE...

... I LIKED TO IMAGINE MYSELF AS THE REALIST PAINTER THAT RESCUED AMERICA FROM ABSTRACT EXPRESSIONISM...

...OR THE UNION ORGANIZER WHO FINALLY BROUGHT SAFE CONDITIONS TO THE WEST VIRGINIA COAL MINES.

BUT SOMETIMES AFTER SEEING A DOUBLE FEATURE ON 42ND STREET, I'D WONDER IF I COULD BE A SCREENWRITER — IF I COULD BE THE ONE TO RETURN AMERICAN MOVIES TO THEIR FORMER GLORY.

OTHER TIMES I'D IMAGINE MYSELF AS A MERCHANT SEAMAN WHO SECRETLY WRITES POETRY - POEMS THAT DEFINE THE AMERICAN EXPERIENCE

I'D EVEN SEE MYSELF AS A CHARISMATIC POLITICAL LEADER — A SPOKESMAN FOR THE AMERICAN UNDERCLASS.

WHAT I ACTUALLY DID WAS GET MARRIED, HAVE CHILDREN, AND MAKE MONEY ANY WAY I COULD. I DON'T HAVE MANY REGRETS...

...BUT SOMETIMES I FEEL I'VE LET MY COUNTRY DOWN.

7

Friends

One big difference moving back to the city made in our lives was the number of interesting friends we now had. While Nancy and I lived in the country, we saw the same three or four couples month after month. We liked some of them a lot, but their chief virtue was that they all lived within ten miles of our house. Our evenings out consisted of having dinners in one of their houses and then reciprocating with a dinner in ours. In the city, we were making new friends all the time, and our evenings with them were spent at gallery openings, plays, lectures, and a surprising number of "pub" parties, to celebrate the publication of some friend's book. These social engagements took up time, but Nancy and I still met our deadlines and they filled the void we felt when Katherine left us to attend Oberlin College in Ohio.

Many of the friendships we made in those first years on Franklin Street proved lasting. One was Katherine Hourigan. Kathy was the managing editor of Knopf when we met, and she still is at Knopf—but is now a vice president. Besides oiling all the wheels that make Knopf run, Kathy has assisted in the editing of Robert Caro's many volumes on Lyndon Johnson. One of those is dedi-

cated to her. There were just two things I had to be careful about in my long friendship with Kathy. I must never go on and on about what a disastrous president Kennedy was (she still adores him), and I must not say anything negative about any of her friends. Kathy considers all her friends to be without a single flaw. And if, in addition to being her friend, you are also a writer or an artist or even know how to cook, then to Kathy you are a *genius*. Why argue?

After Ann Close edited *First Encounters,* she became one of the friends who came up to our house in the country every Columbus Day weekend. The ritual on those occasions was a walk on the Appalachian Trail—it was only a mile from our home—followed by dinner at our long table that could squeeze in fourteen. Ann was, as the saying goes, an ornament to any dinner table, with the added charm of unconsciously lapsing into a Southern drawl any time she told stories about growing up in Savannah, Georgia.

Another buddy I found after I moved back to the city was Jim McMullan. I had met him briefly years earlier when I visited my ex-partners at Push Pin Studios. He was one of the half-dozen artists on staff there in the 1960s. I tried to get a peek at what he was working on, but saw that my curiosity was unwelcome and so moved along. Some twenty years later, as I was exiting from Track 32 in Grand Central Terminal, I spotted a theater poster for *Six Degrees of Separation.* It was one of a series that Jim had begun producing for Lincoln Center in 1986. This one had a huge image of a man sitting in a chair looking at us. Drawn in crayon, it had a beauty and originality that stopped me dead, and I stood studying it for a while as the crowds brushed past me.

As soon as I got back to my studio I wrote a note to Jim, whom I hadn't seen in years, telling him how much I admired his poster. His reply included an invitation to lunch, and that led to our becoming friends, especially after his wife, Kate McMullan, and Nancy met and hit it off. Jim was born in China, the grandson of Protestant missionaries, and he had lived a privileged life of household servants and rickshaw drives to school. I was born in the Bronx, the son of poor, nonbelieving Jews from Eastern

Europe, but Jim and I bonded because we loved the same art-
ists, and we both struggled hard and long on every drawing. No
computer-generated effects for us.

For the past thirty years Jim and Kate and I have remained
close friends. Kate is a prolific writer of books for children and
young adults, and a warm, witty woman who laughs easily. Jim
and I share our problems and disappointments and rejoice in each
other's successes—no kidding. It's a friendship without schaden-
freude, even though we're both hungry for and grateful for any
scintilla of fame that comes our way.

I met Patrick Oliphant when I had an exhibit at his girlfriend's
gallery in Georgetown. The Susan Conway Gallery was in a hand-
some Federal house once owned by the painter William Glackens.
Oliphant was from Australia, and you didn't need to be Henry
Higgins to figure that out once he started talking. He came to
America in 1964 to be *The Denver Post*'s editorial cartoonist, and
three years later won the Pulitzer Prize for a cartoon he did about
Vietnam. Rather than rejoice, Pat was furious with the Pulitzer
committee for choosing a drawing he regarded as inferior. He was
certain they chose it simply because they approved of its subject
matter. After that he refused to be considered for the award ever
again. (Why he expected Pulitzer judges to know a good drawing
from a bad one, I don't know.)

Whenever Pat and Susan came to New York they would have
dinner with us. In 2004, when Nancy and I moved to Harlem and
had a guest room, they slept over and brightened our breakfast
table. By then Pat and Susan had long been married and were
living in Santa Fe. The computer had made it possible for Pat to
do his cartoons anywhere. In Santa Fe he began doing sculptures
and etchings, and he invited me to visit so we could work together
at an etching workshop not far from his home. After seeing the
wonderful prints he was making, I surprised myself by going. It
was in Santa Fe that I did this aquatint of "The Last Flossing," and
then hand-colored it.

What I always envied about Pat's drawing was his ability to draw
figures in action without needing reference material or a model

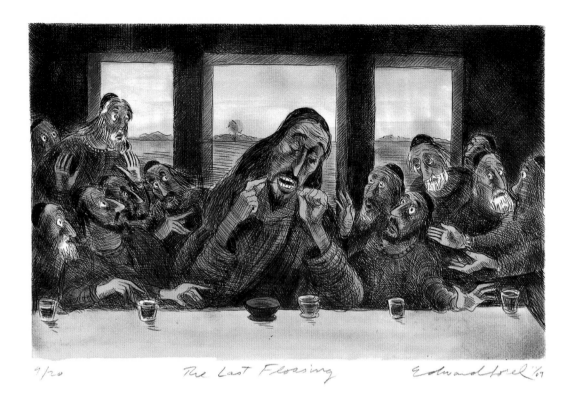

9/20 *The Last Flossing* Edward Sorel '09

to pose for him. He was able to draw anything he could imagine because throughout his life he continued to go to life class. He was surprised to learn that I didn't. "You get into bad habits otherwise, with just cartoons," he said. He may be right, but the kind of poses that artist's models take are seldom useful for the kind of gestures illustrators need. I get those from my large collection of movie books and from photographs that I've cut out of magazines and then filed. These days there's also Google Images. The last time I felt compelled to hire a model was when I illustrated my children's book *The Saturday Kid.* My ten-year-old model posed for all three boys. You can see him posed on the next page.

When it comes to drawings with spontaneity and energy, it's hard to beat Jules Feiffer. I've known Jules for more than sixty years, but we didn't see one another much until the 1970s, when my cartoon feature began appearing only a page apart from his in *The Village Voice,* the paper that had given Jules his start in 1956. It might be more accurate to say that Jules gave *The Village*

Voice its start, since he offered that paper his cartoon strip free of charge, just to get it published, and then the strip became so popular that the *Voice* became known as "the paper that carries Feiffer." Once the strip was syndicated he became the most talked-about satirist in the country.

By the time we became friends, Jules was already the author of the hit play *Little Murders*, the screenwriter of *Carnal Knowledge*, and the creator of *Munro*, the animated short film that won an Academy Award

in 1961. Our friendship was never going to be one of equals as far as celebrity was concerned, but in other ways we were twins. We were both from the Bronx, born only two months apart; both lefties; and we both shared the humiliation of not getting laid until we were twenty-three—but, as I've already explained, that achievement wasn't so easy to come by in the 1950s.

Sometime in the eighties, Jules called to ask if I wanted to join him at the Players Club where the caricaturist Al Hirschfeld was going to be honored. I did. Hirschfeld's skill at caricaturing a face with just line and no shading was a magic trick that somehow always caught the celebrity perfectly. The evening was black tie. José Ferrer, president of the Players Club, Jules, and Bernadette Peters toasted Al, and after dinner Hirschfield and I talked. Al was about ninety at the time—my age now—and with his snow-white beard, potbelly, and tuxedo, he looked like a prosperous Santa Claus whose business was doing well. The next time I saw him was in the apartment of Anna and Philip Hamburger—two more new friends that Nancy and I had fallen in love with. We had been invited there for dinner.

Phil, who had covered FDR's inauguration for *The New Yorker* in 1933, was still writing for the magazine (occasionally) in the early 1990s. Nancy and I were the first to arrive at the Hamburgers' apartment. The other guests would be Al Hirschfeld, whose wife, Dolly Haas, had recently died, and S. I. "Si" Newhouse with his new wife, Victoria. Newhouse, as all of New York knew, was the fabulously wealthy owner of Condé Nast publications. In 1985, he had added *The New Yorker* to its many other magazines. There was nothing surprising about Phil and Al being old friends, but why was multibillionaire Si Newhouse coming to this small apartment on an unfashionable stretch of Lexington Avenue? Because, Phil explained, he had been Si's counselor at summer camp, and they had remained friends for the next sixty years.

Al arrived after we did, was supplied with the bourbon he expected to find in any civilized home, and began to describe his two hours spent standing in line at the Department of Motor Vehicles to renew his driver's license. I, ever alert to the injustices committed under capitalism, expressed my belief that the

big shots of this world didn't have to stand in line to renew their license. At this, Nancy took umbrage at my questioning America's dedication to equality for all and suggested that the rich simply have homes in towns where there are no lines at the courthouse, and they get their licenses there. To decide whose version was true, Al proposed we ask Newhouse when he arrived.

Enter Victoria and Si. She was both beautiful and charming. Si was less so, but easy to amuse. At the dinner table Al elbowed me and whispered, "Ask him." There was no smooth way to lead into the question. "Si, when your driver's license expires, do you have to go to the Department of Motor Vehicles and stand in line like everybody else?" Newhouse smiled at the impudent question, then responded somewhat guiltily, "Well . . . as a matter of fact . . . my lawyer *did* know someone down there." I did not press the point by asking if he ever served on a jury.

A few years later, I read that Al had remarried at ninety-three. The bride was Louise Kerz, a theater historian. She looked lovely in the Sunday *Times,* where the paper devoted a lot of space to their wedding. When I read that Al would be at the Forty-second Street library to be interviewed by Frank Rich, then the drama critic for the *Times,* Nancy and I went to hear them. The place was packed and the audience laughed at Al's amusing stories. At the close, as Nancy and I exited onto Forty-second Street, we saw Al and Louise standing in the cold looking around for a place to eat. I invited them to join us at a club I had recently joined. Let's call it the Millennium Club, since the actual club is uptight about members mentioning its name in print. It was only a block away. They accepted. Louise at sixty was a knockout, and vivacious to boot, while Al, a bit tired after hours onstage, was continually interrupted at dinner by old friends just wanting to say hello. Al knew way more people in my club than I did.

After that night, Nancy and I became regulars at Louise and Al's dinner parties. These gatherings took place in a lovely limestone townhouse on Ninety-fifth Street, east of Park Avenue. It's easy to spot. It's the one with a brass plaque near the door announcing that Al Hirschfeld once lived there. Al bought it in the depths of the Depression for seventeen thousand dollars. In the 1930s, Al

was doing all right, not only drawing caricatures for the *Times* and *Herald Tribune,* but for MGM posters as well, including those memorable ones of the Marx Brothers. Those dinners that Nancy and I attended were always jolly affairs despite their elegance. The enormous oval table was usually set for twelve or fourteen, and the guests were, for the most part, from Broadway and Hollywood.

Walter Bernard and I have been friends since 1966, when he was part of the *Esquire* art department and gave me an assignment. Two years later I found myself working for him at *New York* magazine, where he was the art director. (Milton preferred listing himself as the "design director" on the masthead, but there was never a question as to who was the final arbiter of what went on the page.) It was at *New York* that I began doing my parodies and satires, and where I first enjoyed the pride of having a byline and seeing my name in bold type on the cover of a magazine. Later still, when Walter redesigned *Time* magazine and later became art director there, I did my best *Time* covers for him. On one occasion, when my sketch of Jimmy Carter in a lion's den with leaders of the world was approved for a cover, Walter told me the magazine needed it by five p.m. the next day. It was a very complex image, containing five different caricatures, and I told Walter I wasn't sure I could do it that fast. Putting a consoling arm on my shoulder, Walter smiled and whispered, "We always have an alternate cover at the ready in case an artist fucks up." With that reassurance I worked through the night and delivered it in time. You can see it on the next page.

Walter, who is also a terrific painter in both oils and watercolor, joined the Wednesday night painting group organized by David Levine and Aaron Shikler. David by that time had been caricaturing authors in *The New York Review of Books* since its second issue, but he shared in none of the millions that the founders made when they sold the paper. Miffed, David proposed to Walter that I join them to create a monthly newspaper about movies similar to the *NYRB.* I loved the idea of caricaturing actors, directors, and the movies themselves. To get *The New York Review of*

The lions clockwise from Jimmy Carter: Leonid Brezhnez, Menachem Begin, Anwar Sadat, Mao Tse-tung, and Helmut Schmidt

Film started, Walter enlisted our friends Byron Dobell and Shelley Zalaznick, former editors at *New York,* to help with the editorial content for a prototype issue.

David drew the cover and I did the center spread, depicting Jack Warner dividing the loot he and his actors made from their gangster melodramas. The figures included George Raft, Eduardo Cianelli, Humphrey Bogart, Jack Warner, Barton MacLane, John Garfield, Edward G. Robinson, and James Cagney. It was to illustrate an article that did not yet exist called "The Warner Mob."

We hired someone who had experience getting start-up money for magazines and who said that six hundred thousand would be enough to get the *NYRF* off the ground. But in 1980, when Walter printed the dummy issue, the inflation rate was so high that prospective investors could get 15 percent interest by investing in an annuity, so they saw no need to risk their capital on something as iffy as our publication. It was just as well that we never got the money. Ten years later, people began buying personal computers, and soon after that magazines and newspapers began going belly-up. But it was fun creating our *Review of Film,* even if it never saw the light of day.

I sent a copy of the *Review* to Richard Snow, editor of *American Heritage,* who just happened to be planning an issue on California. He used my drawing of the Warner Mob for an article about Warner Bros. Studio, and assigned Neil Hickey and me to write it.

A dozen years later *American Heritage,* like so many other magazines, also bit the dust. Richard now had the time to have lunch with me more often and to write several admired histories and biographies. My favorite of those is *Iron Dawn,* about the *Monitor* and the *Merrimack*—far more exciting than it seemed to me in high school.

· · ·

OVERLEAF When I started drawing the Warner Mob, I was familiar with the lives of most of the characters I was going to draw. From what I had read about Jack Warner, I decided he was the sleaziest, cruelest, and most untrustworthy man in Hollywood. I did my best to convey my low opinion of him in my portrait. When you turn the page you can judge if I succeeded.

I met Dan Okrent and his wife, Becky, in the early 1990s, when he was in his late forties and I was in my late sixties. He was the editor of *Life* at the time, but better known for being the inventor of Rotisserie League Baseball, the precursor of all fantasy-sports games. That game was just the kind of inventive foolishness he'd dream up. Dan has a love of nonsense and a genius for creating merriment that I envy. To give you an example of Dan's passion for all things ridiculous, as well as his weakness for the romantic songs of the 1930s, I'll tell you about the party he choreographed for himself when he turned fifty.

It took place at the fabled Rainbow Room, on the sixty-fifth floor of 30 Rockefeller Plaza. Nancy arrived in a long gown, I in a tux, per instructions on our invitations. We were surprised to find that we were not sitting at the same table, and puzzled by the Scrabble-sized tiles that lay next to our table assignments. The number four was stamped on ours, but the other tiles had other numbers, many in double digits. Whatever these numbers meant, we dutifully pinned our "4" to our clothing, and then walked into the glorious ballroom to find our respective tables.

Nancy was seated next to the writer Nelson Aldrich. I was next to Dick Pollak, at the time the managing editor of *The Nation*. He explained that the seating had been arranged according to the initial letter of one's first name, and the number four on my button indicated the number of years I had known Dan. I was between Dick and a woman named Elinor, Nancy between Nelson and Nick, and Dan's mother, Gizella, was seated among a bunch of Glorias, Garys, and Gabriels whom she had never met before. The number on her button, of course, was fifty.

Dan acted as his own master of ceremonies and introduced Mr. Spoons, a performer on many of the city's subway stations, who then hammered out "Tea for Two" on the dozens of spoons that lined his overcoat, accompanied by a nine-piece jazz band. He was followed by Andrea Marcovicci, whom Dan had flown in from the West Coast so she could sing his favorite song, Jerome Kern's "The Folks Who Live on the Hill." After dinner, the band played foxtrots and Lindy Hops, and Nancy and I joined the others on the dance floor. It remains the best party I have ever been to.

After Nancy and I visited Dan and Becky in Cape Cod, where they took us sailing, I drew this caricature of them—with a bit of help from Edouard Manet. Becky, who is actually beautiful, never asked for any modifications in my unflattering portrait.

I can't leave Dan without remarking on the dichotomy between the mischievous merrymaker and the serious, socially conscious writer of spellbinding histories. His last book, *The Guarded Gate*, exposed those eugenicists who used fake science to feed the anti-immigrant fever that ran high in the early twentieth century.

Graydon Carter, the longtime editor of *Vanity Fair,* has been a generous and good friend for years. We met over the telephone in 1990 when he was editor, and one of the founders, of four-year-old *Spy* magazine. It was brash, satiric, and delightfully irreverent. I got a kick out of reading it, but not out of looking at it. I'm too old-school to enjoy flashy editorial design that makes reading dif-

ficult. Graydon's call was to ask if I'd be interested in illustrating an article for a forthcoming issue. I asked him what his page rate was. It was low. I declined.

The following week, he called again, this time to invite me to lunch. I accepted. I assumed it was either to ask how much I wanted, or to con me into working for the greater glory of satire. In any case I didn't want to miss a possible opportunity of getting one of my anti-clerical drawings into print. There were only two magazines that allowed me to make fun of organized religion: *The Nation* and *Penthouse,* that raunchier version of *Playboy.* Maybe *Spy* would be a third. I prepared for my lunch with Graydon by sketching a parody of Gustave Doré's engraving of Moses atop a mountain, holding aloft the stone tablets containing the Ten Commandments. In my version, Moses and all the idolaters of the golden calf were dogs, and what was written on the tablets was HEEL, STAY, COME, SIT, FETCH, PAW, LIE, JUMP, SIC 'EM, BEG.

I can't remember a damn thing about what was said over lunch, but I have the feeling that I disappointed him. I was on the wrong side of middle age, and there was nothing mischievous or "hip" about me. I think he was hoping for a young, edgy nonconformist. Over coffee I handed him my sketch of "The Dogs' Ten Commandments." He looked at it, gave me a weak smile, handed it back, and said, "It's got Lee Lorenz's fingerprints on it." Lorenz was the art editor of *The New Yorker,* and by saying that, Graydon was accusing me of handing him something *The New Yorker* had turned down. I explained that, in fact, I had never appeared in that magazine, but he turned it down anyway. Here's the kicker: Lee Lorenz and I were friends, and we had a lunch date the following day. I handed Lee my Ten Commandments sketch. Days later I learned that it had been accepted, and a week after that I handed in my finished drawing. When it appeared in the magazine three weeks later, I was pleasantly surprised to see that a whole page had been devoted to it. I had made it into *The New Yorker* in a big way, and at the precocious age of only sixty-one.

Days later I received a note in my mailbox from Graydon: "If I knew *The New Yorker* was going to buy it, I'd have bought it

myself." I didn't quite know what that meant, but I chose to take it as congratulations. Eight years after that lunch with Graydon, in 1998, when the economy fell into a slump, *Spy* magazine folded, but Graydon had already left in 1992 to become editor of *Vanity Fair,* replacing Tina Brown when she took over *The New Yorker.* Graydon was now the editor of a magazine that was bursting with lush ads for cars, perfumes, and evening gowns, and able to offer me the highest page rate in town. Furthermore, I took pride in

seeing my name listed as a regular contributor on its credits page. In time I would do some of my best work for *Vanity Fair,* which was printed on that glossy stock that made all my pictures look gorgeous. His brilliant editorship led him to other enterprises, including movie producer, that would catapult him to fame that he had never dreamt of. Or maybe had.

When Graydon resigned as editor of *Vanity Fair* in 2017, it was so unusual for an editor to resign when his magazine was still on top and thriving that it made the front page of the *Times.* The news article made it clear that he was keeping his future plans close to his waistcoat, but we knew he was not the kind of man to devote himself to golf or flying off to Wimbledon. After he returned from a six-month vacation in France, he threw an enormous dinner party at Balthazar, one of the best French restaurants in SoHo, to say a final farewell to the troops who had served him bravely for twenty-five years.

It was made up of members of his *Vanity Fair* staff, a few Condé Nast executives, and a small battalion of freelance writers and photographers. I think I was the only artist there. At one of the tables I was delighted to spot Cullen Murphy, the managing editor of *The Atlantic* in the years when Nancy and I did "First Encounters." Graydon had made him his editor at large, and that necessitated his coming to New York every week, so we often had dinner together. Cullen is a friend who has been enormously generous with his time whenever I needed help with my *Vanity Fair* pieces, or needed advice with this book. He is also the author of a remarkable book, *God's Jury: The Inquisition and the Making of the Modern World,* published in 2012. I was pleased to be asked to do the jacket.

The first thing to be said about Graydon's dinner is to note the warm affection that everyone felt for their editor—their boss. It was something I hadn't experienced before. (How could I? I haven't had a boss for seventy years.) I happened by chance to be present for Tina Brown's farewell address to her staff at *The New Yorker.* Yes, there were a few people drying their eyes. And I know many felt real affection for Clay Felker. But "love" is the only word

to describe the vibe at Balthazar that night. After the dinner, the encomiums began. Some were prepared, most were spontaneous, and all seemed genuine. It was getting late, and I prepared to steal away. As I reached the door an attractive woman stood up to have her say. She looked familiar. When she expressed her gratitude to Graydon—trying very hard not to cry—I suddenly recognized her as Monica Lewinsky. Graydon had given her pages in *Vanity Fair* to tell her side of the event that led to an impeachment.

Although we ran into each other often, Christopher Hitchens and I were never close friends. I was too much in awe of that brilliant, erudite polymath to be comfortable talking to him for more than three minutes. Nevertheless, since he once expressed to me his pleasure at one of my anti-clerical cartoons, and since I drew this perfectly perfect caricature of him for *Vanity Fair,* and since

I haven't found another spot in my book to place it, I'm putting it here.

I'll close with a tip of my cap to Anthea and Richard Lingeman, friends for over half a century; to Lisa and Neil Hickey, dear neighbors in Carmel; to Sylvia Calabrese, Ellen McCourt, and Candy Kugel, my jolly Scrabble mates; and to Vera Zalaznick, Alex Birnbaum, and Tia Speros-Harker for always lifting my spirits.

8

Sitting on Top of the World

Now where were we? Yes, I remember. I had sold my first cartoon to *The New Yorker,* and was determined to get a lot more of my work into the magazine. Lee Lorenz explained the procedure that all gag cartoonists followed. We were expected to come up with sketches for at least seven ideas. All were to be done on a sheet of typewriter paper, and be delivered by Tuesday morning. From the load of sketches that Lee received each week, he would pull out those he thought suitable, and present them to the editor, who was the final arbiter of what went in, and what didn't. In 1990, the editor was Robert Gottlieb.

Bob Gottlieb had had that job for three years when I arrived on the scene. He had been put in charge of *The New Yorker* by the same Si Newhouse we met a few pages ago in Phil Hamburger's apartment. Newhouse, concerned because that magazine's previous editor, William Shawn, refused to make any changes in the then-moribund magazine or to name a successor, brought in Gottlieb, the celebrated publisher and editor in chief at Alfred A. Knopf, which Newhouse also owned at the time. He was sure that Bob—whom he described as having "charisma"—would know

how to make *The New Yorker* talked-about again. When Bob had served as editor for five years, Newhouse decided that his charisma wasn't doing the trick, so he gave Bob the most glorious golden parachute money could buy and pushed him out of his nineteenth-floor office. It is rumored to be the most comfortable landing any editor has ever had. For some people, getting fired by Newhouse was even better than getting hired.

Gottlieb was replaced by Tina Brown, who had saved *Vanity Fair* from going under and made it the most talked-about magazine in town. She was certain she could work the same magic at *The New Yorker* by giving it "buzz."

Months before Tina took over, she told Lee Lorenz to call all the illustrators and cartoonists he thought were any good, and ask them to submit ideas for future covers. They would be paid for their sketches even if no assignment resulted. This broke a long-standing tradition at the magazine, in which management expected all artists to submit their work "on spec"—in other words, no money if they don't use it. When I visited Lee's office to submit my three sketches, Lee was barely visible under the stacks and stacks of submissions.

They were piled on the floor, on desks, and on the one extra chair meant for visitors. I was told that Tina was planning to go to a dude ranch in Wyoming—or someplace out West—and take all these sketches with her. This short vacation was to invigorate her for the herculean task ahead.

When she returned, with the mountain of sketches, she informed Lee that she had chosen three. Two of them were mine. I was told to do a finish on one of them right away for Tina's first cover as editor.

When I submitted the sketch for that cover, I had nothing in mind other than to produce a funny sight gag, but when the finished drawing hit the newsstand, some people saw a deeper meaning. Was the insolent punk a stand-in for Tina Brown, who had no respect for tradition? Or, unkindly, did it mean that the vulgarians had taken over *The New Yorker*? No matter, I was very pleased with myself. You can tell that by the absurdly large signature in the bottom right.

When I drew my first *New Yorker* cover, I was careful to keep the top of it
light enough so that the logo in black would show up easily over the yellow
leaves. When that issue hit the newsstands, I was surprised to see that it had a
yellow logo that required putting a shadow behind it to be seen on the yellow
background.

At some point after she took over, Tina invited all the cartoon-
ists to meet with her in a conference room, so she could tell all of
us how valuable we were to the magazine. Since *The New Yorker*
was pretty much the only magazine left that was still publishing
cartoons, there was no need to tell her how valuable the maga-
zine was to us. Weeks later, I received a call inviting me to have
lunch with Tina at the Royalton. I was aware of the honor being
bestowed on me, but at the same time terrified at having a one-on-
one lunch with this glamorous dynamo from London.

I needn't have worried. The lunch went off just fine. In spite
of her rapid-fire, breathless speech, I found it easy to talk to her
after she brought up *Simplicissimus,* the weekly German satiri-
cal magazine of the early twentieth century. Tina said she wanted
to bring that same spirit of sass and irreverence to *her* weekly.
Since I myself was a collector of old issues of *Simplicissimus* and
its French equivalent, *L'Assiette au Beurre,* I began to harbor the

hope that Tina Brown might surprise us all by bringing about a renaissance for a *New Yorker* that had lost its daring.

In the year that followed that lunch, more of my drawings appeared on covers of *The New Yorker,* and Tina Brown became a familiar face on late-night talk shows. One evening when I was watching television with my (now widowed) mother in her apartment, we found ourselves watching Charlie Rose interviewing Tina Brown. By chance, we had tuned in at exactly the moment when she was talking about the cartoonists at her magazine. That topic brought her to the covers, and since she had brought in several new artists to do covers, she mentioned us by name. When she came to mine she added, "But, of course, he's a genius." I could hear my mother gasp for breath, and then say, "Eddie! Did you hear that? She called you a genius!"

I will forever be grateful to Tina Brown for that moment. It was my mother's reward for sending me to Saturday art class at Pratt Institute when I was nine years old and to Mr. Peck's Saturday class at the Little Red School House when I was ten.

That wasn't all Tina did for me during her reign. She also included me in many of the parties she threw. There was the banquet at the Metropolitan Club—the only truly baroque palace in America—to support the American Academy in Rome. *The New Yorker* paid for several tables, and Nancy and I found ourselves seated with the magazine's popular essayist Calvin Trillin, whom Nancy had gone to high school with in Kansas City. There was also the red-carpet party at the New York Public Library to celebrate Richard Avedon, at which Mike Nichols was the witty master of ceremonies and Adam Gopnik tried, once again, to be amusing. Those, and the many other parties we were invited to, were designed to create "buzz." They gave Nancy something to write home about.

I mention all this to show how much I owed Tina, and to contrast it with the incredibly stupid, ungracious thing I said to her after her many kindnesses to me. This is what happened. On Sunday, August 31, 1997, Princess Diana died in a car crash in Paris. Not being particularly interested in the Royal Family, I was not much affected by the news. When the phone woke me up at

eight a.m. on the Tuesday after Labor Day, I was groggy as I picked up the receiver and heard a breathless voice say, "Ed, this is Tina. Listen, darling, you've got to help me. We're doing a special issue of *The New Yorker* that will come out on Thursday, in time for us to ship it to London for Diana's funeral on Friday, *and you've simply got to do the cover!*"

On those rare occasions when Tina Brown called me on the telephone, it was always her assistant who made the call to inform me that she had Tina on the line. That gave me a few seconds to tell myself to choose my words carefully and act like a grown-up. This time I was denied those precious seconds to compose myself. Instead, I responded to Tina's plea for help with, "Please, Tina, don't ask me to do a cover about Princess Di. To me she was just an empty-headed twit." Tina's response was a very angry "Thanks a lot" and a slam. Believe me, you can *hear* when somebody slams down a phone.

I immediately realized what a colossal blunder I had just made. I was later to learn that Princess Di was Tina's *close personal friend,* but even without that knowledge I realized I had offended my benefactress. I feared I had just put an end to my career with *The New Yorker*—which by the end of the 1990s was just about the only game in town for satiric drawings. I didn't have time to kill myself, because I had to get ready for the lunch date I had made with Françoise Mouly, the new art director for covers at the magazine. (Tina had fired Lee Lorenz as art editor, and then hired four art directors to handle the different art departments that were now needed: Robert Mankoff to decide which cartoons to submit to the editor, Christine Curry to hand out the illustration assignments, another art director whose name I've forgotten to lay out the magazine, and Françoise to give Tina the kind of covers that people would talk about.)

When I picked up Françoise at her office she gave me a knowing "I know what you said" smile. Over lunch she told me that Tina's office was full of those editors who were (somehow) going to put together an entire issue on Princess Di in three days. All of them had been alerted to come in at seven on Tuesday morning, because the magazine had been closed for Labor Day. They

were all there when Tina said "Thanks a lot" into the phone and slammed it down. Then, according to Françoise, Tina announced to everyone there, "He says Princess Di is an empty-headed twit, *and he's glad that she's dead.*"

I did not say that. But of course the people there thought I did, and some of them no doubt went back to their offices and phoned a few friends to tell them about the outrageous thing Ed Sorel had said. I make that assumption because when I got back to my studio there were no less than three messages on my answering machine, all of them from friends, all asking essentially the same question: "Is it true that you said what everyone says you said?" On that day I guess I became a hero to certain anti-establishment types.

Epilogue: Tina got the special issue done in time to get it shipped to London for the funeral, where Tina herself was present, acting as an on-the-spot commentator for CBS television. I can't think of the name of the artist who drew the cover for that issue of *The New Yorker,* but I remember it showed a Beefeater guard with a tear running down his cheek. I am happy to report that Tina pretended to forget that that phone call ever happened and continued to buy almost all the cover ideas I sent her. About a year after Diana's death, Tina's book *The Diana Chronicles,* a sympathetic portrait of the princess, was published and became a best-seller. When I found out later that Diana had been part of a campaign to remove the land mines left from previous wars that are still killing children, I realized that there was more to her than I thought, and cursed, yet again, my intemperate mouth.

One last word on that special issue: I assumed that, like me, readers of *The New Yorker* would be put off by Tina's devoting a whole issue to the death of Diana, but in fact, it sold over 140,000 copies on the newsstand, more than any issue in thirty years. That same year, 1997, the ad pages of her *New Yorker* were up 4.9 percent, giving it the most ad revenue in the history of the magazine. She had given Newhouse what he wanted. Nevertheless, the magazine was still losing millions, and when Hollywood producer Harvey Weinstein encouraged Tina to start her own magazine, she just couldn't resist. Her next magazine, *Talk,* was a

monthly. That should have been a bit easier than pulling together a weekly, but that ballyhooed magazine did not turn out as well as she had hoped. *Talk* went silent after just two and a half years.

Newhouse chose David Remnick to replace her. He kept the Tina Brown innovations that worked, and avoided her excesses. I continued to do covers and illustrations for David much as I had for Tina, but I never submitted another idea for a gag cartoon after Robert Mankoff became the cartoon editor and brought in a motley crew of cartoonists who drew even worse than he did. Here are a few of the gag cartoons I did while Lee Lorenz was in charge, and some of the spreads I did after he was (regrettably) gone. And, because some of the illustrations I did for articles by others turned out better than they should have, considering how tight most of the deadlines were, I'm showing them off as well.

Comic drawings with dialogue are known as "gag cartoons." For this one I drew with a china marker (a grease pencil), a medium I like using for gags when there is no need for small details.

"Before we married she seemed like the sort who would suffer a fool gladly."

"On the other hand, the examined life doesn't seem to produce much income."

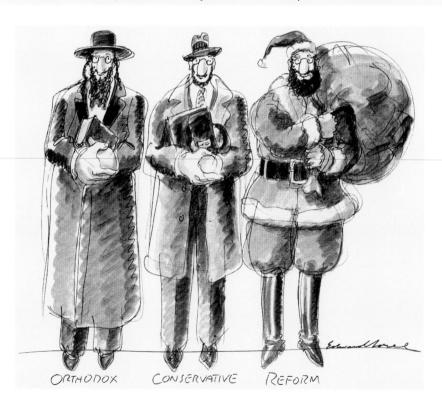

ORTHODOX CONSERVATIVE REFORM

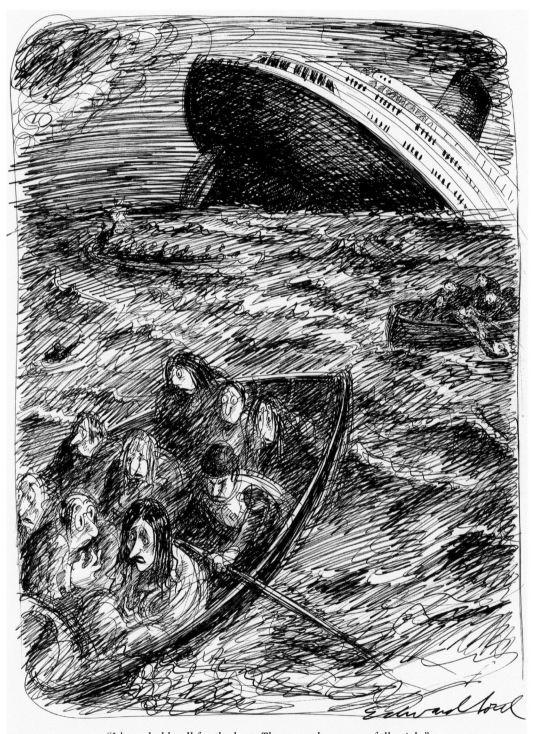

"It's probably all for the best. Those meals were awfully rich."

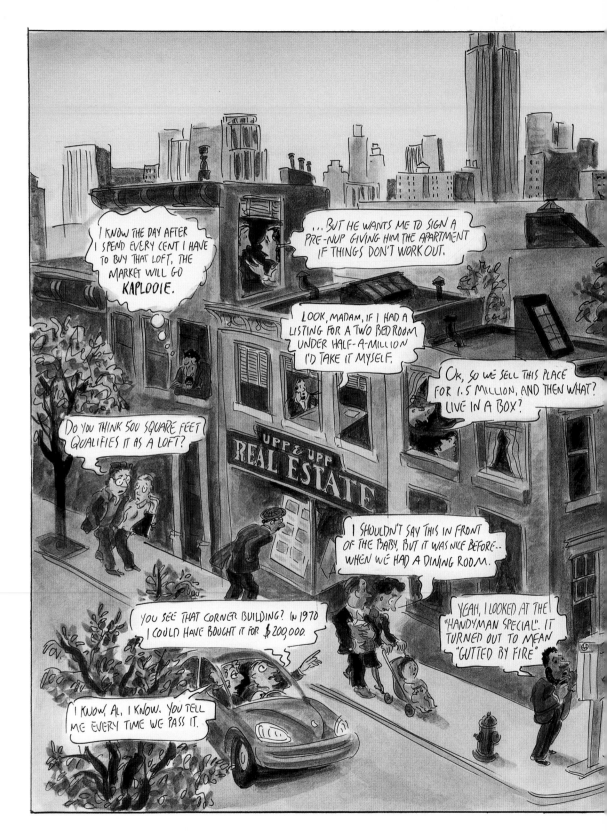

Autumn in New York

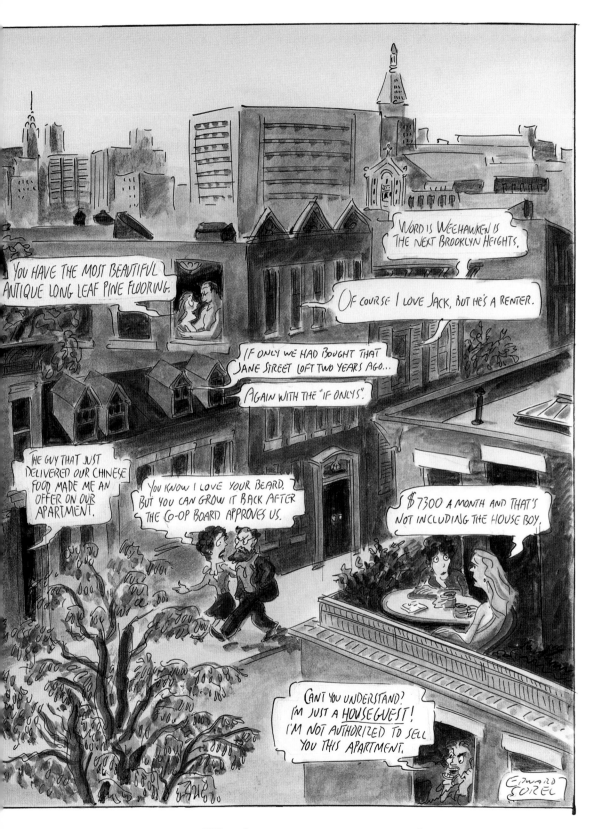

Why does it seem so expensive?

Bovine Pride

by Edward Sorel

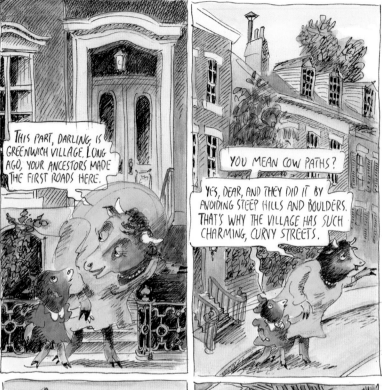

This strip was inspired by a time I hitchhiked a ride on the curvy road near my house in the country. The big burly man who picked me up kept yapping about how infuriating it was that the town still hadn't straightened out the zigzaggy road so that a person could drive faster than thirty miles an hour. I said nothing, but was grateful the road had remained unchanged, preferring to live on a road designed by cows than on one designed by man.

Here, Colin Powell, George W. Bush, and Condoleezza Rice are planning a "regime change" in France because the French government did not support Bush's plan to invade Iraq and bump off Saddam Hussein.

In the years when *The New Yorker* still had a lot of advertising, they could afford to have their book reviews adorned with full-page caricatures by a roster of their artists. I was among them. I did this one of John O'Hara in pastel, a medium that does not lend itself to spontaneity but is good for portraits. In addition to being a best-selling novelist, O'Hara was perhaps *The New Yorker*'s most prolific short story writer. No one ever accused him of being a fool, but few suffered his company gladly.

When the Film Forum in New York ran a festival of Edward G. Robinson movies, *The New Yorker* gave me a quarter of a page in its Goings On About Town section to draw him. Robinson had a face easy to capture, but I think it was my affection for him as an actor that made this portrait the best caricature I ever did. If I were a pharaoh, I'd ask to have it buried with me.

Between the two of them, Woody Allen and Mia Farrow must have gone through half the shrinks in New York. When the scandal broke in 1992, it occurred to me that all their analysts should get together somewhere and compare notes. They might also compare their prices. This ran in *The New Yorker* a week after their breakup hit the papers.

The Second Sunday in May

When I showed David Remnick this drawing about Mother's Day, he objected to the exchange of words between the two Jewish ladies at the bottom right. But on this occasion I refused to cave, and David let it go.

This was one of several illustrations I did for an article by Alfred Kazin in which he wrote about some of the writers he knew. He didn't hide his distaste for Jerzy Kosinski and found it odd that Kosinski would visit the old and the dying in hospitals to cheer them up by reading from his novels, which were inevitably about rape, murder, and incest.

I couldn't believe my good luck when I was asked to do a small drawing of *Trouble in Paradise* for the Goings On About Town section. That 1932 movie, made before Hollywood censors began to enforce their Code, is full of suave, sophisticated, amoral characters. It is my favorite Ernst Lubitsch comedy. Seen here are Herbert Marshall, Kay Francis, C. Aubrey Smith, and the most glorious Art Deco clock I've ever seen.

As I approached eighty, I found I had enough money to do only work I wanted to do. At that point taking assignments to illustrate the work of other writers wasn't as much fun as it had been—especially when the articles were terribly earnest essays that offered nothing to satirize. I decided I would illustrate only my own writing from then on. And doing covers for *The New Yorker*, something that gave me enormous pleasure and pride, seemed to get a lot harder for me to pull off—probably because I wasn't giving it the time they demanded. Or maybe I was simply running out of ideas. In any case, I'm very proud of some that I did, and this is as good a time as any to put them on parade.

Springtime in New York

The life of Martin Luther King, Jr., told without words

Jan. 25, 1993 THE Price $1.95

THE NEW YORKER

Bill Clinton's speeches tended to be long, and I anticipated that his inaugural speech would be no exception, so I drew Theodore Roosevelt impatiently looking at his watch. In fact, Clinton gave one of the shortest on record. When I handed in my drawing, one of the fact-checkers objected to Roosevelt looking at a wristwatch rather than at a pocket watch, which most men used before the First World War. I made the change and learned that it was the war and the need to count the seconds before throwing a hand grenade, or starting a bombardment, that made wristwatches popular with men.

For the annual fiction issue: Columbia celebrating both her highbrow and lowbrow novelists. Cover ideas that require dozens of caricatures take me forever to finish, and I promise myself after each one that I'll never do another. But months pass and I forget how much I hate doing them.

TOP LEFT Celebrating the New York Public Library's one-hundredth anniversary. The two lions in front of the main entrance to the Forty-second Street library were named Patience and Fortitude by Fiorello La Guardia during the Second World War. TOP RIGHT Whistler's mother waiting for him to call on Mother's Day BOTTOM LEFT Summer school for bugs BOTTOM RIGHT Afternoon break at the Metropolitan Museum of Art

Taxi drivers in New York change their shift between four and five, so it's almost impossible to get a cab at quitting time.

Mother's Day updated.

Young Sinatra meets old Sinatra. Done to trumpet a long piece about him in that issue.

For Valentine's Day

The power couple at breakfast

THE NEW YORKER

Price $1.95

Two weeks after the 9/11 attack, Françoise Mouly, art director of *The New Yorker*'s covers, asked me to do a drawing showing New Yorkers courageously carrying on. It was the only cover I ever did that wasn't comic.

I don't remember at what point I was given the contract that
The New Yorker gives to its regular contributors, but I remem-
ber being pleased to get it. It meant that I got a bonus at the end
of every year. The amount depended on how much work I had
done for the magazine in the previous year. The only drawback to
signing it was that it forbade me from working for *The New York
Times, Vanity Fair,* and a few other magazines that might take
advertisers away from *The New Yorker*. Since Tina was buying
just about everything I sent in, I had no hesitation in signing. But
when Graydon Carter called to offer me an assignment for *Vanity
Fair,* I had to explain that my contract would not allow it, even
though both magazines were owned by Condé Nast.

When my 1993 contract arrived I saw that *Vanity Fair* had
been taken off the verboten list, so when I found myself in the
same elevator with Graydon (all the magazines owned by Condé
Nast were in the same building), I told him I was available. Within
days I had a dream assignment from Graydon that let me carica-
ture George Bush and the entire cabinet as medieval warriors who
had captured Sadam Hussein. Later I got the chance to do Con-
doleezza Rice as Pandora opening up our troubles in the Middle
East.

I was on a roll. In addition to appearing regularly in *The Atlan-
tic Monthly,* and frequently in *The New Yorker* and *Vanity Fair,*
and occasionally in *GQ, Rolling Stone, Forbes,* and contributing
gratis to *Freethought Today,* a monthly newspaper put out by the
Freedom From Religion Foundation, I was continuing to write
and/or illustrate books. I've already shown you pages from my last
two children's books, but there were also several books I produced
for grown-ups who like pictures with their words. One was *Liter-
ary Lives,* a collection of the comic strips I did for *The Atlantic
Monthly.* E. L. Doctorow wrote the introduction, which imparted
a bit of gravitas to my gleeful character assassinations. Here I've
chosen to show single panels from the longer strips about Lillian
Hellman and Leo Tolstoy.

Another book I dreamed up (while taking a hot bath) was *Cer-
titude,* a book about blockheads who believed what they wanted

My first assignment for *Vanity Fair*'s new editor Graydon Carter: the capture of Saddam Hussein.

Condoleezza Rice as Pandora, opening up the Middle East and letting all our enemies out of the box

The Four Horsemen of the Wall St. Apocalypse

When we were in the middle of what became known as the Great Recession, Graydon Carter asked me to illustrate a serious article about how Wall Street was responsible for the financial disaster. The subject matter was not conducive to anything comic and forced me to draw an allegory—the kind of drawing I hate doing. It's the only drawing in this book in which I felt the need to label the participants to explain what they represented—a very old and corny device.

After eight years of George W. Bush, and yet another unnecessary war that made matters even worse, the United States was unrecognizable from the country that it had once been.

I drew my nine-paneled strips about the lives of authors for ten months and then gave it up. They took too much time.
All the writers I chose were pretty weird (Yeats, Proust, Brecht, Mailer, Ayn Rand), but Lillian Hellman was one of only two who regarded Stalin as our last best hope for mankind.

On the other hand, the deeply religious Tolstoy felt we must all do as Jesus did. But Leo's cruel treatment of his wife and children and his lust for the daughters of his serfs was not entirely Christlike.

to believe regardless of the facts. Among those dozens of ideologues were Pope Urban II, who started the Crusade to capture Jerusalem because it was in the center of the (flat) earth; Sam Goldwyn, who invested millions in a Russian actress named Anna Sten because he believed she was the next Garbo; and Joseph Stalin, who refused to believe reports that the Nazis were at the border ready to invade. I asked Adam Begley, book editor of the (short-lived) *New York Observer,* to write brief biographies to accompany my drawings, and Christopher Hitchens to write the introduction. Happily, both said yes.

Two of my favorites in the book were Edgar Degas, who refused to believe that Alfred Dreyfus was innocent of treason even after he was exonerated, and Aimee Semple McPherson, the evangelist who proved there's no business like God business.

The Masters Series:

EDWARD SOREL

Edward Sorel, *The Commandments*, 2011

 VISUAL ARTS Gallery

RECEPTION: Thursday, October 13, 6 – 8PM EXHIBITION: October 7 – November 5, 2011

601 West 26 Street, 15th floor, New York City
212.592.2145 Monday – Saturday, 10AM – 6PM

EDWARD SOREL IN CONVERSATION
WITH JAMES McMULLAN
Tuesday, October 25, 7PM
SVA Theatre, 333 West 23 Street, New York City

www.sva.edu

In 1988, the School of Visual Arts (SVA) instituted its Master's Series, which annually awarded an exhibition to honor "the great visual communicators—designers, illustrators, art directors and photographers—of our time." In 2011 I was tapped for the honor, and was asked to draw an image to be used for a poster promoting my exhibit. Because my drawing of "The Dogs' Ten Commandments" had been such a turning point in my career, and because I always wished I had drawn it better, I decided to redo it in color for my exhibit. It will be followed by a few other posters I did over the years.

This drawing of George McGovern and Richard Nixon in a chariot race was one of six posters I did for the *Times* in 1972, when these two were running against each other. Since McGovern was the peace candidate, I put a wreath of olive leaves on his head to indicate that. But the editors were so afraid of seeming partisan that they insisted I put a wreath on Nixon's head as well. I also had to cover up the knife that I had placed in Nixon's belt. Nixon was a lot easier to caricature than McGovern, but I didn't let self-interest influence my vote.

My friend Jim McMullan has been designing all the Lincoln Center posters for over thirty years, but about twenty years ago the theater asked *me* to do one. I was flummoxed. I called Jim to ask if he had turned the job down. He said he hadn't and assured me he had no objection to my accepting the assignment. I loved doing it.

STOP THEM!
they can't stop themselves

MARCH ON WASHINGTON—SAN FRANCISCO **APRIL 24, 1971**

NATIONAL PEACE ACTION COALITION

1029 Vermont Ave. N.W, 8th floor, Washington D.C. tel. 638-6225

This poster was for yet another march on Washington to protest the war. The first one I was in was in 1963. The military man to the left of Nixon and Kissinger is Melvin Laird, the secretary of defense. (After World War II, when the United States began starting wars around the globe, they changed the name of the War Department to the Defense Department.)

The men in the tree are Ralph Ginzburg and E. E. Cummings. Below are Anaïs Nin, Margaret Sanger, Djuna Barnes, Edward Albee, Marlon Brando, Fran Lebowitz, Dawn Powell, Jackson Pollock, left-wing cartoonist Art Young, and William S. Burroughs.

In 2006 Graydon Carter called to tell me that he had bought the Waverly Inn in Greenwich Village and wanted me to do the mural for the dining room. Doing a mural in a restaurant had been a dream of mine for years, and now, miraculously, that wish was going to be granted. What he wanted were caricatures of Greenwich Village notables gamboling along the western wall of his long narrow restaurant. Best of all, he wanted it in a hurry, which meant that there wouldn't be time to paint it on the wall. I could draw it right on my drawing table, to a quarter of the size. It would then be blown up digitally.

Although I didn't have to paint it on the wall, it was important that it *appeared* as if it had been. My usual scribbly pen-and-ink method of drawing would not do, because no matter how large it

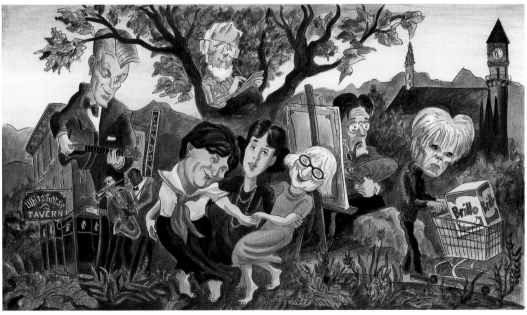

Eddie Condon, Donald Barthelme, Willa Cather, Gertrude Vanderbilt Whitney, Jane Jacobs, John Sloan, Andy Warhol

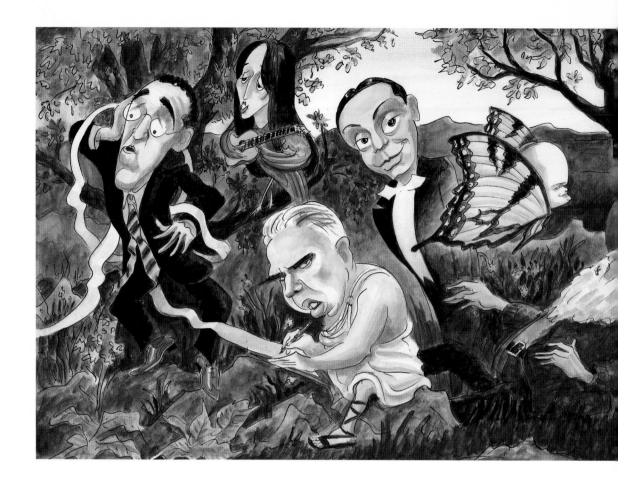

was blown up, it would be clear that it was a pen-and-ink-on-paper drawing and not a painted mural. That meant I had to find a different style. I did do all the outlines with pen, but used a brush dipped into rubber cement thinner and grease pencil to do the shading. When it was blown up from thirteen inches to six feet, it looked like a painting.

It took less than six months to finish—one eighth the time it took Michelangelo, but of course I didn't have to paint it lying on

OPPOSITE The Waverly Inn, built in 1844, was originally used as a tavern and bordello. In the 1920s it became a popular neighborhood restaurant in Greenwich Village. It was then owned by the secretary to Clare Booth (later Luce) who was at that time an editor at *Vanity Fair*. In 2005 it was purchased by Graydon Carter and his friend Roberto Benabib. It was Graydon's idea to install the plush red banquettes, the white tablecloths, American comfort food, and a mural of the notables who had lived in the Village. He worked with the architect Basil Walter and co-owner Sean MacPherson to sparkle up the place without losing its old-world quality. My only instructions before I started the mural was to make it look as if it had a century of cigarette smoke on it.

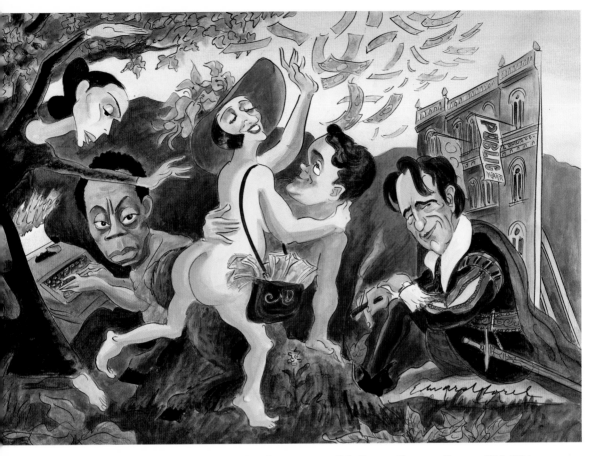

ABOVE S. J. Perelman, Joan Baez, Theodore Dreiser, Cole Porter, Truman Capote, Walt Whitman, Martha Graham, James Baldwin, Mabel Dodge, John Reed, and Joe Papp

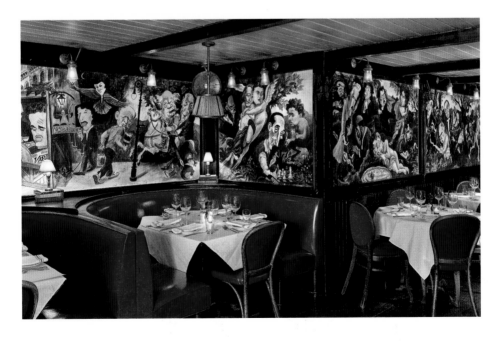

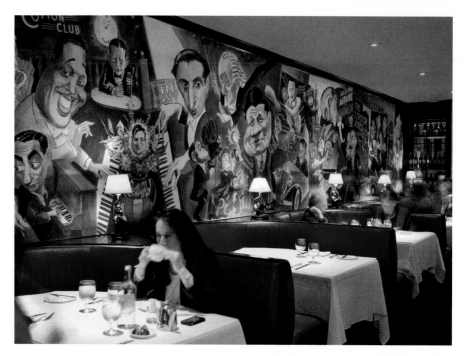

ABOVE When I peeked at Basil Walter's architectural plans for the Monkey Bar, and saw that it would have an Art Deco flavor, I made certain that my mural echoed that style. Confession: When it came to caricaturing Arturo Toscanini, I couldn't resist copying the caricature that Miguel Covarrubias did of the conductor. I'd like to think it was simply my homage to the most inventive caricaturist of the twentieth century, but maybe it was just plain plagiarism.

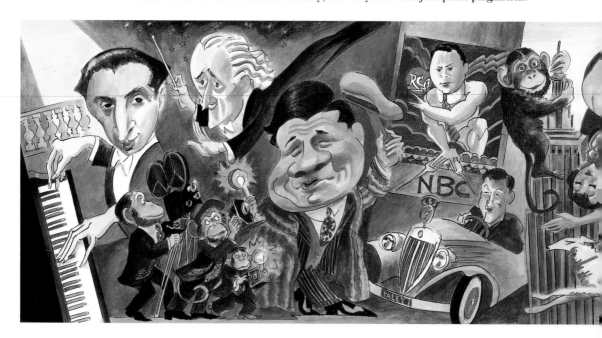

my back as he did. After the Waverly Inn opened it became a mag-net for every Hollywood celeb visiting New York—the paparazzi kept a vigil at its entrance for months.

My friends at Knopf, Kathy Hourigan and Ann Close, came down to see the mural, and Ann thought it could be published as a book if it had short bios of the men and women caricatured. Dor-othy Gallagher wrote those, and everyone agreed that Dorothy's sardonic style was a perfect match for my satiric portraits. Two years later, Graydon bought the run-down Monkey Bar restaurant in the Hotel Elysée and had the architect Basil Walter turn it into a glittering Art Deco dreamscape. I did its immense mural—three times the size of the one in the Waverly Inn—caricaturing New York celebrities of the twenties and thirties.

One week before the Monkey Bar officially opened in April 2009, I threw myself a party there to celebrate the mural's comple-

BELOW This is only half of my mural that covers the enormous wall that faces guests when they enter the restaurant. See if you can recognize—Vladimir Horowitz, Arturo Toscanini, Babe Ruth, Robert Sarnoff, William S. Paley, Adele and Fred Astaire, Blanche and Alfred A. Knopf, Paul Robeson, Sherman Billingsley, Ernest Hemingway, Walter Winchell, Cary Grant, Tallulah Bankhead, and Mae West.

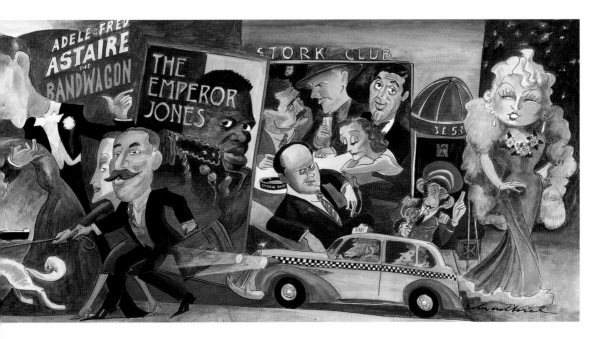

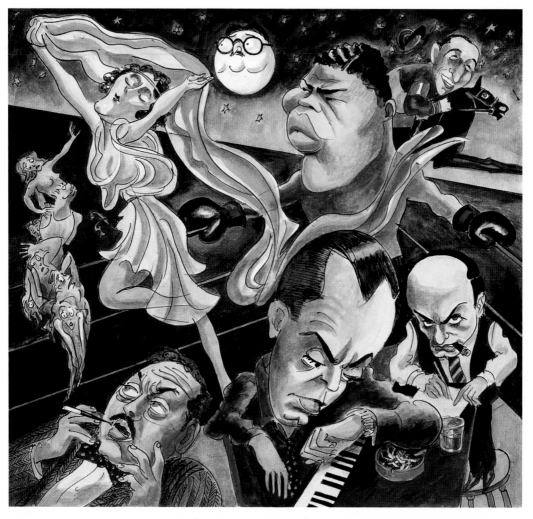

CLOCKWISE FROM UPPER LEFT Isadora Duncan, Alexander Woollcott, Joe Louis, Eddie Arcaro, Lorenz Hart, Richard Rodgers, and Tennessee Williams

tion and my eightieth birthday. It should have been an evening of unclouded happiness, but it wasn't. Five years earlier Nancy had been diagnosed with Alzheimer's. By the time I threw the party, she was a shadow of her former self, no longer able to remember what she had just read in the newspaper or where she had hidden "the good silver." In the years ahead she would wander off, not knowing where she was going, and lose more and more of her memory. The only thing she did not lose was her kindness. When, a few months before her death, it was necessary to place her in

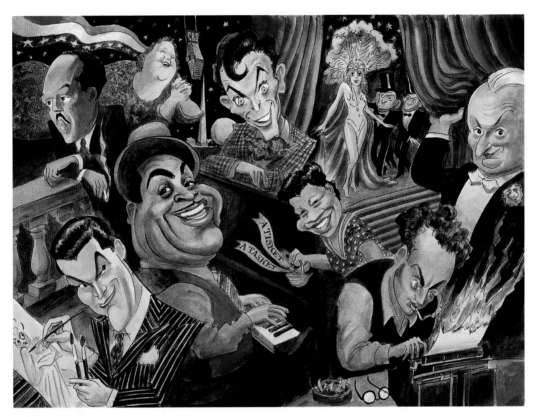

CLOCKWISE FROM UPPER LEFT Langston Hughes, Kate Smith, Frank Sinatra, Florenz Ziegfeld, Clifford Odets, Ella Fitzgerald, Fats Waller, and Peter Arno

a nursing home, she would seek out those patients who seemed most troubled, then take their hands and try to comfort them.

In those last weeks of her life she didn't know who I was or who her children were. When I suspected she was about to die, I alerted all my children. We were all at her bedside when she breathed her last breath.

9

Leaders of the Free World

When Nancy died in 2015, Barack Obama was near the end of his second term. In his eight years, there had not been even a hint of corruption in his administration. He had served with dignity and moderation, but as we were to learn in the 2016 election, that was no longer valued by a great many people who found it a lot harder to get by than it used to be. What's more, their children seemed to have an even less promising future than theirs. Mad as hell, a lot of them voted for a man who was xenophobic, vulgar, racist, ignorant, and whose only joy lay in spiteful vengefulness.

Of course, the fact that Trump's opponent, Hillary Clinton, could not resist taking big bucks to speak before Goldman Sachs and other elite Wall Street firms, while at the same time proclaiming her allegiance to the downtrodden, convinced many that she was not to be trusted. During the campaign, Trump, like Hitler, received tacit support from the Roman Catholic Church. Hitler, himself a Catholic, got his church's support by promising an end to godless communism. Trump got it by promising an end to godless abortion. Both of those superpatriots—one promising

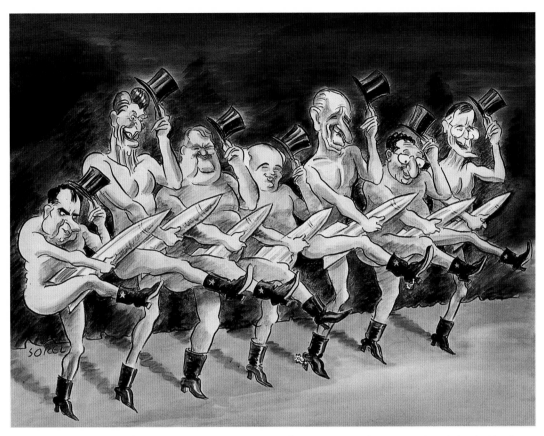

This chorus line of men with missile envy was drawn for the jacket of Robert Scheer's book *Thinking Tuna Fish, Talking Death: Essays on the Pornography of Power.* The hoofers are Nixon; Reagan; Edwin Meese, attorney general under Reagan; Mikhail Gorbachev; LBJ; Kissinger; and George Bush, Sr.

Deutschland über Alles, the other promising America First—also had the support of financiers and industrialists, who were sure these loonies would be good for business.

How we ended up with Trump has many explanations, but mine is that the sixty years of anti-communist fearmongering that followed World War II had a lot to do with it. Both political parties convinced the public that our government was run by subversives taking orders from Moscow, and together they began passing legislation to weaken labor unions, by accusing their leaders of being communists. My goal in writing about the actions of our last twelve presidents was a hope that readers would see how each president, in his own way, committed unconstitutional acts that

have turned our country into an oligarchy. I got as far as Jimmy Carter, but then became so involved in writing about myself that I put aside the presidents. I now have a lot of catching up to do, beginning with Ronald Reagan.

Let's go back a bit, to the early 1950s, when Ron, a liberal Democrat, had just been dropped by Warner Bros. He was still paying child support for two children from his ex, and he had a new wife, a new daughter, and a lot of horses to feed on the 320-acre ranch that he had recently bought. He had a really bad cash-flow problem, but was rescued by his friends at General Electric. They had sponsored his television show and now decided to make the likable actor their goodwill ambassador. As such he would help sell a political agenda that was favorable to GE to its 250,000 employees, delivering fourteen speeches a day. It paid well.

Traveling with GE's public relations man, an arch-conservative, Ron was spoon-fed a diet of free-market ideology, and his speeches soon began blasting the irrational and meddlesome government regulations that were "ruining" the country. Speaking to the graduating class at Eureka College—his alma mater—he assured them that the American people were on a mission from God and implied that God, too, must surely disapprove of government regulations. At the time, 1959, General Electric was being sued by the government for rigging prices with Westinghouse on the work they had done for the Tennessee Valley Authority. Laws against price-fixing may have been some of those meddlesome regulations that infuriated Reagan. Twenty years later, after he was sworn in as president of the United States, Ron returned to his favorite theme in his inaugural address. "Government is not the solution to our problem," he told the nation. "Government is the problem."

Once in the White House, he acted on his certainty that large corporations did not need laws to make them act in the best interests of the nation. He decided to eliminate the fairness doctrine that required broadcasters to present controversial issues in an honest, balanced way. That regulation had been in effect since 1949, but Reagan saw no need for it and appointed men to the Federal Communications Commission who put the kibosh on it.

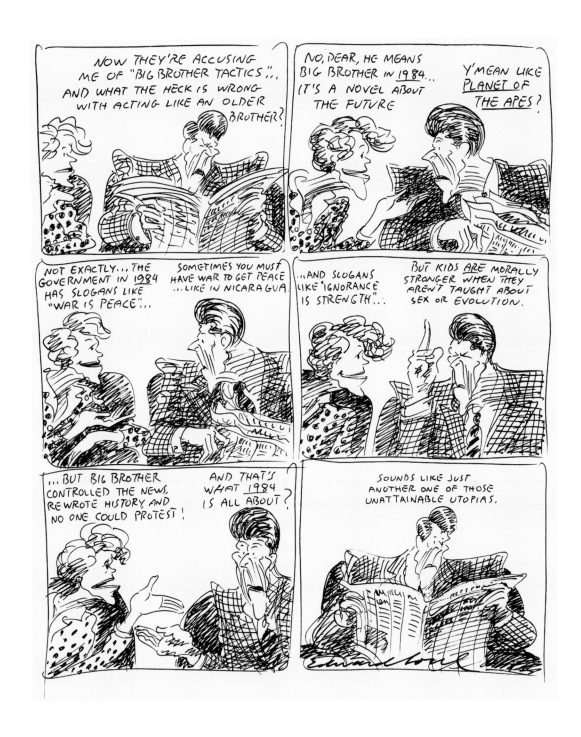

In 1987, when the Democrats regained control of Congress, they passed a bill to reinstate the fairness doctrine, but Reagan vetoed it, thus making it possible for Fox News to emerge and disseminate misinformation, lies, and Christian zealotry.

Do not conclude from this that the seventy-four-year-old president was opposed to *all* government intervention. On the contrary, one of his very first initiatives as president was to formally propose a constitutional amendment permitting organized prayer in public schools. He did so precisely because *permitting* children to pray in schools was in fact a *demand* that they do so—as I well remember from singing Christian hymns in my own childhood at P.S. 90. Since the Supreme Court had ruled in 1962 that school prayer violated the constitutional separation of church and state, Reagan's proposal went nowhere.

A few chapters back, I related how Eisenhower and Dulles overthrew the democratically elected government of Guatemala. They did it in the name of anti-communism, but the real reason was that the United Fruit Company didn't like the Arbenz government forcing them to pay a minimum wage. After Arbenz was overthrown, the United States financed a brutal counterinsurgency campaign with forces it trained in Columbus, Georgia. In 1966, the U.S. Army set down rules that allowed Guatemalan forces to use "selective terror" but stipulated that "mass terror" was "not an alternative." When Reagan became president, those prohibitions were swept aside, and General Ríos Montt, our puppet ruler in Guatemala, began slaughtering the native Mayan population.

Reports of the large-scale killing leaked out, and on December 5, 1982, Reagan flew to Honduras to meet with the generalissimo. After the meeting, Reagan called Ríos Montt "a man of great personal integrity" and "totally dedicated to democracy." One day later, the general was emboldened to send Guatemalan soldiers to the Mayan village of Dos Erres, where a new bloodbath began. Reagan's support for General Montt never wavered.

Few Americans at the time knew about the Guatemalan genocide, and now almost no one does. What people remember is the Iran-Contra affair, in which Reagan secretly sold arms to Iran (in

spite of a trade embargo that the United States had initiated) in order to free American hostages held by Iranians in Lebanon. By the time the arms deal was exposed in a Lebanese newspaper, 1,500 American missiles had been sold to Iran for $30 million. Reagan first denied, then admitted that he had negotiated with terrorists. In time, we learned that $18 million of that $30 million had been diverted to the contras in Nicaragua, who were fighting to overthrow the democratically elected socialist government—another government that United Fruit wanted out of the way.

In truth, the contras didn't have much trouble funding their insurrection. Thanks to help from the CIA, the contras were making a mint from shipping cut-rate cocaine to the United States. It was, in fact, the drug trafficking by the contras that caused the crack cocaine epidemic in Los Angeles and New York that continued into the 1990s. At the same time Ronald Reagan was describing the contras as "the moral equivalent of the Founding Fathers."

I'd like to stop talking about Ronald Reagan, but he did so many bad things, illegal things, wrongheaded things, that I have to go on for just a tiny bit longer. I can't leave out the AIDS epidemic, whose peak coincided with his two terms in office. He did not acknowledge it as an issue until 1987, when his second term was almost over. By that time twenty-one thousand Americans had been killed by it—including his friend Rock Hudson—yet he refused to find funds for research to combat the disease, or even to speak about the crisis. This had the effect of stigmatizing the LGBT community as being unworthy of our concern, or, for some, unworthy even of life itself. Similarly, the suffering of the poor never evoked in him the same kind of empathy that he had for poor, persecuted corporations beset by government regulations. When he spoke before affluent, all-white audiences, he enjoyed making jokes about "Welfare Queens" (understood by the audience to be Black) and alcoholics who used their food stamps to buy booze.

His feelings about the 12 percent of his fellow citizens who were at that time African American can be gleaned by the fact that he kicked off his campaign for the presidency in 1980 at the

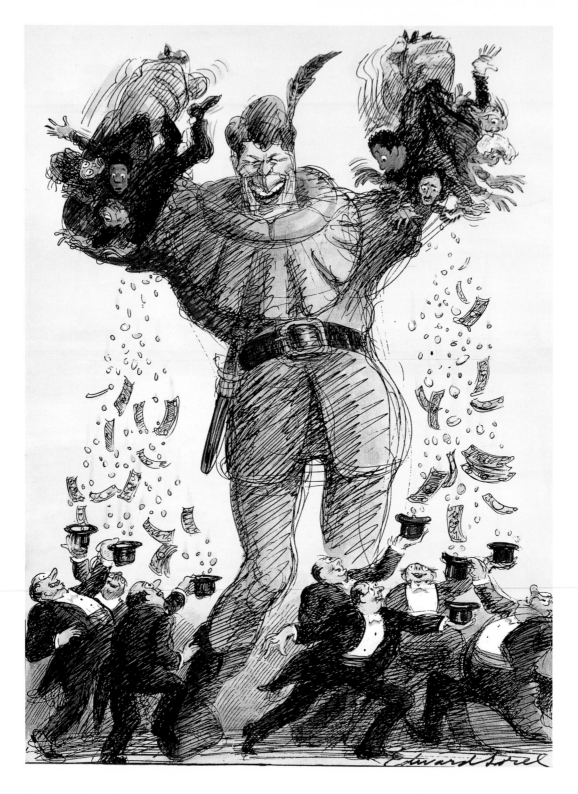

Ronnie as Robin Hood, taking from the poor and giving to the rich. It originally appeared in *The Nation*.

Neshoba County Fair, which was seven miles from Philadelphia, Mississippi, where three civil rights workers were murdered in 1964. Reagan, in his remarks that day, told his white audience, "I believe in states' rights," and he promised to "restore to states and local governments the power that properly belongs to them." Thus, he carried on Nixon's Southern strategy, which, with a lot of help from Rupert Murdoch's Fox News and the Electoral College, has worked all too well for the Republicans, who have now won two presidential elections while losing the popular vote.

What Reagan left behind was an "us versus them" nation. It has become even more so in the years that have followed. However his legacy is judged, it must be admitted that he cared deeply for those who, through no fault of their own, were born wealthier than he was, and he did what he could to make them even more prosperous than they had been before he took office.

I've given too much space to Reagan, so I'm going to make up for it by squeezing all of George H. W. Bush's presidency into a single paragraph. But before I perform that amazing act of pres- tidigitation, I think you should know about the work that Bush did when he was made head of the CIA in 1976. He was on the job for only one year, but in that year he worked with the intel- ligence services of six Latin American dictatorships to help them coordinate ways to repress all their dissidents. The program was called Operation Condor, and Bush's CIA took the lead in educat- ing those six countries on effective ways to eliminate protests, set up detention camps, and implement the latest advances in torture techniques.

Bush served as vice president under Reagan for two terms, and then the Republicans made him their candidate for presi- dent. Although Bush was not himself a racist, he used Lee Atwa- ter's racist strategy in his campaign. It worked. Eager to prove that he wasn't the "wimp" many perceived him to be, he invaded Panama to capture Manuel Noriega, Panama's dictator and drug trafficker. He did capture Noriega, but the U.N. General Assembly condemned the invasion as "a flagrant violation of international law." He then chose an unqualified right-wing harasser of women

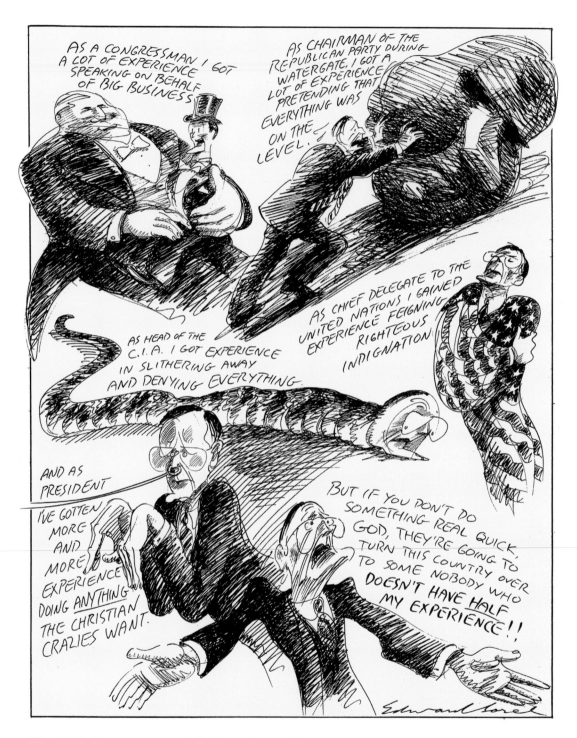

When Bush Senior ran against Bill Clinton for president, Bush stressed his vast experience in Washington, D.C, compared to Bill's in Arkansas. So I decided to examine exactly what Bush did in Washington.

to replace Thurgood Marshall on the Supreme Court; sabotaged legislation that might have slowed climate change; vetoed civil rights legislation; and gave a presidential pardon to Defense Secretary Caspar Weinberger, and five others who committed crimes in the Iran-Contra affair. But whatever questionable actions he took, and whatever waffling he did on controversial issues and such U.S. mistakes as accidentally blowing up an Iranian civilian aircraft with 290 people aboard, Bush was, first and foremost, a fierce patriot. This he made perfectly clear in a speech he made at the National Press Club: "I will never apologize for the United States of America. Ever. I don't care what the facts are."

The road to hell is paved with good intentions, and William Jefferson Clinton was full of them. In his 1992 campaign he promised to cut taxes for the middle class, provide better education at every level, train workers for high-skill, high-wage jobs, and guarantee a college education to everyone in return for community service. And since Bill was a brilliant orator who could speak extemporaneously for over an hour without ever hesitating for the right word or losing the point he was leading up to, it was easy to believe he could do those things. He was charming, bright, and a Rhodes scholar who could complete the *New York Times* Saturday crossword puzzle without looking anything up.

He was so smart that he thought he could get away with a dalliance with an impressionable intern. When this bit of hanky-

After I had such an easy time caricaturing Nixon, Reagan, and Bush, the handsome face of Clinton posed a problem for me.

panky was discovered, the Republicans tried to impeach him for lying about it. For reasons that remain mysterious, the scandal sent Bill's approval rating up, up, and up. But many Democrats were not amused when they realized that Clinton had actually outdone Reagan and Bush in deregulating the financial industry. He supported and signed the bill that dissolved the Depression-era Glass-Steagall Act barring investment banks from commercial banking activities. He also deregulated the risky derivatives market and gutted state regulation of banks. All of this led directly to the global financial crisis to come in 2008.

In Clinton's first year in office he promoted and signed the North American Free Trade Agreement (NAFTA), which took manufacturing jobs out of the United States and sent them abroad. The fact that this bill, favored by Republicans, was passed by Democrats, who controlled Congress, was proof to many that there was little difference between the two parties. That is a somewhat unfair conclusion—the Democrats had previously refused to approve exactly that kind of legislation. But Clinton put the pressure on. By giving in they sent seven hundred thousand jobs abroad and gave U.S. corporations a chance to cut wages and benefits by threatening workers with moving their jobs to Mexico.

Bill had campaigned for the presidency by promising "an end to welfare as we know it." Once elected, he signed a welfare reform bill every bit as heartless as Newt Gingrich's Contract with America. It allowed states to decide how funds were allotted and what constituted eligibility. And guess what! States with large numbers of African Americans on welfare chose the toughest rules, and those states with a large number of white recipients chose the more lenient ones.

I've chosen a lighthearted mini-scandal to close out this otherwise depressing report card on Bill. It's the one about the Lincoln Bedroom in the White House. In 1966 the Center for Public Integrity released their "Fat Cat Hotel" report. It examined the connection between overnight stays in that historic bedroom and contributions of big bucks to the Democratic Party. Between the years of 1995 and 1996, overnight guests donated some $5.4 mil-

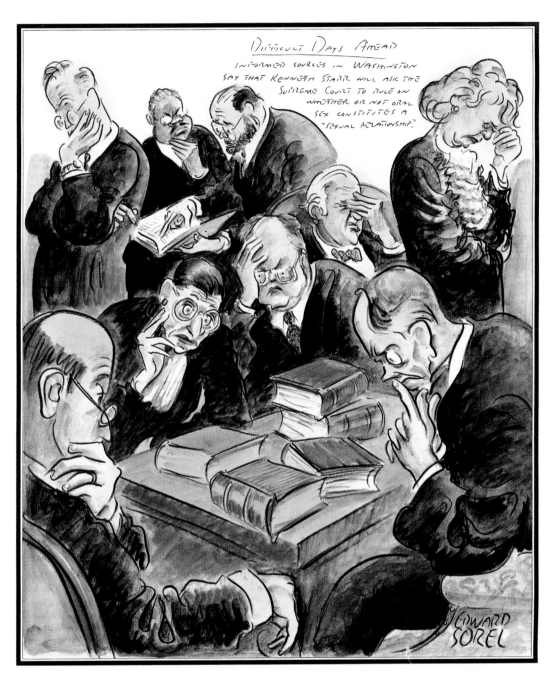

In his second term as president, Bill Clinton got caught with his fly open with an attractive White House intern, then denied that he ever had a sexual relationship with her. It seemed inevitable that the Supreme Court would in time be called on to decide if he did or didn't. I couldn't resist drawing all the justices agonizing about what exactly constitutes a sex act, and *Rolling Stone* printed it.

lion to the DNC. Extremely generous contributors were sometimes permitted to join the president in a morning jog or even a round of golf. It was a brilliant ploy to get billionaires to cough up checks with a lot of zeros—so brilliant that all succeeding presidents have used it.

. . .

Many caricaturists have parodied Rembrandt's painting *Aristotle with a Bust of Homer*. President George W. Bush had such a brain-dead, confused face that I thought it would be funny to have Condoleezza Rice, his secretary of state, contemplating a bust of him, looking very worried.

Who was the stupidest man ever to be elected president of the United States? Once you eliminate Donald J. Trump, on the grounds that he is deranged rather than stupid, I think a lot of people would say it was George W. Bush—especially those who remember his difficulty in speaking the English language. This born-again chief executive garbled words so badly that they often came out saying the opposite of what he meant to say. These gaffes—and there were hundreds of them—became known as "Bushisms." Here are a few of them.

"I'm not sure 80 percent of people get the death tax. I know this: 100 percent will get it if I'm the president."
 —*said while campaigning against the estate tax*

"I know how hard it is for you to put food on your family."
 —*January 2000*

"I couldn't imagine somebody like Osama bin Laden understanding the joy of Hanukkah."
 —*at a White House menorah-lighting ceremony, December 2001*

"Our enemies are innovative and resourceful, and so are we. They never stop thinking about ways to harm our country and our people, and neither do we." —*August 2004*

"They misunderestimated me." —*January 2000*

"Goodbye from the world's biggest polluter."
 —*his parting words (grinning broadly)*
 to French president Nicolas Sarkozy at a G-8 Summit

Yes, George the Second was a jerk, but he was lucky. In 2000 he was running against Al Gore, who was intellectually brighter, but had no political savvy. Of all the possible running mates Gore could have picked, he chose a super-religious Jew whose political beliefs were more in tune with those of the Republican Party. In

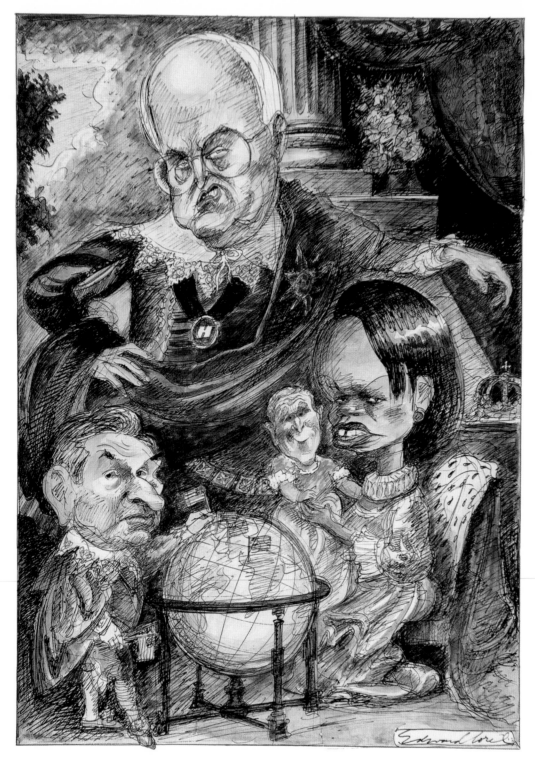

Here is the Royal Family. Dick Cheney as the regent for the not-quite-ready-to-be monarch, who is being held by Queen Condoleezza. In the bottom left, playing with the globe is Paul Wolfowitz, architect of the Iraq War.

fact, in 2008 Joseph Isadore Lieberman addressed the Republican Convention to endorse John McCain for president. With Lieberman as Gore's running mate, Al didn't even carry his home state of Tennessee. Gore also refused to let Bill Clinton (still very popular) campaign for him, because he didn't want to be associated with the impeached adulterer. In this contest between Dumb and Dumber (I voted for Ralph Nader), the result was a tight race and a disputed election. It was decided by a Republican Supreme Court, where Bush was declared the winner.

In August of his first year as president, Bush II was on vacation at his Texas ranch when he received a memo from the CIA entitled "Bin Laden Determined to Strike in US." Bush didn't bother to respond. Weeks later, on September 11, 2001, hijacked planes flew into the World Trade Center and the Pentagon. Bush and his vice president, Richard "Dick" Cheney, together with their foreign policy advisers, decided to retaliate by overthrowing the government of Afghanistan, since that country knowingly harbored the men who committed the attacks. The war began a month later, and by November 13, the United States was able to install Hamid Karzai shortly after as Afghanistan's interim leader, although only a part of the country was under his control. Osama bin Laden, who had bankrolled the attack on 9/11, escaped, together with the senior leadership of the Taliban and al-Qaeda.

In 2002, egged on by hawks in his administration, Bush set forth a policy of preemptive military strikes against nations aiding terrorist organizations. Iraq, North Korea, and Iran now became the "Axis of Evil." Defense spending doubled and a campaign was mounted to win public and congressional support for an invasion of Iraq, where, Bush insisted, the dictator Saddam Hussein had weapons of mass destruction (WMD). After a U.N. weapons inspection failed to find any evidence of such a program and Germany, China, France, and Russia said they saw no need for regime change, Dick Cheney ordered the CIA to invent proof that there were WMDs in Iraq. They obeyed, and in March 2003 the invasion began. Iraqi forces caved after two months, and Bush delivered his "Mission Accomplished" speech aboard the aircraft carrier

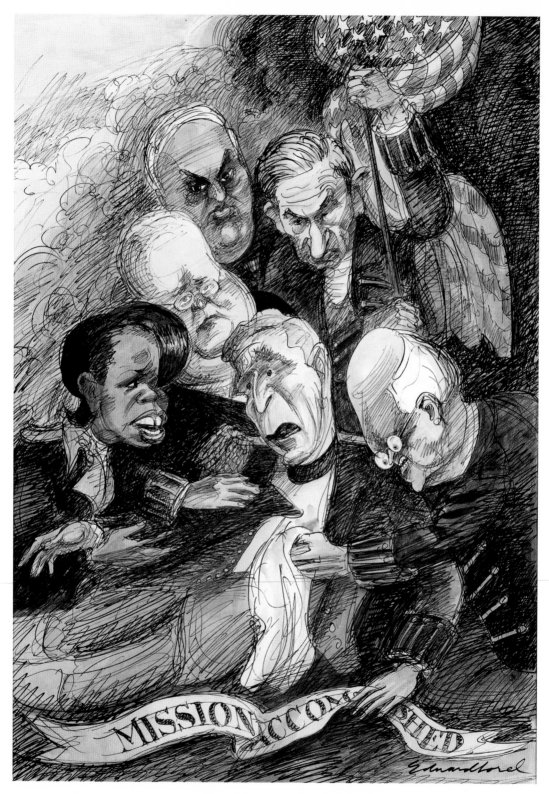

As you can see, I never hesitate in ripping off the work of artists who know how to compose paintings better than I do. This time I used Benjamin West's famous painting *The Death of General Wolfe,* with Bush the Younger taking Wolfe's place. Those attending the fallen leader are Condoleezza Rice, Karl Rove, Richard Perle, Paul Wolfowitz, and Halliburton's favorite son, Dick Cheney.

USS *Abraham Lincoln*. At this televised ceremony, the president dressed up as an air force pilot wearing battle gear. He strutted on deck as if he were a war hero, although he, like his vice president, had taken care to avoid combat in the Vietnam War.

Of course, no evidence of WMDs was ever found, and Bush's assertion that "major combat operations" were at an end proved to be somewhat premature. The war in Iraq is still going on to some extent as I write this. As of 2018, an estimated 295,000 Iraqi civilians had died. The figures for American soldiers killed are more specific: 4,418 as of March 2021. The casualties from the invasion of Afghanistan are even more horrific. But for George W. Bush, the continuing war had a bright side. Since presidents are never turned out of office in the middle of a war, he was reelected to a second term.

Besides inventing a false premise for going to war, Bush also gave fake estimates for the cost of the war, saying it would amount to $50 or $60 billion. By 2008 it had already cost $600 billion. He cut costs by not giving troops the body armor they needed in Iraq, and the entire invasion, done without an international mandate, is still considered illegal by the United Nations.

It's time to move on, but I can't leave without mentioning that Bush II gave the green light to torturing prisoners at Abu Ghraib; he sent deficits skyrocketing by hiding the cost of the Iraq War; he awarded contracts for Iraq's reconstruction to Dick Cheney's old employer Halliburton, which charged whatever it pleased; and he politicized the Department of Justice, long before Trump corrupted that organization. And let's not forget his attempt to change Social Security so individuals could use their accounts to gamble on the stock market, or his appointing an unqualified crony to head FEMA, a man who botched recovery efforts during Hurricane Katrina. And, finally, his greatest achievement, causing the economic collapse of 2008—the worst since the Great Depression—by deregulating banks even further, so they could do whatever they damn pleased.

Now it's time for Barack Obama's report card. Of course I will give him an "S" for "Satisfactory" and a star for "works and plays well with others." But I did not for vote him when he ran against

John McCain because I knew Obama would carry New York State without my vote. I again voted for Ralph Nader, whose beliefs coincided with my own. (Also, the fact that Obama closed every speech and every rally by asking God to bless his audience and bless the United States of America stuck in my atheist craw.) Nevertheless, I rejoiced on the night when the networks declared Obama the winner.

Nancy and I had moved to Harlem by then, so we heard the roar go up from every apartment when his win was made official. We heard horns honking and shouts from the street and decided to go outside on that cool November evening and join the merriment. We walked toward 125th Street, on Adam Clayton Powell Jr. Boulevard, where families, many with small children, had gathered to celebrate. One boy kept doing somersaults to entertain the crowd. It was memorable. It was joyous.

Looking back on his eight years, I think Obama did a pretty good job, considering that he was dealing with a Republican Party whose only aim, at every turn, was to thwart his agenda regardless of the public good. Yet Obama made blunders. The worst, I think, was not alerting the public to Russian attempts to throw the election to Trump. Obama wanted the Republicans to join the Democrats in a bipartisan statement condemning Russian interference in the 2016 election. Senate Majority Leader Mitch McConnell wouldn't hear of it, and Obama, fearing he would be accused of electioneering, told the public nothing about Russian cyberattacks. Whether he did so because he didn't want to be accused of railroading the election to Hillary or because he was certain that she would win in any case, his reticence, I believe, was what gave the win to Trump—whom some wag called "President Agent Orange."

Obama inherited two declared wars in Iraq and Afghanistan, two undeclared wars in Pakistan and Somalia. He then added three wars of his own. Under pressure from Hillary Clinton, his secretary of state, Obama initiated an all-out aerial attack on Libya to overthrow Colonel Muammar Gaddafi, destroying that country, and funded insurgents in Syria to bring down Bashar al-Assad,

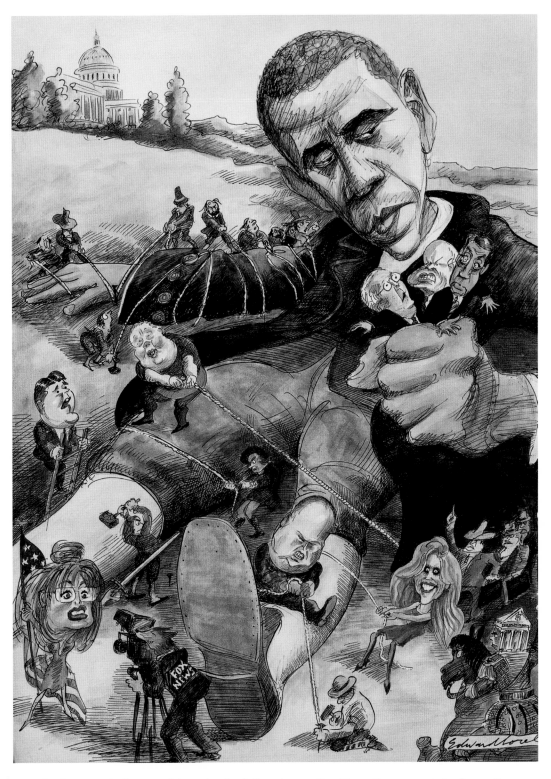

Barack Obama as Gulliver tied down by the Lilliputians at Fox News. Seen among the future Trump Troopers are Sarah Palin, Sean Hannity, Rush Limbaugh, and Glenn Beck.

an effort that only succeeded in throwing Assad into the arms of Vladimir Putin. Obama then supplied weapons to the Saudis, who launched a bombing campaign on Yemen that reduced the place to ashes. He also surreptitiously implanted the American military in forty-nine of Africa's fifty-four countries. When Obama left office none of those seven wars had been won, and none had been lost. Thanks in large part to Bush II, the Middle East had become a region of perpetual warfare.

No, I don't know what Obama should have done in the Middle East after Bush screwed up everything there for the foreseeable future, but here are a few things I would *not* have done. I would not have promised to wear an American flag pin on my lapel just because some yahoo in the audience questioned why I wasn't wearing one. I would not have appointed the ever-pompous Lawrence Summers to head the National Economic Council, since it was some of his policies that caused the economic crisis in the first place. I would not have visited an ailing Billy Graham, an anti-Semite who once said that he believed Richard Nixon (another Jew-hater) "had been sent by God." I would not have let Lloyd Blankfein and all those other sleazeballs on Wall Street get away with their crooked shenanigans without at least *trying* to throw a few of them in the slammer. And I would not have kept saying, "I look forward to working with my Republican friends" when I knew they were a bunch of racists who hated me.

Having said all that, I have to add that I found it comforting to have an intelligent, sane man in the White House. When he appeared on my television screen I did not immediately shut off the set, as I was compelled to do with most of his predecessors. As a result I was not inspired to do any critical cartoons about him. The only caricature of Obama that I drew during his eight years in office was this flattering one that appeared in *Vanity Fair*.

As I think I have already confessed, this book is essentially an attempt to save a few of my drawings from the oblivion that is the usual fate of ephemeral magazine art. It's also a way to convince myself that spending a lifetime making funny pictures was not an entirely worthless endeavor. Admittedly, my political cartoons

and satires did not change a damn thing, but they did, I think, reassure some of my fellow citizens that they were not alone.

Unfortunately, a few years before Trump became president I realized I had lost interest in doing political protest drawings. I'm not sure why, but the idea of once again expressing outrage on paper now exhausted me before I started. I had been doing it for sixty years, and not having the savagery of German expressionists Otto Dix or George Grosz, I felt my drawing style inadequate to express my contempt for the likes of Donald J. Trump. I did few caricatures of Trump, and none seem witty enough or angry enough to deserve an encore here. But here's one I did for *Vanity Fair* that at least describes some of his crimes.

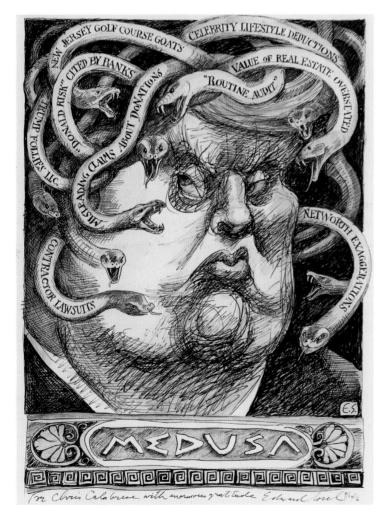

Donald Trump was in his third year as president before I got around to caricaturing him as Medusa, using his head of snakes to list his criminal acts. He was such a serious fascist threat to our country that I simply could never figure out a way of being amusing about him.

10

Act III

Flashback to 2015: Nancy died in February of that year. Months later, when warm weather melted the snow around our country house and all my children were gathered there, we buried Nancy's ashes in a grave we dug near our pond. We put small rocks around the oval, and each of us spoke of our memories of her.

I continued to live in our large Harlem apartment. Being alone after fifty years took some getting used to, but there was no time for self-pity because I had an important deadline to meet. A year before Nancy died, I had signed a contract with Liveright Books, an imprint of W. W. Norton, to write and illustrate a book about the life of Hollywood actress Mary Astor. Unlike the books I had written for children, this one, *Mary Astor's Purple Diary: The Great American Sex Scandal of 1936,* wasn't for the little ones.

I had been planning to write about the Mary Astor custody trial for close to fifty years, ever since I had ripped up several layers of decaying linoleum in my tenement kitchen and found a batch of newspapers, all dated from August 1936. The *Daily News* and the long-gone *Daily Mirror* both had screaming headlines about the

contents of Astor's diary, which Mary's ex-husband had brought to court to prove she was an unfit mother. After reading all the smelly papers, I got hold of the surprisingly well-written memoir that Astor wrote back in 1959. I promised myself that someday I would write and illustrate her story. When I was in my mid-eighties, I decided it was now or never. I had little reason to think I could write such a book, but on the basis of the one chapter I wrote, along with a few finished illustrations and a jacket design, Robert Weil, the head man at Liveright, bought my book.

After I promised him I'd do a hundred illustrations for the book (I did only fifty), he offered me a fifty-thousand-dollar advance and asked who my agent was so he could draw up a contract. "I no longer have one." "Well, who do you want?" After a moment, I decided to ask for Amanda Urban, one of the most powerful agents around. I remembered her fondly from the early days of *New York*

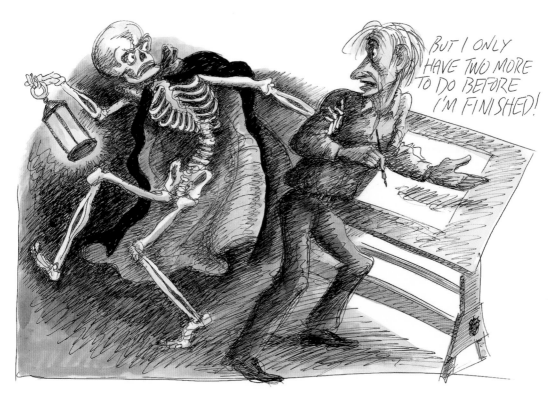

I was eighty-six when I started writing about Mary Astor, and in this drawing from the book, I am asking Death to give me a few more days to finish the drawings.

This illustration shows a room in the New York Archdiocese at the moment when Mary flies in through the window (looking as she did in the 1930s) to be interviewed by me.

magazine when she—known to everyone as "Binky"—was Clay Felker's secretary. She is still called Binky. You may wonder why I didn't sign the contract without an agent and keep her 15 percent for myself. That might have been smart if I could make myself read a contract, understand what the language meant, and not lose my temper with my editor when things went wrong. When things *did* go wrong all I had to do was complain to Binky, she fixed it, and I stayed out of trouble.

Writing for grown-ups was hard. I had never taken a writing class—they didn't have one at Cooper. Back then it was just a three-year art school that gave out a diploma, not a degree, when someone graduated. Writing *Purple Diary* was like flying blind until I enlisted my friend Prudence Crowther, an editor at *The New York Review of Books,* to help me out. Her aid made an enor-

The author discovering the old newspapers that would inspire him

OVERLEAF This summing up of Mary Astor's life was used as the endpapers for my book *Mary Astor's Purple Diary.* The airplane going down in flames refers to her first husband, who was killed while filming a scene for a movie about World War I.

Mary and George S. Kaufman taking a ride in Central Park at dawn, after a wonderful night in the sack.

mous difference. Even a book that ended up with only 167 pages took me a lot of time. Nevertheless, my manuscript and drawings were delivered on time in early 2016. The period between handing in my book and waiting for the reviews seemed endless. Dan Okrent calls it "the lull before the lull." The book's publication date of October 20 came and went without a single review or even a mention of it in *The New York Times.* And without a favorable review from the *Times,* I knew my book would die.

My diminishing hopes were kept alive by Graydon Carter, who bought my book's prepublication rights for *Vanity Fair.* When the October issue hit the newsstands, I was elated to see that Graydon had devoted six illustrated pages and some back pages to excerpts from the book. The illustration I had used for the book's end-

Mary had hopes that George would leave his wife for her.

papers ran over two pages in the magazine, bleeding off all sides.
The effect was sensational. My favorite illustrations from the book
are here.

Graydon Carter went even further in promoting *Purple Diary*.
He gave me a nifty publication party at the Waverly Inn. I loved
having all of my children, Madeline, Leo, Jenny, and Katherine,
at that jolly event. My editor, Bob Weil, was of course at the pub
party. He had made certain that the editor of *The New York Times
Book Review,* Pamela Paul, received an invitation to the festivi-
ties. Bob was still hoping against hope that she would somehow
squeeze in a review of my book before Christmas. At that jam-
packed party Bob introduced me to the beautiful Ms. Paul. She,
knowing what was on our minds, assured us that the book would

be reviewed, but not before Christmas. Seeing the despair on our faces, she added, "But when it comes out, you'll be very happy."

Three months after that October pub party, when all the Christmas book buying was over, a review of *Purple Diary* was published in *The New York Times Book Review*. To say that it made me "very happy" would be an understatement. My thin 167-page book was reviewed on the front page! And the review was written by Woody Allen. What's more, it was a rave. For a few days after it appeared—January 1, 2017—the book was a best-seller on Amazon. Of course, Woody Allen's review was forgotten in days, and the book barely sold out its first printing of fifteen thousand. No matter. I kept receiving letters and emails from total strangers telling me they loved my book. Best of all, I enjoyed the utter astonishment of certain friends (Jules Feiffer, for one) who had warned me that doing a book about an alcoholic supporting actress, now remembered only by a few octogenarians, was an incredibly stupid idea.

The reason the book wasn't reviewed in time for Christmas was that Allen was directing a movie when *Purple Diary* was sent to him. He replied that he'd love to review it, but couldn't do it until after he finished shooting. To get a review by Woody Allen, the editors decided to wait until he could deliver. I'm happy that they did.

Okay, it was wonderful having a mini success with *Purple Diary,* but what was I going to do next? I had turned down a number of assignments from *The New Yorker* in the three years I had been working on *Purple Diary,* and now they no longer called with illustration assignments and I couldn't seem to think of any new ideas for *New Yorker* covers. Maybe I was intimidated by the brilliant covers young Barry Blitt was now doing. They were terrific. Also, I couldn't help noticing that a lot of the illustrations inside the magazine these days are computer-generated, so perhaps my sketchy drawing style was now old hat.

If so, I won't be the first illustrator to suddenly find himself out of fashion because of technological advances. That's been going on since the Reformation, when Protestant artists in Holland and Germany—Holbein, Dürer, and Lucas Cranach—used the new

technology of woodcuts to mass-produce their caricatures that vilified Pope Leo X. In retaliation, Catholic artists in Italy produced woodcuts demonizing Martin Luther, and voilà!, the political cartoon was born. Centuries later etching replaced woodcuts and wood engraving, allowing artists for the first time to actually *draw* on a plate rather than cut into wood. That gave us the genius of Rembrandt, and later Thomas Rowlandson. Next came lithography, which meant that artists could draw with a crayon or a brush, and suddenly we had Daumier and Toulouse-Lautrec.

As far as I'm concerned, printmaking technology could have ended there. But it didn't. The computer allows artists to do unimaginable things by pushing the mouse around. Some of the effects are spectacular, and I admire many of them. But I'm too much in love with making images by hand to want to discover what magic I could do on the computer. Perhaps it's just a case of being too old to learn new tricks.

I'm pleased that Françoise Mouly, the art editor at *The New Yorker,* still urges me to submit ideas. Perhaps one morning I'll wake up with an idea for a pictorial essay like the ones I used to do when *The New Yorker* had more pages for the light stuff. It's a thin magazine these days, and pretty serious. How could it be otherwise in these frightening times? Turn the page and you'll see another of the double-page spreads I did for one of that magazine's fiction issues, in happier, less frightening days.

Without *The New Yorker* I looked around for another publication that would publish me on a regular basis. I found one at *The New York Times Book Review,* where my "Literati" page began appearing monthly in 2018. I interrupted working on the feature to write this book, but I'm sure I'll be back there by the time you read this. I think my "Literati" drawings are as good as any I have done in the past. It's comforting to be in a profession where you don't lose your skills when you get to be a geezer. Here are seven of my favorite pages from the *Book Review* and one (Dorothy Parker and George S. Kaufman) from *Vanity Fair.*

I've already confessed that my initial impetus in starting this book had no larger purpose than to show off my caricatures. (By calling all of my work *caricature* I'm using the word as it is under-

LEO TOLSTOY WORE A PEASANT'S TUNIC TO SHOW HIS SERFS THAT ALL MEN ARE BROTHERS. BUT AFTER COUPLING WITH SEVERAL OF THEIR DAUGHTERS, HE WAS FORCED TO ADMIT THAT ALL MEN ARE JUST MEN.

NORMAN MAILER HAS ALWAYS USED CLOTHES TO ASSERT HIS MACHO INDIVIDUALISM. IN 1949, WHEN AN ELEGANT RECEPTION WAS HELD TO HONOR HIM AS THE AUTHOR OF "THE NAKED AND THE DEAD," HE ARRIVED IN A T-SHIRT AND BASEBALL CAP.

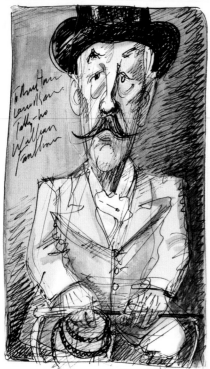

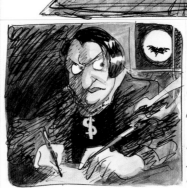

AYN RAND, PROUD TO SHOW HER LOVE FOR THE FREE-ENTERPRISE SYSTEM, WORE A HUGE DOLLAR SIGN AROUND HER NECK. THIS SYMBOL, SOME BELIEVED, HAD THE POWER TO FEND OFF VAMPIRES AND LIBERALS.

WILLIAM FAULKNER WAS FRIGHTENED OF HORSES, BUT HE LOVED DRESSING UP FOR THE HUNT. WHEN RANDOM HOUSE ASKED THE AUTHOR FOR HIS PHOTOGRAPH, HE SENT THIS ONE.

LITERARY FASHION

FRAN LEBOWITZ'S TRADEMARK DARK TROUSER SUIT IS APPROPRIATE FOR A COINER OF CYNICAL APHORISMS. ("MY FAVORITE ANIMAL IS STEAK.") SHE IS SEEN HERE WITH THE WRITER-DIRECTOR **JOHN WATERS** WHOSE JACKET SUGGESTS A MORE CHEERFUL VIEW OF LIFE.

OSCAR WILDE ARRIVED IN AMERICA WEARING THIS GREEN FUR-TRIMMED COAT. HIS COMMENT THAT THE SEA WAS "NOT SO MAJESTIC AS I HAD EXPECTED" RESULTED IN THE HEADLINE "MR. WILDE DISAPPOINTED WITH ATLANTIC."

JOHN O'HARA PREFERRED TWEEDS WITH HIS MONOGRAMMED MG-TC AND A THREE-PIECE SUIT WITH HIS ROLLS ROYCE. BUT NO MATTER WHAT HE WORE, HE SELDOM FORGOT TO PIN ON HIS ROSETTE FROM THE NATIONAL INSTITUTE OF ARTS AND LETTERS.

Zora Neale Hurston and Fannie Hurst

In 1925, Zora Neale Hurston won two literary prizes from the Urban League and a scholarship to Barnard University from Barnard's founder, Annie Nathan Meyer. When Zora needed a job with flexible hours so she could attend classes, novelist Fannie Hurst hired Zora as her secretary. Hurst and Hurston became close friends, and over coffee Zora would relate what it was like being Barnard's only Black student. Fannie, a Jew from a tiny town in Ohio, found it easy to empathize.

Sinclair Lewis and Theodore Dreiser

Both wrote novels that skewered the patriarchal, conformist towns in which they were raised, both had their books assailed as immoral, and both were angling to be the first American to win the Nobel Prize for Literature. Lewis got it in 1930. They met a year later at New York's elegant Metropolitan Club, where Lewis publicly accused Dreiser of having plagiarized three thousand words from his wife's book on the USSR. When Lewis refused to retract his words, Dreiser slapped his face twice in front of the horrified guests.

Leo Tolstoy

In 1877, Tolstoy decided to do what Jesus would do. Leo became a vegetarian, made his own shoes, and gave to the poor. When guests came to visit, he ordered them to empty their own chamber pots, while servants idly stood by. At the end of Tolstoy's life, when Sonya found out that he was planning to surrender his copyrights, leaving their children penniless, a violent confrontation followed that led to the eighty-two-year-old author fleeing his home. His railway car was unheated, and he died of pneumonia days later.

T. S. Eliot

The publication of Eliot's epic poem, "The Waste Land," was greeted with outrage by some; others believed him to be the greatest poet of the twentieth century. By 1946 he was invited to read for the king and queen of England—he was living there at the time. (But not his own verse, which he didn't think the royals would understand.) Later he received the Nobel Prize, the British Order of Merit, and France made him an Officier de la Légion d'Honneur. He should have been happy, but he decided that wouldn't suit his image.

Dorothy Parker

Newlyweds Dorothy Parker, forty-one, and Alan Campbell, thirty, arrived in Hollywood in 1934 to begin their careers as a screenwriting team. They quickly racked up credits on fifteen films, but Dorothy, concerned about the rise of fascism, cofounded the Hollywood Anti-Nazi League. When World War II began, she tried to become a foreign correspondent but found she couldn't get a passport because she was "a premature anti-fascist." After the war she was blacklisted. No more movie work.

Dorothy Parker and George Kaufman

When Dorothy Parker and Lillian Hellman arrived at George Kaufman's home for a weekend visit, Dottie got a call informing her that Sunday's *Times Book Review* would carry her remark about George—"So much kudos for so little talent." On Sunday Dottie woke early, grabbed the *Review*, and took a walk with Lil and buried it. But George learned about her remark, and when she and Lil were about to leave, he innocently asked, "Dottie, did you take the real estate section?"

H. G. Wells and George Bernard Shaw

The socialist Fabian Society invited the popular futurist H. G. Wells to join in 1901. He served passively for two years, then delivered his "Faults of the Fabians" talk, listing the reasons for their ineffectiveness. Shaw, feeling that his leadership was being threatened, used his skill as a debater to force Wells to resign. During Wells's association with the society, its membership tripled. He had joined to promote socialism but, instead, had only succeeded in promoting the Fabians.

Arthur Conan Doyle and the Cottingley Fairies

In 1920, Conan Doyle, famous author of Sherlock Holmes, received a letter from a friend who had a photograph in which tiny females with diaphanous wings are cavorting in front of sixteen-year-old Elsie Wright. The photo had been taken by her ten-year-old cousin in the village of Cottingley. Doyle regarded the photograph of fairies as genuine and continued to believe in fairies until his death in 1930. In 1983, a much older Elsie owned up to the hoax. She had cut pictures of fairies out of a book.

stood in Europe, where the word covers anything satiric.) Adding autobiographical material to this collection was the idea of my editor, Ann Close, who was undaunted by my protest that I had led a remarkably unremarkable life. She conceded my point, but reminded me that whatever I thought of my personal life, I had lived through some interesting times. I couldn't deny that.

One damned thing after another: the Crash of 1929 (my birth year), the Great Depression, Mussolini, Hitler, Tojo, Pearl Harbor, World War II, Auschwitz, Hiroshima, Truman, TVs in every home, the Red Scare, the CIA, the Korean War, the Cold War, the Blacklist, Joe McCarthy, Eisenhower and John Foster Dulles, Julius and Ethel Rosenberg, JFK, Allen Dulles, Bay of Pigs, the Cuban Missile Crisis, Vietnam, Lee Harvey Oswald, LBJ, Nixon's Southern strategy, white supremacists bombing Black churches, devout Christians bombing abortion clinics, computers in every home, Clinton caught with his fly open, 9/11, Bush II invades Iraq on fake intelligence, the Tea Party takes over the Republican Party, Obama wins two terms, the Electoral College puts Trump in the White House, and the Coronavirus takes over the world.

When I started writing this book a friend suggested I call it "Dumb Luck." Like me, she was a Jew who grew up poor in New York during the Depression. Both of us were first-generation Americans, and both of us were able to use whatever talents we had to live interesting, creative lives. We did not die in an extermination camp, nor were we born in Haiti or Afghanistan or Mississippi. Dumb luck.

My grandmother and her five daughters were lucky too. When they arrived at Ellis Island in 1923, the new immigration laws that would have kept them out of the United States would not go into effect until a short while after they landed. Opposite is their passport photo. The tallest daughter is Rebecca, my mother. I'll end my book with a toast to her, her mordant sense of humor and her kind heart. I thank her for sending me to that Saturday art class at the Little Red School House, and for not pushing me into a career that was safe, steady, and stultifying. A life making funny pictures suited me just fine. Thanks, Mom.

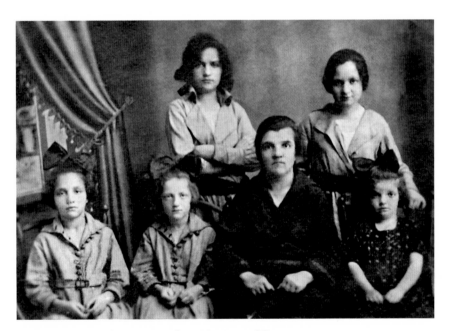
Jeanette, Sally, Rebecca, Grandma, Nettie, and Yetta

Acknowledgments

I started collecting my drawings for this book just when the pandemic hit. Suddenly there was no one in Knopf's offices to take my art, and no one there to photograph it. That job fell to my son, Leo Sorel, a busy portrait photographer, who, thanks to COVID-19, suddenly had time to save his father's book. Leo soon discovered that most of my originals were no longer available due to the fact that I had sold almost all my pictures to the Howard Gotlieb Archive of Boston University, which closed, due to the Plague. The missing originals would have to be photographed from pages in magazines. That meant Leo would have to use his computer skills to bring the poorly reproduced tear sheets up to Knopf's exacting standards. Not easy, but he did it. Leo also served as a sounding board for my doubts and insecurities, and came up with many ideas that made this a better book. I could not have done this book without him.

Ann Close has been my editor for all of the four books I've done for Knopf. It was her idea to have me accompany my collection of comic drawing with stories about my life. I am, I believe, the only caricaturist who Ann edits. Writers such as Alice Munro, Lawrence Wright, and Norman Rush are the sort of authors Ann usually works with, but I suspect that editing them was not nearly as time-consuming as dealing with this small (but complicated) book.

Maggie Hinders was handed a hodgepodge of unrelated material—black-and-white drawings, comic strips, photographs of murals, and paintings of every shape and size, and somehow designed a book that flowed like Strauss's Blue Danube. Genius!

Roméo Enriquez handles the production at Knopf, and his attention to detail means that I didn't have to worry about how my artwork would reproduce. Roméo would see to it that each and every one of my pictures appeared as close to the original as is humanly possible. And a salute to Nicole Pedersen, the production editor who oversaw the copyediting and proofreading.

And to Kathy Zuckerman, my publicist, who has promised to make me famous and adored; I'm counting on you to keep your promise.

Norman Schwartz, my brother, has always been there when I was in trouble. Although fifteen years younger, he magically turned into my big brother after I was widowed, and saw to it that I got a flu shot every year, and chicken soup when I had a cold. So good having him nearby.

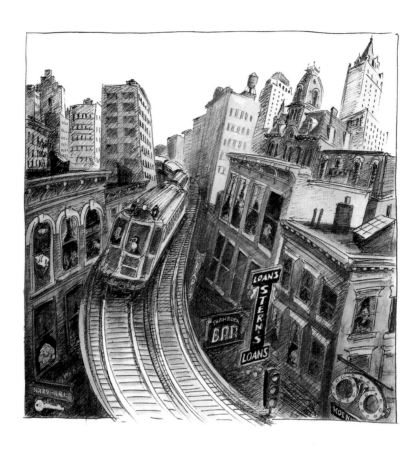

A NOTE ABOUT THE AUTHOR

Edward Sorel is an illustrator, caricaturist, and cartoonist whose satires and pictorial essays have appeared in many, many places, among them *Vanity Fair, The Atlantic, The Nation,* and *The New Yorker,* for which he has done numerous covers. He lives in New York in the apartment that he shared with his wife and sometime writing partner, Nancy Caldwell Sorel.

A NOTE ON THE TYPE

This book was set in a modern adaptation of a type designed by the first William Caslon (1692–1766). The Caslon face has enjoyed over two centuries of popularity in our own country. It is of interest to note that the first copies of the Declaration of Independence distributed to the citizens of the newborn nation were printed in this typeface.

Composed by North Market Street Graphics, Lancaster, Pennsylvania

Printed and bound by Mohn Media, Gütersloh, Germany

Design by Maggie Hinders

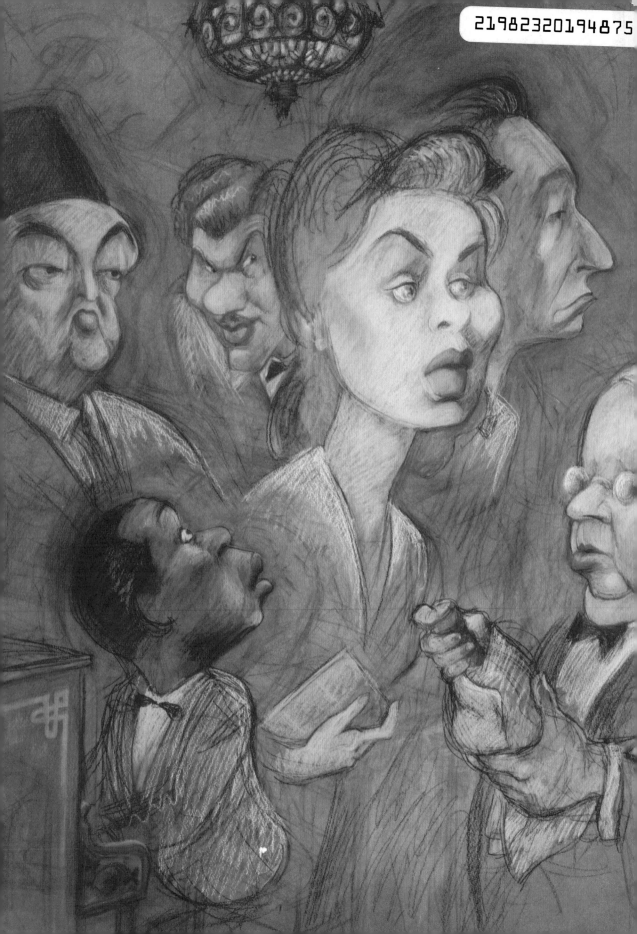